Color

DECODER

Color
DECODER

Unlock your physical, spiritual, and emotional potential

Dorothye Parker

BARRON'S

Contents

A QUARTO BOOK

First edition for the United States, its territories and dependencies, and Canada published in 2001 by Barron's Educational series, Inc.

All inquries should be addressed to:
Barron's Educational Series, Inc.
250 Wireless Boulevard
Hauppauge, NY 11788
http://www.barronseduc.com

Copyright © 2001 Quarto Inc.

Library of Congress Catalog Card No.
00-110913

International Standard Book No.
0-7641-1887-0

QUAR.CODE

Conceived, designed, and produced by
Quarto Publishing plc
The Old Brewery
6 Blundell Street
London N7 9BH

Editor: Nadia Naqib
Senior art editor: Elizabeth Healey
Designer: Rod Teasdale
Text editors: Andrew Armitage, Paula Regan
Picture Research: Image Select International

Photographer: Rosa Rodrigo
Illustrator: Julie Anderson
Indexer: Diana Le Core

Art director: Moira Clinch
Publisher: Piers Spence

Manufactured by Regent Publishing Services Ltd,
Hong Kong
Printed by Leefung Asco, China

9 8 7 6 5 4 3 2 1

Introduction

Color is intrinsic to life. Yet although we are at all times surrounded by it, we frequently neglect to see it. Often we become conscious of color only when it is relatively absent—on a gloomy, overcast day for example—or when a single color is starkly presented to us as on a bright car or showy item of clothing. The natural world is replete with all manner and tone of color; flowers, animals, sunsets, the color of people's eyes, hair, skin, and lips all play a vital, animating role in how we, consciously or unconsciously, see and interpret the world and how we are in turn perceived. Seen through the sepia lens of an old-fashioned movie camera, the world would seem dull, devoid of warmth or delight, without color.

And just as color has immense significance for us at an individual level, so have entire cultures, at different times and in different places, ascribed enormous meaning to color. The ancient Egyptians believed that the true essence of things was in part revealed by their color. Most religious traditions evolved color codes that also subliminally reflected their natural and cultural environments. In Christian tradition, the Virgin is frequently associated with blue, the color of the soul and healing. In India and Sri Lanka, many Ayurvedic healers associate a color with each of the major chakras (or spiritual centers of power in our bodies). Red is the color of the base chakra, the chakra which feeds our instinct for self-preservation, while green is the color ascribed to the heart chakra, the central chakra that mediates between the world of spirit and matter. Although no one color has ever meant exactly the same thing to cultures the world over, the instances of overlap and difference point again and again to the fact that color meaning is universal.

CHAKRAS
Chakras are vortices of energy, which act as conduits channeling vital life energy from the earth and cosmic energy from the heavens into all living things.

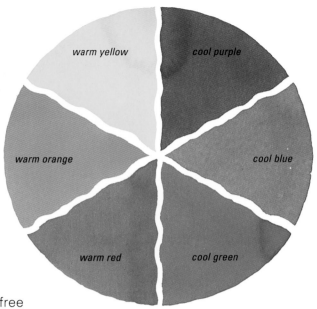

Modern-day color psychologists hold that color influences our mood and sense of well-being. Not for nothing do artists divide colors into rough categories of warm (red, orange, and yellow) and cool (green, blue, and violet), depending on the effect that they are seen to have on our psychological states. The Austrian philosopher Rudolf Steiner (1861-1925), one of the earliest pioneers of color therapy, developed theories that drew attention to the importance of using different colors in school classrooms. The Swiss psychiatrist Carl Jung (1875-1961) believed that Sigmund Freud's method of "free association" in dreams, in which a patient is encouraged to follow the chains of free associations that follow from a single dream image, could be applied to states of waking reverie. If we stare at an irregular shape for a length of time, we can form associations with past events that have been repressed in the unconscious mind. Color healers and practitioners hold that the same "free association" can happen with color—via the visual perception of color, the feel of it on our skin, or the visualization of color in our minds. This revival of interest in color as a method of emotional and psychological healing is a return to the healing practices of the ancients. It draws particularly on the ancient Indian system of chakras, which provides an intricate and delicate system of correspondences between particular colors, emotions, spiritual states, and body systems, organs, and glands.

This book shows you how you can raise your awareness of color to a more conscious level using the three-step colorology method, which determines the three essential colors that make up the core of your being. By drawing attention to the colors that are dominant or missing in your life, it allows you to take the necessary steps at all levels, physical, emotional, and spiritual to unblock negative influences and achieve your fullest potential.

COLOR WHEEL
Many color wheels have been devised through the ages. This color wheel shows artists' basic warm and cool colors.

BLUE MADONNA
In Christian tradition, the color blue represents detachment from worldly matters, and is frequently associated with the Virgin Mary.

Scientific Principles
OF LIGHT AND COLOR

EINSTEIN

The great theoretical physicist, Albert Einstein, showed that light could be regarded either as a wave motion or as a stream of particles.

The electromagnetic spectrum

To understand the phenomenon of color it is important to know about light and where it stands in the electromagnetic spectrum (EMS). Electromagnetic energy originates from the sun and contains different wavelengths, from radio waves, which are the longest, to gamma rays, which are the shortest. Light occupies only a small portion of the total EMS and is the only part visible to the human eye.

The nature of light

There have been numerous theories about the form light takes. The British physicist and mathematician Sir Isaac Newton (1642–1727) theorized that a beam of light consisted of a stream of tiny particles. The Dutch astronomer, mathematician, and physicist Christiaan Huygens (1629–1695) said that light was made up of waves and developed a wave theory, which explained the phenomena of reflection and refraction with great success. In the nineteenth century, the British theoretical physicist James Maxwell (1831-79) showed that light waves were in fact made of electric and magnetic oscillations through space and are thus electromagnetic waves. The wave theory of light thus became the established scientific wisdom and remains so to this day.

But the story did not end there. In the early twentieth century, Albert Einstein (1879–1955) postulated that light was made of small bundles ("quanta") of energy, now called photons, to explain the way light and electrons interact (the so-called photoelectric effect). He held that light could be regarded as either a wave or a stream of particles depending on its behavior in experiment. It is this Jekyll-and-Hyde nature of light—known as the "wave–particle duality"—that is now widely accepted by scientists.

COLOR WAVE LENGTHS	
Red light	627—780nm
Orange light	589—627nm
Yellow light	556—589nm
Green light	495—556nm
Blue light	436—495nm
Violet light	380—436nm

Light leaving upright prism splits into color spectrum

Light leaves inverted

PRISMATIC EFFECTS
When white light enters a prism, it refracts toward the prism base to give the colors of the spectrum. This effect is canceled when the colors enter a second, upturned prism to re-emerge as white light.

Newton's refracted-light experiment in particular showed that when light was directed into a prism it broke up into all the colors of the spectrum and that when these colors then entered another prism they re-emerged as white light. Light waves (or wave lengths) are measured in nanometers (nm)—one billionth (one thousand-millionth) of a meter—and they are perceived by the eye because of nerve endings called rods and cones, which are sensitive to particular wave lengths or frequencies of light. As can be seen from the spectral measurements shown opposite, each individual color has its own range of wave lengths. Hence color is simply light of different wave lengths as perceived by the eye and the brain.

Primary, secondary, and tertiary colors

Pigments, once derived chiefly from natural sources but now produced synthetically, are vital substances used to impart color to other materials such as dyes and paints. The color of a pigment corresponds to the wave length of light it reflects because it absorbs all other wave lengths. Hence a red-colored pigment absorbs all wavelengths apart from red, which it reflects back into the eye. Multiple shades and hues of pigment are produced by mixing together different-color pigments.

Different results are produced when colored lights, as opposed to pigments, are mixed. The primary colors of light are red, green, and blue and they too can be combined to produce almost any color sensation in the human eye.

The primary colors of pigment are red, yellow, and blue. Secondary colors are made by mixing any two primary colors together. So red and yellow combine to produce orange; yellow and blue, to produce green; and blue and red, to produce violet. The color wheel on pages 14–15 is based on the primary colors of pigment and their combinations. Diagonally opposite to each primary color on the wheel is its complementary color. So the complementary color to yellow is violet, and the complementary color to red is green.

A tertiary color is made by mixing a primary color with a secondary color. For example, if you mix the primary color of red with the secondary color of orange you create the tertiary color scarlet. There are six tertiary colors in all: scarlet, gold, lime, turquoise, indigo, and magenta.

If white is added to any of these colors, a lighter shade or tint will be produced, and with black a darker shade.

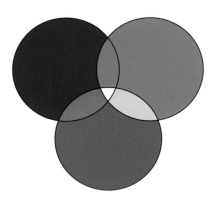

LIGHT WHEEL
The primary colors of light can be combined to produce almost any color perceivable by the human eye. Nowhere is this better utilized than in color television receivers.

PIGMENT WHEEL
This is one example of an artist's color wheel. The largest segments indicate primary colors, the medium-sized segments, secondary colors, and the smallest segments, tertiary colors. Another color wheel is shown on pages 14–15.

DESIGNING WITH COLOR
Artists mix different-color paints (left) to produce a vast array of colors. The pantone color system (above) provides the designer with a multitude of color options and effects, including metallic and fluorescent colors.

PANTONE® 804 C

Color ENERGY

The emerging model of vibrational medicine, which views the body as a multidimensional human energy system, begins to make sense of ancient healing practices, in which color and other forms of energy were used to restore health.

The aura

The concept of auras holds that we not only have a physical body but several other subtle bodies, which are linked to our spiritual, mental, and emotional selves. These bodies vibrate at a speed that makes them invisible to the human eye and emit color vibrations to form what is known as an aura.

It is believed that, extending outward from the physical body, is an auric field, which contains different layers of electromagnetic energy, or bodies of light. Each of these four bodies vibrates to a frequency of color that is constantly changing according to one's thoughts, moods, and emotions.

Chakras

Linked to the aura are energy centers known as chakras. Traditional maps plot both major and minor chakras, but this book is concerned chiefly with the seven major chakras located, metaphysically speaking, along the spine. The chakra system takes the view that in order to live a full, balanced life, we must tend not only to our physical needs but to our emotional, mental, and spiritual requirements as well.

Chakras, from the Sanskrit *chakrum* meaning "wheel," have been described as whirling vortices of energy. They are directly affected by spiritual or subtle energy called *prana* (Sanskrit for "moving force" or "breath"), which we obtain via the light rays entering our body. This flow of pranic energy is distributed via the chakras to our cells, organs, and body tissues and is heavily influenced by our personality, emotions, and spiritual state.

Moreover each chakra is associated with a particular organ or system in the physical body. A link is also perceived from the chakras to the endocrine system, which controls the hormonal glands.

Color and chakras

Each chakra vibrates to a dominant color. When there is an imbalance in the color frequency of a chakra, this creates disharmony or disease within the body, which can be restored by the introduction of the appropriate color (see pages 138–141). The seven major chakras with their correspondences are shown on the opposite page.

WHEEL
The word chakra *comes from the Sanskrit for "disk" or "wheel." Ancient medicine perceives the chakras as points where channels transporting the vital life force energy (or* prana*) meet.*

CHAKRA'S NAME	DOMINANT COLOR	LOCATION		PHYSICAL ASSOCIATION	EMOTIONAL ASSOCIATION
Crown	Violet	Middle on top of head		Headaches Migraines Pineal gland— light-sensitive, regulates the hormone melatonin	Spiritual connection to higher energies Gives sense of purpose and meaning in life
Brow	Indigo	Middle of forehead directly above eyes		Pituitary gland, regulates hormonal function Mental ability Eyes and ears	Perception of emotional issues
Throat	Blue	Nape of neck over thyroid gland		Voice, throat, speech Regulates metabolic rate	Personal expression of feelings
Heart	Green	Middle of breastbone		Thymus gland Immune system	Issues of self love, nurturing
Solar plexus	Yellow	Below ribcage, middle of the diaphragm		Pancreas, adrenals, stomach, digestive organs	Personal power, self-esteem issues
Sacral	Orange	Lower pelvic region		Human reproductive system: ovaries (women) testes (men)	Personal relationships
Root or base	Red	Bottom of spine		Blood disorders Bone marrow Energy depletion	Safety, security Survival issues

Color
PSYCHOLOGY

We all know that seeing color affects our moods, that we find some colors calming and others disturbing. Color is therefore a highly effective psychological tool that can be used by trained practitioners to access our inner emotional states and bring unresolved issues and problems to the surface.

Color in language and nature

The use of color metaphors in everyday language is deeply embedded in cultures the world over. In the United States and Britain, color is used to describe a whole range of emotions—the term "red-blooded" denotes someone vigorous or virile; if someone is green this means that they are either naïve and inexperienced or envious. In France, green is also used to denote envy, but a blue person is someone who is inexperienced. In Germany, if someone is blue this means they are drunk, and yellow, not green, is the color of envy.

The world of nature also uses color language, often in warning signs to either attract or repel. Ladybird beetles, for instance, are red and black, wasps, yellow and black. These color combinations are used for the express purpose of discouraging other creatures from approaching.

Color meaning

Each color has a specific quality and meaning, and an understanding of a color's positive and negative attributes can raise your awareness of the influences at play in your life. If a particular color dominates your personal reading (see pages 16–17), this will tell you a great deal about your character and potential.

COUPLE (left, top)
Color psychology plays a vital part in how we perceive others, including those closest and dearest to us.

HONEY BEE (left, center)
Insects have a very discriminating sense of color, which they use to find their food.

CHILD IN THE SAND (left)
Color is believed to have a marked effect on our mood. The colors of sky, sea, and sand can promote a sense of happiness and serenity.

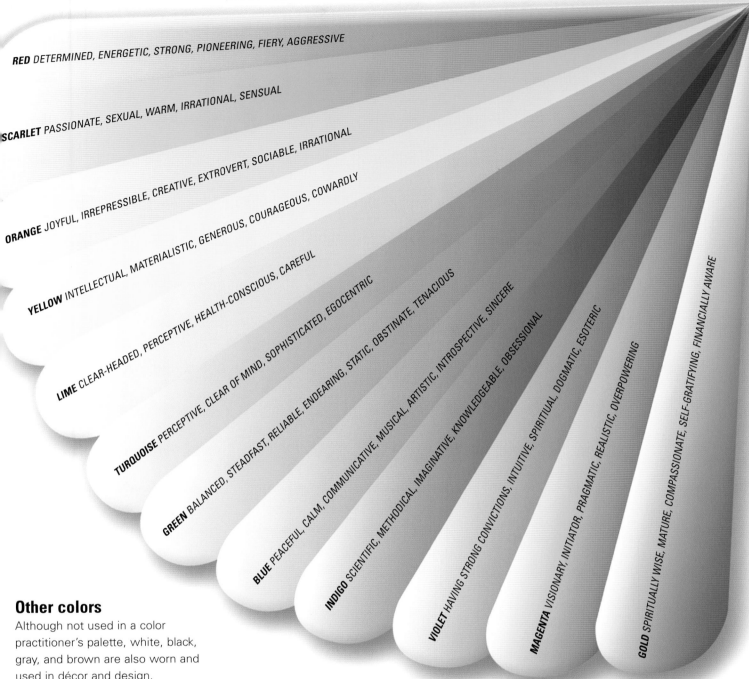

RED DETERMINED, ENERGETIC, STRONG, PIONEERING, FIERY, AGGRESSIVE

SCARLET PASSIONATE, SEXUAL, WARM, IRRATIONAL, SENSUAL

ORANGE JOYFUL, IRREPRESSIBLE, CREATIVE, EXTROVERT, SOCIABLE, IRRATIONAL

YELLOW INTELLECTUAL, MATERIALISTIC, GENEROUS, COURAGEOUS, COWARDLY

LIME CLEAR-HEADED, PERCEPTIVE, HEALTH-CONSCIOUS, CAREFUL

TURQUOISE PERCEPTIVE, CLEAR OF MIND, SOPHISTICATED, EGOCENTRIC

GREEN BALANCED, STEADFAST, RELIABLE, ENDEARING, STATIC, OBSTINATE, TENACIOUS

BLUE PEACEFUL, CALM, COMMUNICATIVE, MUSICAL, ARTISTIC, INTROSPECTIVE, SINCERE

INDIGO SCIENTIFIC, METHODICAL, IMAGINATIVE, KNOWLEDGEABLE, OBSESSIONAL

VIOLET HAVING STRONG CONVICTIONS, INTUITIVE, SPIRITUAL, DOGMATIC, ESOTERIC

MAGENTA VISIONARY, INITIATOR, PRAGMATIC, REALISTIC, OVERPOWERING

GOLD SPIRITUALLY WISE, MATURE, COMPASSIONATE, SELF-GRATIFYING, FINANCIALLY AWARE

Other colors

Although not used in a color practitioner's palette, white, black, gray, and brown are also worn and used in décor and design.

In many cultures white is the color of purity, simplicity, and innocence. It is associated with spiritual qualities and all that is good and pure. Black often represents death, fear of the unknown, and that which is hidden, and is therefore the color of mystery. Adding white to black creates gray, the color of confusion and fear, lack of direction, and doubt. Brown, linked to the color of the earth, corresponds to stability, solid foundations, and security.

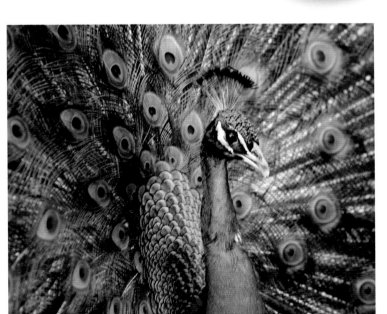

COLOR MEANING
The chart above summarizes the general psychological meanings and effects of the main colors.

PEACOCK
The peacock is justifiably famous for its glorious train of multi-colored feathers, which it fans during courtship.

Colorology

Colorology uses the principles of color energy inherent in nature to help us better understand ourselves and those around us. To discover the colors that resonate with any individual involves an analysis of his or her sun sign, name, and date of birth. This gives a three-part combination of colors from which a personal reading can be made. Moreover, by highlighting which colors are dominant or missing and hence where there is a likely imbalance in mind, body, or spirit, the reading will enable the individual to take steps toward self-improvement and self-healing by rebalancing those colors in his or her life.

Colorology works with 12 colors for the sun signs and 9 colors for the date of birth and name. These determine respectively each individual's life lesson color, destiny color, and personal expression color. The palette from which these colors are drawn is derived from the primary colors of red, yellow, and blue pigment. Different combinations of these colors produce the secondary colors of orange, green, and violet. If these colors are then mixed with the colors closest to them they produce the six tertiary colors of the palette (see pages 8–9).

(see pages 8–9)

1 Sun sign color

The sun sign color is the soul's development or life lesson color, which reveals what you have been put on this earth to explore or do. It is where your soul resides, and it reflects the development of your soul to date. It is the underlying force in everything you do, even when you aren't conscious of it. The color wheel opposite gives you your sun sign color; this in turn will show you a combination of colors which are manifesting within your life. If, for example, your sun sign is Scorpio, your essential sun color is turquoise, but you will also find that blue, green, and yellow will have relevance to some aspects of your life. Being aware of influences from colors other than just your single sun sign color can help you to clarify your reading.

Pisces
Magenta
Red and Violet

Aquarius
Violet
Red and Blue

Capricorn
Indigo
Blue and Violet

Sagitarius
Blue

Scorpio
Turquoise
Green and Blue

Libra
Green
Blue and Yellow

Colorology Table

Number	Color	Letters
1	Red	A J S
2	Orange	B K T
3	Yellow	C L U
4	Green	D M V
5	Blue	E N W
6	Indigo	F O X
7	Violet	G P Y
8	Magenta	H Q Z
9	Gold	I R

The color denoted by your date of birth is your life purpose or destiny color, and determines what the future might have in store, and what decisions you should make.

To work out your birth color, you need to reduce your birth date to a number between 1 and 9. Then using the colorology table (left) relate your birth number to one of the nine colors. To calculate your birth number, separate out the digits for the month, day, and year in which you were born, and add them together.

For example, if your birthday is November 21, 1964, you calculate your birth number as follows:

$$1 + 1 + 2 + 1 + 1 + 9 + 6 + 4 = 25$$

Reduce the number 25 down to a single-digit number by adding again:

$$2 + 5 = 7$$

From the birth number 7 you see that your destiny color is violet.

Aries
Red

Taurus
Scarlet
Red and Orange

Gemini
Orange
*Red and
Yellow*

Cancer
Gold
*Yellow and
Orange*

Leo
Yellow

Virgo
Lime
Yellow and Green

Your name color is your personal expression color, and represents the tools or keys you have been given to unlock your potential. It is found by relating each letter in your name to a number and its associated color.

Using the table above, look up the numerical value of each letter of your name. For example, if your name is John Smith, the letters of your name have the following numerical values:

$$\begin{matrix} \text{J} & \text{O} & \text{H} & \text{N} & & \text{S} & \text{M} & \text{I} & \text{T} & \text{H} \\ 1 & 6 & 8 & 5 & & 1 & 4 & 9 & 2 & 8 \end{matrix}$$

Add the numbers together:

$$1 + 6 + 8 + 5 + 1 + 4 + 9 + 2 + 8 = 44$$

Reduce the number 44 down to a single-digit number by adding again:

$$4 + 4 = 8$$

From the name number 8 you see that your personal expression color is magenta.

So, for John Smith, born on November 21, 1964, the unique color combination is Turquoise, Violet, and Magenta. An interpretation of this, and your own unique color combination, is found in the following pages.

Refining your reading

Once you have discovered your life lesson color, destiny color, and personal expression color, you can create a personal color chart. Together with the more advanced techniques of color analysis on the following pages, this will give you the key to a greater understanding of yourself and others, showing the whole spectrum of colors that are influential or lacking in your life.

Your
THREE
Essential
Colors

How to Use this Book

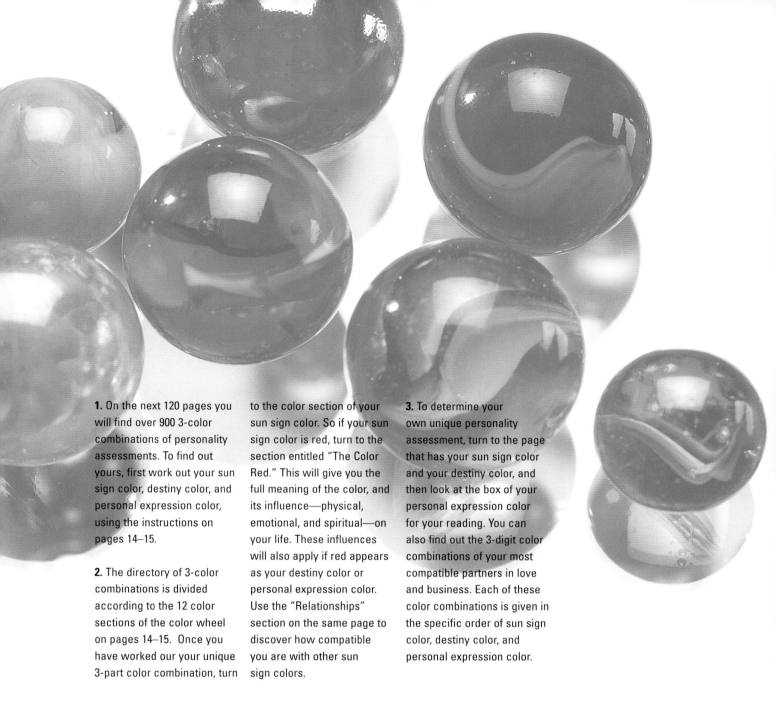

1. On the next 120 pages you will find over 900 3-color combinations of personality assessments. To find out yours, first work out your sun sign color, destiny color, and personal expression color, using the instructions on pages 14–15.

2. The directory of 3-color combinations is divided according to the 12 color sections of the color wheel on pages 14–15. Once you have worked our your unique 3-part color combination, turn to the color section of your sun sign color. So if your sun sign color is red, turn to the section entitled "The Color Red." This will give you the full meaning of the color, and its influence—physical, emotional, and spiritual—on your life. These influences will also apply if red appears as your destiny color or personal expression color. Use the "Relationships" section on the same page to discover how compatible you are with other sun sign colors.

3. To determine your own unique personality assessment, turn to the page that has your sun sign color and your destiny color, and then look at the box of your personal expression color for your reading. You can also find out the 3-digit color combinations of your most compatible partners in love and business. Each of these color combinations is given in the specific order of sun sign color, destiny color, and personal expression color.

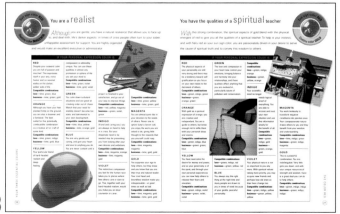

3

The color red

Red is the color of physical energy, passion, and desire. A very powerful color, it is linked to our most primitive physical and emotional needs, particularly our will to survive. Red is the color of the base chakra, the chakra that feeds our instinct for self-preservation. It strengthens our will, and stimulates passions like love and hatred. Too much of it and we become agitated, angry, or even violent. Too little of it and we become lethargic, cautious, and manipulative.

The complementary color to red is green (see page 78), so, if you find your chart exhibiting too much fiery red energy, you may want to consider introducing more green into your life. On the following pages you will find a personalized reading for each three-part combination with red as the sun sign.

Physical health

The color red affects the circulatory system. Where your health is concerned, its influence can manifest itself in a variety of blood disorders such as anemia, high blood pressure, hot inflamed conditions, and an exaggerated amount of energy and drive. If you are lacking in energy, or suffering from physical exhaustion, introducing more red into your life will kick-start your system. Bear in mind that, if your exhaustion is caused by driving yourself too hard, red is not the color to help you recharge your batteries—it may even cause long-term damage. In this case, green is what is needed.

Emotional health

The emotions associated with a good balance of red are power, empowerment, motivation, passion, assertion, and ambition. Red is often viewed as the color of love and when love leaves us we are broken-hearted. An individual with a well-balanced influence of red in his or her color chart, will make a natural leader. But, if red is overactive, the negative aspects will come to the fore: a dominance over others that merely disempowers, aggression, violence, frustration, and lust. A shortage of red energy can cause an individual to feel lethargic, powerless, and devoid of motivation. Here, red can be reinvigorating.

Spiritual health

The ultimate goal of a red person should be to transmute his or her passion and desire from the red base chakra to the crown chakra, as they renounce their physical drives and self-love for a higher spiritual goal. When the red energies are overactive this can denote a narrow-minded individual with strong religious beliefs who seeks domination over others to obtain power. Underactive red energy will produce a person who has their head in the heavens all the time and lives in a fantasy world.

Relationships

RED WITH RED Both partners must work hard to form a relationship, because both have driving energy and crave control. Compromise may be difficult.

RED WITH SCARLET If you value and respect each other this will work well, as each will stimulate the creative abilities of the other.

RED WITH ORANGE Your relationship will be filled with joy—and, in view of the sociability of orange, quite possibly a lot of other people.

RED WITH GOLD Your life will become richer and more fulfilling as you grow together in wisdom and find the true meaning of love and compassion.

RED WITH YELLOW While you will gain intellectual stimulation you will also need to give a fair amount of emotional support.

RED WITH LIME Into the chaos you create lime will bring order. Provided it doesn't restrict you in any new initiative, this can be very beneficial.

RED WITH GREEN This favors stability, but, with your love of the new, you may find conflict and frustration from your partner's mistrust of change.

RED WITH TURQUOISE You may find the laid-back attitude and secretive nature of your partner difficult to cope with in this relationship.

RED WITH BLUE You could work well together, since blue will do anything for a quiet life and is unlikely to contradict you, being content to let you make the decisions.

RED WITH INDIGO It may be difficult for you to get close because, unlike you, indigo lives in a self-sufficient world, and finds it difficult to share feelings.

RED WITH VIOLET Violet will make a good spiritual teacher, enabling you to aim higher and then reach your ultimate goals.

RED WITH MAGENTA A very good combination, because magenta will be able to ground your most far-reaching ideas and help them become realities.

You are a born survivor

Sun sign color RED

Destiny color RED

With red as both your sun sign and destiny color you are a powerhouse of energy and a natural leader. You drive yourself to the point of exhaustion, expecting others to do the same. Nothing gets you down for very long. You are an initiator and can quickly become bored once a project is up and running. You need to learn how to control this powerful energy to bring harmony into your life and an understanding of the following personal expression colors will help you to do this.

IF YOUR PERSONAL EXPRESSION COLOR IS:

RED
You are hard-hitting with a fiery personality, great drive, and enthusiasm, and you like to get your own way. Try to channel this fire into assertion rather than aggression, and you will be surprised by how much more effective you will be.
Compatible combinations
love—green, magenta, gold
business—green, gold, orange

ORANGE
Taking the best bits from red and yellow in your personal expression color, yours is a winning blend of joyfulness and creativity. You are sociable with a generous spirit and care about the needs of others.
Compatible combinations
love—green, gold, indigo
business—green, gold, magenta

YELLOW
You are laudably ambitious but with an unavoidable love of material possessions. Take some time to figure out what is really important to you, and, above all, learn to relax and unwind more.
Compatible combinations
love—green, green, violet
business—green, gold, violet

GREEN
You seek balance and harmony in all areas of your life and find change hard to cope with. Try to see change as an opportunity for new things to happen rather than something to fear.
Compatible combinations
love—turquoise, gold, magenta
business—green, gold, orange

BLUE
You are very kind and considerate, but do you sometimes feel taken advantage of? Your caring personality may leave you open to the demands of others. Practice assertion and you will soon be back in control.

Compatible combinations
love—green, green, orange
business—turquoise, gold, green

INDIGO
Stop dreaming and plant your feet firmly back on the ground. Daydreams and visions can be realized only once you recognize that you need to put some effort in too. Deep down you are probably afraid that your ideas will fail. But you have nothing to lose from trying.
Compatible combinations
love—turquoise, yellow, gold
business—green, gold, magenta

VIOLET
Nobody's perfect, but you tend to demand it in yourself and others. Adopt a more tolerant approach: expect less and you will be less frequently disappointed.
Compatible combinations
love—green, green, yellow
business—green, gold, yellow

MAGENTA
You are a good administrator and facilitator, able to realize the ideas of others. You are often called upon by others to help resolve their differences.
Compatible combinations
love—lime, gold, blue
business—lime, gold, green

GOLD
Sociable and a partygoer, you generate feelings of love and compassion in all those around you. In times of trouble, others find you a great source of succor and comfort. You sometimes push yourself too hard however and may learn to be a bit more selfish with your time.
Compatible combinations
love—green, green, indigo
business—green, green, violet

You have great creative ability

Still in the physical aspect of your personality, red as your sun sign color and orange as your destiny color show you have great creative ability with the drive and enthusiasm to get things done. Your love of life makes you a very sociable person, capable of staying up all night to party. You're a great participator, particularly enthusiastic about sporting activities and the arts.

IF YOUR PERSONAL EXPRESSION COLOR IS:

RED
If you don't stop rushing around so much you may well burn out. Try to relax, do some meditation or go for a walk in the country or by the sea and slow those energies down.
Compatible combinations
love—green, blue, green
business —green, indigo, gold

ORANGE
You have a vast well of creative potential, so make something of it; you must channel it properly. You are easily frustrated if things don't work out immediately—learn to see a project through to completion and you will reap the rewards.
Compatible combinations
love—green, blue, blue
business—green, gold, magenta

YELLOW
You radiate sunshine and happiness but your generous nature may be taken advantage of. Be more discerning in your choice of friends, and you will be less frequently disappointed.

Compatible combinations
love—green, blue, violet
business—green, gold, indigo

GREEN
You are a real creature of nature. You thrive upon taking the role of nurturer and teacher, and bring balance and harmony into difficult situations. Your love of the environment and the world around you often expresses itself in painting or other artistic pursuits.
Compatible combinations
love—green, blue, red
business—lime, gold, magenta

BLUE
By channeling your inspiration through communication you will gain the confidence to realize that your needs are as important as everyone else's, if not more so. Look after yourself for a change.

Compatible combinations
love—green, blue, orange
business—green, blue, gold

INDIGO
Learn to live a little, and don't be ashamed to let yourself go. Life will seem a great deal more fun if you don't take it so seriously. Play is just as important as work, and without it you will never be truly centered in yourself.
Compatible combinations
love—green, blue, gold
business—green, violet, gold

VIOLET
You are lucky enough to have links to both the visionary and the material world. While your head is in the heavens, your feet are firmly planted on the ground. This is a wonderful combination and the world needs people like you to turn ideals into reality.
Compatible combinations
love—green, indigo, yellow
business—green, blue, gold

MAGENTA
You have always seen life through rose-tinted glasses. Is this a defense mechanism? We are all human, and it is time you awakened yourself to the qualities, positive and negative, that make us who we really are.
Compatible combinations
love—lime, blue, gold
business—green, gold, blue

GOLD
You have great wisdom and insight, and create harmonious conditions around you through your gentle, nonjudgmental attitude, which shines like a beacon dispersing all negative thoughts.
Compatible combinations
love—green, blue, indigo
business—green, green, blue

You excel in matters of finance

You generate sunshine and happiness all around you with yellow in your physical aspect. But your love of material possessions and the need to succeed in everything you do can sometimes blind you to what is really important in life. This tendency must be watched, as it may become an obsession and turn your generous nature into a miserly one.

IF YOUR PERSONAL EXPRESSION COLOR IS:

RED
Driving force and energy stifle the creative ability deep within you. Guard against giving precedence to your physical needs over your emotional and spiritual ones, or else your energies will remain unbalanced.
Compatible combinations
love—green, violet, green
business—green, violet, gold

ORANGE
Do you find yourself running around all day without achieving anything? What you need is structure in your life. Routine is not something to be dismissed if it enables you to turn those unfinished projects into realities.
Compatible combinations
love—green, green, blue
business—lime, gold, indigo

YELLOW
When are you going to learn that you cannot please everybody all of the time? And trying to buy friendship through relentless generosity will not work forever. You must earn the admiration of others.
Compatible combinations
love—green, violet, magenta
business—turquoise, gold, blue

GREEN
A loyal friend, you will never let anybody down. You have a highly developed sense of responsibility, which ensures you follow through on any commitment. Beware that this is not to your own emotional disadvantage.
Compatible combinations
love—green, violet, red
business—green, violet, gold

BLUE
With this perfect combination of the three primary colors you have within you the capabilities and strengths of every color of the rainbow. Most importantly, you are blessed with great wisdom. Others will quickly see this and learn to appreciate it.
Compatible combinations
love—green, violet, orange
business—green, violet, gold

INDIGO
You must stop pushing people away. If you continue to reject their advances you will end up friendless and alone. Man is a sociable animal, and yours is not the only way of looking at life.

Compatible combinations
love—green, violet, gold
business—green, gold, orange

VIOLET
You act the dreamer but in fact your way of life is admirably instinctive. You're capable and resilient in a crisis, and your calm and peaceful attitude makes you an indispensable leader to have around.
Compatible combinations
love—green, violet, yellow
business—green, indigo, gold

MAGENTA
You have an intuitive grasp of the meaning of life and whatever you do is never an isolated action, but intended for the benefit of the whole. With your mind, your body, and your spirit so finely attuned to each other, you will always bring good to others, even to your own detriment.
Compatible combinations
love—lime, violet, blue
business—green, violet, green

GOLD
Your deeply entrenched belief that all is working to a divine plan may make you seem cold and uncaring on the outside. But, once others get beyond this, they will find the deep compassion you carry within your heart.
Compatible combinations
love—green, violet, indigo
business—green, violet, blue

Sun sign color **RED**

Destiny color **GREEN**

You **fight** for the **rights** of others

Your destiny color of green keeps you in control of the immense power, energy, and enthusiasm at your disposal, allowing you to use it for the benefit of others. You have a strong sense of justice and seek to empower rather than disenfranchise others. But you are also prone to rigidity in your attitude and may find that your principles create turmoil within.

IF YOUR PERSONAL EXPRESSION COLOR IS:

RED
You fight for what you believe in and your tremendous drive and determination makes sure that you will see it through. Go carefully—red is the energy of the dictator and you will never win by strength of force alone.
Compatible combinations
love—green, magenta, blue
business—turquoise, gold, blue

negative situations and attitudes into a positive outcome.
Compatible combinations
love—green, red, blue
business—green, gold, blue

YELLOW
Your ability to generate money makes you financially powerful. But you measure prosperity by material things alone. Compassion and generosity of spirit will be even more prosperous.
Compatible combinations
love—green, red, violet
business—green, gold, violet

GREEN
You can be relied on to stand up for others, particularly children and underprivileged youth. You can make a difference, so make the most of your talents and you will influence others to work toward a better world.
Compatible combinations
love—turquoise, magenta, blue
business—turquoise, gold, violet

ORANGE
When it is a question of fair play and justice, your joyful nature and creativity can work miracles in turning

BLUE
Don't be discouraged when others do not share your passionate conviction in the principles of truth and justice. Just one courageous stand against an injustice can achieve more than the work of several half-hearted supporters.
Compatible combinations
love—turquoise, magenta, orange
business—lime, magenta, gold

INDIGO
You are a firebrand, forging your way through life with daring and enterprise. And once you start fighting for a cause, it's very difficult for you to stop. Try to maintain some element of detachment and you may find that your considerable talents come into even greater use.
Compatible combinations
love—green, red, gold
business—violet, magenta, gold

VIOLET
You willingly take on the role of martyr, sacrificing yourself for your belief in the values of fairness and justice. Try to pare this intensity down, and to draw less attention to yourself. More people

will rally to your cause as a result.
Compatible combinations
love—green, red, yellow
business—turquoise, magenta, gold

MAGENTA
You are living proof of the principle that love makes the world go round and you use your qualities of nonjudgmental, unconditional love to bring peace and harmony into volatile situations.
Compatible combinations
love—turquoise, gold, magenta
business—lime, gold, blue

GOLD
You possess all the qualities of a good mediator. With your wisdom and impartiality, allied to your desire to see right prevail, your skills and strengths are frequently in demand.
Compatible combinations
love—green, red, indigo
business—green, red, blue

You are a peacemaker

You are very caring and with your innate love of beauty, you seek to impart serenity to all those with whom you come into contact. The key word for you is "peace," and you seek this at any price, even when this is to your own detriment. Sometimes you need to stand back from a situation and say no.

Sun sign color **RED**

Destiny color **BLUE**

IF YOUR PERSONAL EXPRESSION COLOR IS:

RED
You are dashing and adventurous but find it difficult to keep a lid on your powerful emotions. Learn to rest and relax more by bringing some gold and green into your life.
Compatible combinations
love—green, orange, gold
business—turquoise, gold, green

ORANGE
You are a natural diplomat and function best in an atmosphere of harmony. This makes you a fine mediator and your abilities are often called upon to resolve the thorniest disputes.
Compatible combinations
love—green, orange, blue
business—turquoise, gold, green

YELLOW
The peace-seeking side of your character always strives to see the best in others. But you need to make sure that your generous nature isn't taken advantage of. Try to see people as they are instead of how you would like them to be.
Compatible combinations
love—green, orange, violet
business—green, violet, gold

GREEN
Issues of conservation and pollution of the environment are close to your heart, and your communication skills combine with your physical energy to make you an ideal champion for this cause.
Compatible combinations
love—lime, gold, magenta
business—green, gold, indigo

BLUE
You try so hard to please others. By looking after your own needs more you will find that emotionally you can learn to be calmer and better able to cope with your life.
Compatible combinations
love—green, orange, orange
business—green, gold, orange

INDIGO
You have amazing powers of endurance but can often be rigid and over-rationalistic in your outlook. Try to see the world in a different way and a whole new set of opportunities could open themselves to you.
Compatible combinations
love—green, orange, gold
business—turquoise, orange, gold

VIOLET
Your spiritual beliefs are very important to you. However, you are afraid to share these with others for fear of being ridiculed. There are many people like you and they would welcome your friendship and ideas.
Compatible combinations
love—green, orange, yellow
business—turquoise, magenta, gold

MAGENTA
You dream the grandest dreams but are terrified of failure. If you could learn to put the pain and fear of the past behind you, you could fulfill all your ambitions.
Compatible combinations
love—lime, orange, blue
business—lime, gold, violet

GOLD
This is a powerful combination of fire and tranquillity. A fascinating communicator, you have the charisma and strength of will to talk almost anyone into anything.
Compatible combinations
love—green, orange, indigo
business—green, orange, orange

You accept nothing at face value

You do not stop until you have reduced a problem or puzzle to its bare fundamentals. With your keen, inquiring mind and natural practicality, you are definitely one of life's fixers and doers. But although you are pragmatic and logical, you are also suprisingly artistic.

IF YOUR PERSONAL EXPRESSION COLOR IS:

RED

Science and spirituality are not nearly as incompatible as you make them out to be. Try to apply this knowledge to your own life and you'll be amazed at what you will see.
Compatible combinations
love—lime, gold, green
business—green, gold, green

ORANGE

When you first see a work of art, do you react to it through the senses or do you try and discover the facts behind the scene and the circumstances of the artist's birth and life? Both approaches are valid, and both could be applied to the art of life as well.
Compatible combinations
love—green, gold, blue
business—green, gold, yellow

YELLOW

With fiery red as your sun sign color, you have the drive and energy to get things done. But you are held back by your over-methodical ways of thinking. Learn to trust in the power of your intuition.
Compatible combinations
love—green, gold, violet
business—green, gold, gold

GREEN

Your emotions are in turmoil as you struggle to find the answers to what you are seeking. Calm down and open your mind to the impossible and you will be guided in what to do.
Compatible combinations
love—green, gold, red
business—green, gold, magenta

BLUE

You keep yourself very much to yourself, closing your mind to the wonders of the artistic world. With your innate sense of beauty and illusion, you have it in you to appreciate and enjoy art of the highest order.
Compatible combinations
love—turquoise, gold, orange
business—green, gold, yellow

INDIGO

You find it difficult to express your individuality and prefer the safety of rules and regulations to the free-flowing anarchy of creative environments. This attitude could leave you isolated if you don't develop the courage to express your truest desires and needs.

Compatible combinations
love—green, gold, gold
business—green, gold, yellow

VIOLET

You are witty, fiery, and independent, but often to the detriment of your spiritual needs. Take time out from your endless commitments to see life in a more holistic way.
Compatible combinations
love— turquoise, gold, yellow
business—orange, gold, yellow

MAGENTA

Although flamboyant and

stubborn, you are not nearly as confident as you make yourself out to be. You secretly fear failure and sometimes need some reassurance to keep you going. Bring some pacifying green and gold into your world to give you some inner peace.
Compatible combinations
love—lime, gold, green
business—lime, gold, magenta

GOLD

You are an enigma: a curious combination of the pragmatist and spiritualist. This doesn't make your life easy but it makes you fascinating to be around. Others still have a great deal to learn from you.
Compatible combinations
love—green, gold, indigo
business—green, gold, blue

You are a perfectionist

Your ability to see the tiniest mistakes mean that very few people are ever in a position to pull the proverbial wool over your eyes. You have a neat and tidy mind and need to see everything correctly in place. But your insistence on the highest standards also manifests itself in an intense fear of uncertainty.

IF YOUR PERSONAL EXPRESSION COLOR IS:

RED
Although you know that you can survive life's difficulties because you have overcome traumas in the past, you are still gnawed by doubt and anxiety. By learning that there is no such thing as absolute security, you can begin to live life to the full.
Compatible combinations
love—green, yellow, green
business—green, yellow, gold

ORANGE
You are a very practical person and cannot abide muddled thinking of any kind. Try and use the creative arts, especially drama and dance, to escape from the strict rules of your day-to-day routine.
Compatible combinations
love—green, magenta, orange
business—green, yellow, orange

YELLOW
Although you crave security, your natural gregariousness and optimism often win the day. In fact, you can call upon your sense of humor to help you surmount most of life's obstacles.
Compatible combinations
love—green, magenta, yellow
business—lime, magenta, gold

GREEN
You keep your emotions under tight control, but they sometimes get the better of you for no reason at all. By learning to trust others' intentions, you can open up to people more and let them know what's bothering you.
Compatible combinations
love—green, magenta, green
business—turquoise, yellow, gold

BLUE
Your critical sense and natural fastidiousness are matched by your ability to see the big picture when the situation demands it. This prevents your sometimes intense desire for security from getting out of hand.
Compatible combinations
love—green, magenta, blue
business—lime, gold, magenta

INDIGO
It is very important for you to get everything right. This can make you seem fussy and dogmatic. Unless you take a more relaxed attitude to life, and learn to have the generosity to admit when you are wrong, you could risk losing many friends.
Compatible combinations
love—green, magenta, indigo
business—green, gold, orange

VIOLET
You struggle all the time to find the solutions to all your problems at once. Being a perfectionist doesn't mean that you can't relax and indulge yourself every now and again.
Compatible combinations
love—green, magenta, violet
business—green, gold, yellow

MAGENTA
You veer between a desire to control every last practical detail of your life, and an equally compelling need to let go and explore your spiritual needs to the fullest. You may need to take a break and find out what it is you really want in life.
Compatible combinations
love—lime, gold, magenta
business—green, gold, green

GOLD
A wonderful combination. In spite of your slightly puritanical tendencies, you are a warm and generous soul. You have very few fears and can help others overcome theirs.
Compatible combinations
love—green, yellow, indigo
business—green, gold, yellow

You are a realist

Although you are gentle, you have a natural resilience that allows you to face up to, and deal with, life's darker aspects. In times of crisis people often turn to your sober, unflappable assessment for support. You are highly organized and would make an excellent executive or administrator.

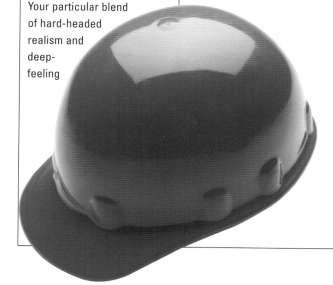

IF YOUR PERSONAL EXPRESSION COLOR IS:

RED

Despite your outward calm you are full of passion and mischief. This expresses itself in your wry, ironic humor and occasional walks on the darker, wilder side of life.

Compatible combinations
love—lime, green, blue
business—lime, green, gold

ORANGE

Although you have your feet planted firmly on the ground, you are also a dreamer and a fantasist. The best outlet for this potentially combustible combination is a creative art or craft of some kind.

Compatible combinations
love—lime, green, indigo
business—lime, gold, blue

YELLOW

Your particular blend of hard-headed realism and deep-feeling compassion is admirably unique. You can use these qualities in almost any profession or sphere of life you set your mind to.

Compatible combinations
love—lime, green, violet
business—lime, gold, violet

GREEN

You calm down turbulent situations and are great at creating order out of chaos. Watch that your need for stability doesn't become too static and detrimental to your own development.

Compatible combinations
love—lime, blue, yellow
business—lime, orange, gold

BLUE

You are very gentle and caring, and give your heart and soul to anything you do. You are never content until a project is finished to your satisfaction, and go out of your way to improve things.

Compatible combinations
love—red, yellow, magenta
business—green, violet, green

INDIGO

A kind and caring soul, you are always on hand to help in a crisis. But your desperate need to be needed may be preventing you from looking after your own desires and ambitions.

Compatible combinations
love—lime, magenta, orange
business—lime, magenta, gold

VIOLET

The instinctive compassion you feel for the human race takes you to places where few others care or dare to go. This, together with your hard-headed realism, would you make you an ideal counselor or carer.

Compatible combinations
love—lime, green, yellow
business—lime, green, gold

MAGENTA

You are almost saint-like in your devotion to the needs of others. Never one to ignore duty's clarion-call, you enjoy the work you are asked to do, giving little thought to the rewards that you yourself could reap.

Compatible combinations
love—lime, magenta, magenta
business—lime, gold, gold

GOLD

You suppress your ego to help others, but they know and you know that you are their true and natural leader. Your cool head and boundless wisdom make you indispensable—in good times as well as bad.

Compatible combinations
love—lime, magenta, gold
business—lime, gold, gold

You have the qualities of a spiritual teacher

With this strong combination, the spiritual aspects of gold blend with the physical energies of red to give you all the qualities of a spiritual teacher. To help is your instinct, and with fiery red as your sun sign color, you are passionately driven in your desire to serve the cause of spiritual truth and to convey this wisdom to others.

IF YOUR PERSONAL EXPRESSION COLOR IS:

RED
The physical aspects of your personality are still very strong and there may be a tendency toward self-gratification as you focus on your own needs to the detriment of others.
Compatible combinations
love—green, indigo, green
business—green, orange, green

ORANGE
With gold as a spiritual expression of orange, you are creative and independent. You are a guide to others, but know enough not to stifle them with your personal ideas and visions.
Compatible combinations
love—green, indigo, blue
business—green, green, blue

YELLOW
You have overcome the desire for money and power, and so your generosity is of the spirit; and through your own personal experiences you can now help others to release their fears and anxieties.
Compatible combinations
love—green, indigo, violet
business—green, violet, violet

GREEN
The love and compassion in your heart now control your emotions, bringing balance and harmony into your relationships, and these qualities affect anything that you are involved in, particularly issues of pollution and conservation.

Compatible combinations
love—green, indigo, red
business—green, yellow, red

BLUE
You always say the right thing at the right time and many people are drawn to you in times of need because of your gentle, peaceful personality.

Compatible combinations
love—green, indigo, orange
business—green, yellow, orange

INDIGO
Your scientific, mind no longer needs logical proof of everything. You are able to access and trust your own intuition and use this information wisely for the benefit of all.
Compatible combinations
love—green, indigo, gold
business— green, orange, gold

VIOLET
Your physical nature is not so important to you any more. With spiritual values taking more priority, you may acquire new friends and perhaps lose old ones as their lives change too.
Compatible combinations
love—green, indigo, yellow
business—green, yellow, yellow

MAGENTA
You work tirelessly to transform negative conditions into positive ones. Your compassionate nature draws others to you and they benefit from your wisdom and understanding.
Compatible combinations
love—lime, indigo, green
business—green, indigo, magenta

GOLD
This is a powerful combination. You are indefatigable. Very little gets you down, and with your unique resources of strength and wisdom, there is a great deal you can do to help others.
Compatible combinations
love—green, indigo, indigo
business—green, indigo, indigo

Sun sign color **RED**

Destiny color **GOLD**

The color scarlet

Scarlet is the color of sexuality, sensuality, and desire. It is the result of combining the two powerful colors of red and orange, so if scarlet is your sun sign color, both these colors must be considered in a reading. In many cultures, scarlet summons up associations of warmth, intensity, and passion. Too much scarlet in your color chart can make you reckless and uninhibited, too little, and you may appear cold and forbidding.

The complementary color to scarlet is turquoise (see page 88) so if you find your chart exhibiting too much reckless scarlet energy you may want to consider introducing more turquoise into your life. On the following pages you will find a personalized reading for each three-part combination with scarlet as the sun sign.

Physical health

Specific parts of the physical body vibrate to the dominant color energies of their associated chakras. Since scarlet is a combination color of red and orange, and orange is in turn a combination of red and yellow, all these colors have an influence on your health. With too much scarlet in one's reading, eating disorders such as anorexia and bulimia may become manifest, although there may be deeper, psychological causes for these illnesses. Too much scarlet can also lead to physical exhaustion. If you suffer from this, the colors of turquoise and green will help you unwind and recharge your batteries.

Emotional health

A good balance of scarlet in an individual's color chart means that they will use their power wisely in all areas of their life, and lead by example rather than through methods of manipulation and control. But if scarlet is overactive, their emotions may run out of control and they could become domineering and controlling as feelings of fear, distrust, and jealousy take over their personality. In this case turquoise should be introduced as a matter of urgency to restore balance and harmony. An absence of scarlet on the other hand can make it difficult for an individual to relate to others and they may come across as aloof and uncaring. Here, scarlet or orange can be reinvigorating.

Spiritual health

The spiritual goal of a scarlet person should be to integrate their creative sacral energies into their creative throat energies where they can find true spiritual expression. This can be done through participation in the media and the arts. For women, the time for this may happen when they no longer need to procreate and as a result become more interested in their spiritual needs.

Relationships

SCARLET WITH RED You will both need to control overwhelming feelings of power if you want to have a happy relationship.

SCARLET WITH SCARLET This is a potentially explosive relationship, which can be stimulating and exciting provided you do not place too many demands on one another.

SCARLET WITH ORANGE You will be able to recognize and stimulate one another's creative abilities, which could lead to a great deal of joy and happiness.

SCARLET WITH GOLD Your partner's wisdom, love, and compassion may help you to tame the powerful desires that rage within you.

SCARLET WITH YELLOW You may become frustrated by the importance your partner gives to possessions and material things, especially if you want to be the center of his or her attentions.

SCARLET WITH LIME If you work together and recognize one another's strengths and weaknesses, this promises to be a strong and lasting relationship.

SCARLET WITH GREEN Your passionate nature may find it difficult to adjust to your partner's solidity and controlling tendencies.

SCARLET WITH TURQUOISE This is a relationship made in heaven, which could last a lifetime as you complement each other in every way.

SCARLET WITH BLUE This promises to be a peaceful relationship provided you are able to adapt your partner's calming energies to your own impulsive nature.

SCARLET WITH INDIGO Try to understand that the restraints your partner places on you are for your own good and that these help you to think before you act.

SCARLET WITH VIOLET You stand to learn a great deal from one another and to reach your highest potential.

SCARLET WITH MAGENTA Your great ideas and your partner's ability to turn theory into action will result in a trusting and loving relationship.

You are passionate

Sun sign color **SCARLET**
Destiny color **RED**

With scarlet as your sun sign color, you must learn to take personal responsibility for your actions. You are a free spirit, and if tied down to one thing for too long you become bored. But with red as your destiny color you will be given chances to explore your self-awareness and to discover what really makes you tick.

IF YOUR PERSONAL EXPRESSION COLOR IS:

RED
You like to be at the center of things and enjoy the feeling of power this gives you. Stop driving yourself so hard and learn how to rest and relax more.
Compatible combinations
love—turquoise, green, violet
business—turquoise, green, gold

ORANGE
This combination is a double whammy of scarlet energies and you need to channel this power into areas where your abilities can be used creatively to help others.
Compatible combinations
love—turquoise, green, blue
business—turquoise, green, gold

YELLOW
Possessions and material things mean a great deal to you and they give you confidence in your abilities. Learn to see that what you are is more important than what you own—and discover your own true inner strengths.
Compatible combinations
love—turquoise, green, violet
business—turquoise, green, gold

GREEN
You hate change. While routine gives you more stability in your life, haven't you ever thought that you could be missing out on a host of wonderful experiences?
Compatible combinations
love—turquoise, green, magenta
business—turquoise, magenta, gold

BLUE
With more control over your feelings you are able to let go of the need to dominate and are able to delegate more of your responsibility to others, giving you more time for rest and relaxation.
Compatible combinations
love—turquoise, green, gold
business—turquoise, green, magenta

INDIGO
You are a solitary soul. This is just as well since your strong feelings about obeying rules and regulations could prove frustrating to others.
Compatible combinations
love—turquoise, green, yellow
business—turquoise, green, gold

VIOLET
One way of moving your earthy nature to a higher spiritual plane is by living a contemplative life. Be warned however, your free spirit will find it very difficult to conform to this.
Compatible combinations
love—turquoise, magenta, yellow
business—turquoise, violet, gold

MAGENTA
Your basic sexual energies have been transmuted. You have given up the need for control, and now empower others, which in turn empowers you.
Compatible combinations
love—turquoise, blue, magenta
business—lime, magenta, gold

GOLD
Spiritual values are more important to you than material possessions, which is why you have such a genuine and supportive circle of friends.
Compatible combinations
love—turquoise, green, indigo
business—turquoise, gold, magenta

You are a born optimist

You are cheerful and gregarious, and with orange as your destiny color, you know that creativity should not simply apply to the realm of art but to all areas of your life. You are a cheerful, gracious, and witty companion, and your disposition helps you face all of life's difficulties with a smile, bringing happiness and light-heartedness to others.

IF YOUR PERSONAL EXPRESSION COLOR IS:

RED
You have so many things you want to do that you rush headlong into new projects and schemes hoping that they will turn out well. Learn to think before you act, and, instead of acting on a whim, plan a definite course of action.
Compatible combinations
love—turquoise, blue, green
business—turquoise, blue, gold

ORANGE
You hide your true self behind your sociable, outgoing personality. Learn to say no on occasion; this won't stop people from liking you or wanting to be with you.
Compatible combinations
love—turquoise, blue, blue
business—turquoise, gold, green

YELLOW
Although it is important for you to earn a living, more important is the joy and happiness you give to others through your creative abilities, which money cannot buy.
Compatible combinations
love—turquoise, blue, violet
business—turquoise, gold, gold

GREEN
This combination brings stability into your life. You are able to harness your creativity and bring out the best in people by encouraging them and teaching them what you have learned.
Compatible combinations
love—turquoise, blue, magenta
business—turquoise, blue, gold

BLUE
Because you do not try to constantly impress people, your life is very calm and by learning to relax you have also found an inner peace deep within yourself.
Compatible combinations
love—turquoise, blue, orange
business—turquoise, blue, gold

INDIGO
Sometimes it is necessary to abide by rules and regulations, but these can restrict your wide-ranging, imaginative, creative spirit, which can leave you feeling depressed.
Compatible combinations
love—turquoise, blue, orange
business—turquoise, blue, gold

VIOLET
You need to feel liked but your desire for personal recognition is not an overriding issue. Your creative gifts can be used in many ways, not simply for financial reward but for the benefit of others.
Compatible combinations
love—lime, blue, magenta
business—lime, gold, magenta

MAGENTA
As a visionary you believe you can take on the world. You often overestimate the amount of work required to achieve your lofty aims. Come down to earth and learn to be more realistic.
Compatible combinations
love—lime, blue, green
business—lime, gold, blue

GOLD
With this combination you are well aware of how to harness the powerful energies that sometimes threaten to overwhelm you and to recognize that you are personally responsible for all your actions.
Compatible combinations
love—turquoise, blue, gold
business—turquoise, blue, yellow

You are a little ray of sunshine

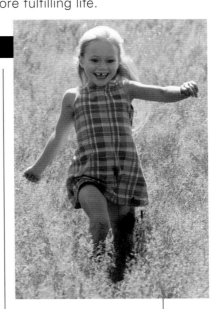

You are full of the joys of life and others just can't get enough of your marvelous sense of humor. Yellow as your destiny color gives you ample opportunity to overcome your need for material possessions. Your sharp mind means that you will never be destitute. Learn the true meaning of prosperity and yours will be an even richer and more fulfilling life.

IF YOUR PERSONAL EXPRESSION COLOR IS:

RED
You are very generous and popular. If you want to learn who your true friends are, stop buying popularity and friendship with money and possessions.
Compatible combinations
love—turquoise, violet, green
business—turquoise, violet, gold

ORANGE
You feel as if you are going around in circles and getting nowhere. Learn to accept responsibility for your actions and your life will become more manageable.
Compatible combinations
love—turquoise, violet, blue
business—turquoise, violet, gold

YELLOW
Your cheerful disposition draws people to you like a magnet. If this is just a front to mask your fear of losing everything you have ever achieved, face your fear so that you may get on with your life.
Compatible combinations
love—turquoise, violet, violet
business—turquoise, gold, gold

GREEN
Your ability to generate prosperity can now be used to make this world a better place for people to live in—people who are a great deal less fortunate than you, especially children and young people.
Compatible combinations
love—turquoise, violet, magenta
business—turquoise, violet, gold

BLUE
Although truth and justice are very important to you, fighting just causes and speaking your mind with no thought for the consequences of your actions can sometimes get you into hot water. Learn to be more diplomatic.
Compatible combinations
love—turquoise, violet, orange
business—turquoise, violet, gold

INDIGO
Your free spirit makes it difficult for you to conform to others' expectations. If you can learn to take control of your life by letting go of the fears and anxieties that sometimes threaten to overwhelm you, this will no longer be an issue.
Compatible combinations
love—turquoise, violet, orange
business—turquoise, violet, gold

VIOLET
This combination teaches that prosperity comes in many forms, and generosity of spirit is just as important as money. You need to become more discerning to stop so many demands being made on you.
Compatible combinations
love—turquoise, violet, magenta
business—turquoise, magenta, gold

MAGENTA
Your flair for business and making money can be channeled into pioneering charitable projects, which will give you a great deal of happiness and satisfaction.
Compatible combinations
love—lime, turquoise, blue
business—lime, turquoise, gold

GOLD
You have wisdom in abundance and are able to view your emotions with detachment when the need arises. This can be misinterpreted by others as a sign of aloofness when you are in fact very loving.
Compatible combinations
love—lime, magenta, indigo
business—turquoise, gold, gold

Your heart rules your head

With green as your destiny color your main impulse is to bring harmony into any situation you encounter. Young people are drawn to you for this reason and although you can teach and nurture them, you must beware of becoming too emotionally involved with others because scarlet as your sun sign color also makes you very warm and sentimental.

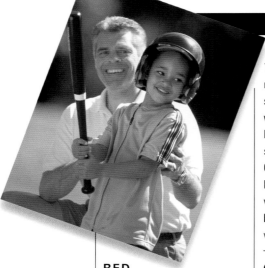

IF YOUR PERSONAL EXPRESSION COLOR IS:

RED
Your generous nature brings warmth and comfort to others. Learn to be more discriminating about your choice of friends and to become more emotionally detached from potentially difficult personal situations, and you will not get so hurt.
Compatible combinations
love—turquoise, magenta, green
business—turquoise, gold, green

ORANGE
With your creative abilities you can help young people to see what they are capable of achieving. Nurture rather than direct, and you will make a wonderful teacher.
Compatible combinations
love—turquoise, red, blue
business—turquoise, red, gold

YELLOW
Your concern with respectability has kept you in safe situations whether in work or in love. It's time to let your hair down and bring some fun into your life.
Compatible combinations
love—turquoise, magenta, violet
business—turquoise, gold, violet

GREEN
Try your luck and take a gamble for a change instead of sitting on the fence all the time. This will help you break free of old patterns that are preventing you from living a full and happy life.
Compatible combinations
love—turquoise, magenta, magenta
business—turquoise, magenta, gold

BLUE
This is a very harmonious combination. Your emotions are under control, you bring peace and harmony into stressful situations, and you create beauty in others' lives.
Compatible combinations
love—turquoise, red, orange
business—turquoise, orange, gold

INDIGO
Your inquiring scientific mind drives your deep desire to discover the secrets of the universe and you are usually to be found with your nose in a book. Haven't you heard of the old maxim, "Man, know thyself and thou shalt know the universe"?
Compatible combinations
love—turquoise, red, gold
business—turquoise, orange, gold

VIOLET
You crave safety and security to the point where you find it difficult to achieve what you really want in life. Learn to let go and trust that you will always have what you need and your fears will disappear.
Compatible combinations
love—turquoise, red, yellow
business—turquoise, red, gold

MAGENTA
You recognize the power that you carry as a spiritual healer and take responsibility for any new ideas that you initiate. Make sure that this power doesn't inflate your ego and turn you from a loving leader into a dictatorial one.
Compatible combinations
love—turquoise, red, green
business—turquoise, magenta, gold

GOLD
Your experience has taught you to recognize the effect your actions have on others. Learn to accept personal responsibility for whatever you do in life.
Compatible combinations
love—turquoise, magenta, gold
business—turquoise, gold, gold

YOUR THREE ESSENTIAL COLORS

You are very tolerant

Sun sign color **SCARLET**
Destiny color **BLUE**

You are very empathetic and have a rare ability to understand and tune into the deepest desires of others. This blesses you with a great capacity for tolerance. But your ability to see both sides of the coin can sometimes be infuriating to others as it makes it difficult for you to make a decision and stick to it.

IF YOUR PERSONAL EXPRESSION COLOR IS:

RED
Your sexual nature can sometimes be overpowering. This can make it difficult for you to practice the gentleness and tolerance that you so firmly believe in.
Compatible combinations
love—turquoise, orange, green
business—blue, blue, gold

ORANGE
You are marvelous at resolving difficult and fraught situations. Instead of denying your abilities, learn to accept that the applause and admiration that you receive is genuine.
Compatible combinations
love—turquoise, orange, blue
business—turquoise, gold, blue

YELLOW
You excel in fighting for truth and justice for others. This is very admirable but it may be preventing you from resolving your own emotional problems.
Compatible combinations
love—lime, magenta, violet
business—green, violet, gold

GREEN
You determinedly seek triumph in adversity. This

helps you to keep your self-esteem at a constant high and to overcome negative emotional feelings.
Compatible combinations
love—turquoise, orange, red
business—lime, gold, magenta

BLUE
You are very good at taking on the cares and responsibilities of others. This not only depletes your own resources, but prevents others from taking full responsibility for their own actions so impeding

their personal development.
Compatible combinations
love—green, orange, orange
business—turquoise, orange, gold

INDIGO
Suffering affects you deeply. However, there is a limit to what you can do about others' pain and if you don't control your feelings they may become obsessional.
Compatible combinations
love—turquoise, orange, gold
business—turquoise, red, gold

VIOLET
As you are slowly transmuting the lower base energies into spiritual awareness, the change in your spiritual values is bringing a deep inner peace into your life.
Compatible combinations
love—turquoise, orange, gold
business—turquoise, gold, gold

MAGENTA
Seeing the good in others is an admirable quality. Don't let your non-judgmental attitude blind you to others' failings. After all, imperfections are what make us the unique human beings that we are.
Compatible combinations
love—lime, turquoise, magenta
business—lime, magenta, gold

GOLD
Your compassionate nature makes you very tolerant of others' weaknesses. Learn how to discriminate between turning the other cheek and standing up for your own beliefs.
Compatible combinations
love—lime, magenta, indigo
business—turquoise, gold, indigo

You are complex

Although outwardly irreverent and carefree, you constantly seek the answer to life's deepest mysteries and are rarely content with even the most sophisticated explanations and theories. Your interest in the unknowable and the unknown runs into conflict with your logical, practical side, but this just makes you all the more interesting.

IF YOUR PERSONAL EXPRESSION COLOR IS:

RED
Although you would love to act on your intuition, your physical nature keeps you grounded in logic. Life will become a lot easier when you learn to trust and accept your intuitive self.
Compatible combinations
love—turquoise, gold, green
business—turquoise, gold, blue

ORANGE
Let your imagination and inspiration take over. Your creations will be out of this world and you will reach new heights of understanding and be even more popular than you are now.
Compatible combinations
love—turquoise, gold, blue
business—turquoise, orange, gold

YELLOW
You are one of life's fixers and doers, always on hand to fix a light bulb or help someone out with their tax returns. If you learn to control your impulsive nature you will find yourself a little more serene and in control.

Compatible combinations
love—turquoise, gold, violet
business—turquoise, gold, violet

GREEN
Your sixth sense of knowing when things are not right prevents you and others from getting into difficult situations. It is still difficult for your logical mind to accept this.
Compatible combinations
love—turquoise, gold, red
business—lime, gold, magenta

BLUE
You are a very gentle and sensitive person and are easily hurt by others. It is not easy for you to argue with anyone, even if you disagree with what they are saying.
Compatible combinations
love—turquoise, gold, orange
business—green, gold, yellow

INDIGO
"If it can't be proved, it isn't true" could be your motto. Your head is full of scientific ideas and principles and you are unwilling to accept any new concepts unless there is irrefutable evidence to support them.
Compatible combinations
love—turquoise, gold, gold
business—turquoise, gold, orange

VIOLET
Science and spirituality can work together. Let go of outmoded traditions and learn to use both your intuition and scientific knowledge for the benefit of all.
Compatible combinations
love—turquoise, gold, yellow
business—turquoise, gold, gold

MAGENTA
Because you have released emotional issues of low self-worth and self-love, you now have a more fulfilling life. Your sexual nature is under control and you are now working to alleviate the pain and suffering of others.
Compatible combinations
love—lime, gold, green
business—lime, gold magenta

GOLD
You are sincere and devoted. Your spiritual values are very important to you and socializing, money, and material possessions are not priorities.
Compatible combinations
love—lime, turquoise, magenta
business—turquoise, gold, indigo

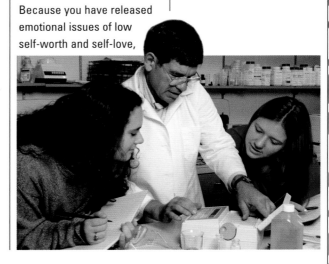

You need balance

With scarlet and violet in your reading, you combine the extreme ends of the color spectrum. You find yourself full of joy one moment and in the depths of despair the next. This is not easy and you need to find the inner strength to transmute your physical nature into selfless service to others, and to overcome your fears of loss and abandonment.

Sun sign color SCARLET

Destiny color VIOLET

IF YOUR PERSONAL EXPRESSION COLOR IS:

RED
Just as you begin to think that life is wonderful, it changes, and all your fears for your personal safety re-surface. Your spiritual goal is to learn to trust in life's processes. Learn to control your physical desires, which are keeping you grounded in the material world.
Compatible combinations
love—turquoise, yellow, green
business—turquoise, yellow, gold

ORANGE
You are deeply spiritual and often live in a dream world. Use this to create masterpieces of art, thought, and personal achievement, inspiring others to do the same.
Compatible combinations
love—turquoise, yellow, blue
busines—turquoise, yellow, orange

YELLOW
This is a good combination with yellow and violet complementing each other. Your intellectual ability will lead you to study subjects that will help you understand the deeper processes of life, giving you greater self-awareness.

Compatible combinations
love—turquoise, yellow, violet
business—turquoise, gold, violet

GREEN
On the surface you appear very stable and reliable but inwardly you struggle to keep your emotions under control. Learn to broaden your vision and recognize the value of change as new opportunities come to light and develop.
Compatible combinations
love—turquoise, yellow, magenta
business—turquoise, gold, magenta

BLUE
Your spiritual goal is to transmute your sexual desires into the creative throat center. As you progress spiritually your life becomes calm and peaceful and your beautiful creations inspire others.
Compatible combinations
love—turquoise, yellow, orange
business— turquoise, gold, orange

INDIGO
You share your time and possessions with others,

serving them in whatever way you can. If taken to extremes this quality can make you authoritarian and dogmatic, as you seek self-recognition instead of empowering those you are serving.
Compatible combinations
love—turquoise, yellow, gold
business—turquoise, gold, gold

VIOLET
You cope constantly with feelings of emotional insecurity. With more spiritual awareness you can learn to welcome change as an opportunity to enjoy new experiences, instead of as a threat, and to increase your understanding of life's true purpose.
Compatible combinations
love—turquoise, yellow, yellow
business—turquoise, gold, yellow

MAGENTA
You have few illusions and are realistic about what you can and cannot achieve. This knowledge allows you to achieve balance and harmony between your spiritual, emotional, and

physical needs.
Compatible combinations
love—lime, gold, magenta
business—green, gold, green

GOLD
With your physical nature under control, you radiate love and warmth to every living thing. As a spiritual teacher you are respected and admired and share your love with others, inspiring them to attain qualities well beyond their expectations.
Compatible combinations
love—turquoise, yellow, indigo
business—turquoise, gold, indigo

You are a strategist

This combination allows you to harness your physical and spiritual natures to revise and release negative thought patterns and beliefs. You are aware of the strengths and inner contradictions of yourself and others but are nevertheless tolerant of them. This makes you a natural strategist as you rarely fail to think before you make the right moves.

IF YOUR PERSONAL EXPRESSION COLOR IS:

RED
Your intense need for love and security is dominating your life. Learn to be more patient and tolerant of others and let them help you.
Compatible combinations
love—lime, green, blue
business—lime, green, gold

ORANGE
Your vibrant and exuberant personality generates a lot of joy and happiness in others' lives. But learn to be a little more discerning about the company you keep, or you may end up hurting others' feelings.
Compatible combinations
love—lime, green, blue
business—lime, gold, blue

YELLOW
Full of fun and laughter, you are a great addition to any social gathering. Make sure though that your outer personality is not hiding inner fears and anxieties, which if not released could be detrimental to your health.
Compatible combinations
love—lime, blue, violet
business—lime, gold, violet

GREEN
Many changes are happening within you as you accept the faults and failings of yourself and others. Although you are anxious to share your new-found freedom, don't impose this or your advice will be seen as interfering rather than helpful.
Compatible combinations
love—lime, blue, red
business—lime, gold, blue

BLUE
Your trust and faith in personal love and security is tested time and time again. Instead of seeing certain episodes as setbacks, recognize the spiritual strength that is developing within you and help others to overcome their difficulties.

Compatible combinations
love—lime, green, orange
business—lime, green, gold

INDIGO
This color combination helps you to enhance your knowledge and understanding of what life is all about. Don't be too serious though: take time out to have fun and enjoy yourself.
Compatible combinations
love—lime, green, gold
business—lime, gold, gold

VIOLET
You sacrifice your physical desires for your spiritual values and beliefs. This is idealistic and holistically not very good for you. Each part of your nature needs to be in balance and harmony for optimal health.

Compatible combinations
love—lime, blue, yellow
business—lime, blue, gold

MAGENTA
Your life has taken on a new spiritual meaning. You are moving forward with energy, enthusiasm, and vitality and empowering others to do the same.
Compatible combinations
love—lime, green, blue
business—lime, gold, green

GOLD
Having overcome your emotional nature, your wise and compassionate nature recognizes the qualities of unconditional love, which you seek to incorporate in all areas of your life.
Compatible combinations
love—lime, green, indigo
business—lime, gold, gold

You are exuberant

Sun sign color **SCARLET**

Destiny color **GOLD**

With the polar opposites of these colors in your reading, your spiritual goal is to transform strong emotional energies into spiritual ones. Gold represents love, wisdom, and compassion and with this as your destiny color you will be given many opportunities to help others in a professional or non-professional capacity.

IF YOUR PERSONAL EXPRESSION COLOR IS:

RED
Your sparkling personality and generous nature attract many friends and admirers. You bring hope and comfort to difficult situations, which is sometimes mistakenly interpreted by others as a means of satisfying your own desires.
Compatible combinations
love—turquoise, indigo, red
business—turquoise, gold, green

ORANGE
You are surrounded by many friends and admirers. Learn to differentiate between those who are true and those who are false and you will not be unpleasantly surprised.
Compatible combinations
love—turquoise, indigo, blue
business—turquoise, indigo, gold

YELLOW
What a happy-go-lucky person you are, without a care in the world! Be careful that your warmth doesn't generate feelings of jealousy in others, creating enemies for you instead of friends.
Compatible combinations
love—turquoise, indigo, violet
business—turquoise, indigo, gold

GREEN
You have a deep love and understanding of nature and of all living things. You work ceaselessly to alert others to environmental and conservation issues.
Compatible combinations
love—turquoise, indigo, red
business—turquoise, indigo, gold

BLUE
With your love of music and the arts, you constantly bring inspiration and happiness to others, raising their awareness to new heights all the time. You are very adaptable and thrive in new and unknown situations.
Compatible combinations
love—turquoise, indigo, orange
business—turquoise, indigo, gold

INDIGO
By no longer conforming to old patterns and beliefs you have freed yourself to explore new and exciting spiritual concepts. Your wisdom shared helps to empower others to learn from their experiences.
Compatible combinations
love—turquoise, indigo, gold
business—turquoise, gold, gold

VIOLET
You have made many sacrifices and given up a great deal to reach your spiritual goal. The peace and serenity you now feel has made it all worthwhile.
Compatible combinations
love—turquoise, indigo, yellow
business—turquoise, indigo, gold

MAGENTA
You have transmuted your physical nature into compassion and love. Your emotions are under control and you demand nothing from others, content to remain in the background.
Compatible combinations
love—lime, indigo, green
business—lime, indigo, gold

GOLD
These are like the colors of the spiritual alchemist as you work to change base metal into gold. Once this has been achieved you will realize the divine within every living thing.
Compatible combinations
love—turquoise, indigo, violet
business—turquoise, gold, gold

The color orange

Orange contains both red and yellow and therefore the attributes of both will be considered in a reading. Orange is the color associated with the sacral chakra, the chakra influencing vitality and sexual performance. The power of orange lies in the joy and creativity it can generate in all areas of one's life. Too much of it, and we become self-centered, wanting to experience all of life's pleasures at once with no thought for the needs of others. Too little of it, and we lose our motivation, seeking solace in the small world of our own thoughts and feelings.

The complementary color to orange is blue (see page 98), so if you find your chart exhibiting too much unbridled orange energy you may want to consider introducing more blue into your life. On the following pages you will find a personalized reading for each three-part combination with orange as the sun sign.

Physical health

Specific parts of the physical body vibrate to the dominant color energies of the nearest chakra. The associated chakra for orange is the sacral chakra. Its influence manifests itself in the physical symptoms of bladder and kidney disorders, circulatory problems, and in illnesses of the colon and small intestine. In women, orange influences the female reproductive system and its associated organs, and in men, the prostate gland. (See also the physical influences of both red and yellow on pages 18 and 58.) A good balance of orange will give optimal health and a healthy sexual drive. Too much of it, and you can become exhausted and drained of energy.

Emotional health

The emotions associated with a good balance of orange are happiness, motivation, optimism, and a general sense of well-being. An individual with a balanced influence of orange in his or her color chart will be a natural jack-in-the-box, able to bounce back quickly from disappointment and heartache. If orange is overactive, negative qualities of selfishness, pride, and arrogance will come to the fore. A shortage of orange energy can contribute to low self-esteem and a poor self-image. In this case, orange can be invigorating.

Spiritual health

The orange person lives his or her life very much in the present. This is probably because they have come to terms with their mortality and see death as part of a natural cycle of things. Their spiritual goal should be to channel their natural sensuality and vitality into artistic pursuits that will in turn enhance and enrich their spiritual life.

Relationships

ORANGE WITH RED This may be a difficult relationship to sustain because your creative abilities will be challenged by your partner's controlling energies.

ORANGE WITH SCARLET You may get frustrated by your partner's achievements while your creations remain unrecognized.

ORANGE WITH ORANGE There is much joy and creativity to be had from this relationship. If you can learn to motivate one another, you will make beautiful music together.

ORANGE WITH GOLD This is a potentially wonderful partnership. You have a great deal to teach each other, and you will both be open to change and growth.

ORANGE WITH YELLOW This relationship will work well if you ally your creativity to your partner's intellect and financial acumen.

ORANGE WITH LIME You may find your partner's dislike of clutter and untidiness stifling.

ORANGE WITH GREEN This could be a stable relationship, but you may also find it difficult to cope when your partner puts breaks on your natural creativity.

ORANGE WITH TURQUOISE Your partner's calm may help you to regulate the overpowering creative energies within you.

ORANGE WITH BLUE You complement each other very well so this stands to be a long and fruitful partnership.

ORANGE WITH INDIGO With your creativity and your partner's natural intuition, you can reach new heights of passion and enjoyment all the time.

ORANGE WITH VIOLET You will enjoy many changes and new experiences in this relationship, and this will feed your impetuous and excitable nature.

ORANGE WITH MAGENTA This union could work beautifully as magenta may be able to turn your inspirational creativity into concrete reality.

You empower others

With orange as your sun sign color and red as your destiny color, you are able to see the beauty of creation in all things and you actively seek out experiences to help you understand this. So you could find yourself working in conditions where there is a great deal of sadness or negativity, and your role will be to bring joy to others.

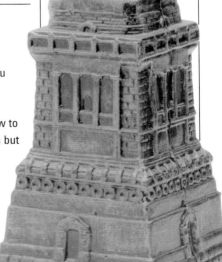

Sun sign color **ORANGE**

Destiny color **RED**

IF YOUR PERSONAL EXPRESSION COLOR IS:

RED
You have great drive and enthusiasm, and simply cannot abide half-hearted effort or lack of energy in others. Try to channel some of your energy into physical activities such as sports or dancing to achieve a more balanced lifestyle.
Compatible combinations
love—blue, green, green
business—blue, green, gold

ORANGE
In a team you are usually the one with all the ideas and vision, but you cannot get by on sheer audaciousness alone. Try finding ways of getting others to go along with you or your frustrations may get the better of you.
Compatible combinations
love—blue, green, blue
business—blue, gold, blue

YELLOW
Your mind is in a constant whirl as you struggle to express the creative visions running amok inside your head while remaining financially solvent. Find a way to bring your ideas to fruition and your life will become so much simpler.
Compatible combinations
love—blue, green, violet
business—blue, green, gold

GREEN
Your love of the beauty of nature brings you much joy and helps you overcome your frustration when your abilities are not recognized and others take all the praise that is your just due.
Compatible combinations
love—blue, green, magenta
business—blue, magenta, gold

BLUE
You rise above conditions of despair and depression and help others overcome their fear and negativity with your joyful nature.
Compatible combinations
love—blue, green, orange
business—turquoise, orange, gold

INDIGO
Empowering others to see their future possibilities is your life's work. You are talented and perceptive enough to learn from your own experiences to recognize and bring out the spark of creative genius in others.
Compatible combinations
love—blue, green, gold
business—turquoise, gold, gold

VIOLET
There have been many changes in your life to date that have required you to make many sacrifices. Your recognition that joy can come from adversity helps others to overcome their own fears and inhibitions.
Compatible combinations
love—blue, green, yellow
business—blue, green, gold

MAGENTA
This is a harmonious combination of colors. You use the ideas and visions in your mind to create success in all areas of your life.
Compatible combinations
love—lime, blue, green
business—lime, blue, gold

GOLD
The experiences and difficulties you have endured have made you more loving and compassionate toward others. Teach them how to tap their inner strength but don't push them too hard.
Compatible combinations
love—blue, green, indigo
business—blue, green, green

Sun sign color ORANGE

Destiny color ORANGE

You are full of zest for life

This double dose of orange gives you the strength to tackle almost anything. Your determination sets an example that others are happy to follow. With yellow as part of orange, your intellectual abilities also come to the fore. You are not just interested in your physical needs but recognize the importance of your emotional and spiritual needs as well.

IF YOUR PERSONAL EXPRESSION COLOR IS:

RED
Your boundless energy and willingness to help others can sometimes make you appear dictatorial and unreasonable. Learn to be more persuasive and you will get better results in dealing with the people in your life.
Compatible combinations
love—blue, blue, green
business—turquoise, gold, green

ORANGE
You are very determined to get what you want and to succeed where others fail. Make sure that your success is not achieved at the expense of others' needs.
Compatible combinations
love—lime, magenta, blue
business—lime, magenta, gold

YELLOW
Yours is the best of both worlds. You enjoy your working life because you are able to do what you like doing best and to use your creative abilities while remaining financially successful.
Compatible combinations
love—blue, green, violet
business—turquoise, gold, violet

GREEN
Your exuberant personality affects others, particularly very young children, who are drawn to you because of the fun and laughter you create in their lives.
Compatible combinations
love—blue, blue, red
business—lime, gold, magenta

BLUE
It is very admirable that you go out of your way to help others. Make sure that your need to be wanted doesn't make others too dependent on you.
Compatible combinations
love—blue, blue, orange
business—blue, gold, orange

INDIGO
Your life is very full and you bring a lot of enjoyment to others. Practicing relaxation and meditation techniques will help you to find your own inner strength.
Compatible combinations
love—blue, blue, gold
business—blue, green, gold

VIOLET
Your spiritual values have changed and are now influencing your life. However this does not mean giving up all the things you enjoy and living like a hermit.
Compatible combinations
love—blue, blue, yellow
business—blue, blue, gold

MAGENTA
There is such a deep love within you for all living things. If you are drawn to help where there is pain and sorrow from war, natural disaster, poverty, and famine, this combination gives you the strength and courage you need.

Compatible combinations
love—lime, blue, green
business—lime, gold, green

GOLD
Every moment of your life is recognized as a learning opportunity. You radiate love and compassion and are an example to all who come to you for counseling and spiritual guidance.
Compatible combinations
love—blue, blue, indigo
business—blue, blue, red

You have a quick mind

Sun sign color **ORANGE**
Destiny color **YELLOW**

With your natural vitality and sharp intellect, you are like the original Renaissance man or woman. You are never at a loss for words to say or ideas to contribute. This combination helps you make the decisions to be successful in all areas of your life. You are also compassionate and in spite of your energy, you are sensitive and do not take people for granted.

IF YOUR PERSONAL EXPRESSION COLOR IS:

RED
You are a workaholic with seemingly endless supplies of energy. This creates tensions for you, which could get out of hand. Learn to curb your materialistic instincts and to finish one project before moving on to the next.
Compatible combinations
love—blue, violet, green
business—blue, violet, gold

ORANGE
Success has to be earned. You owe others a great deal for your current financial success, so give them the recognition they deserve.
Compatible combinations
love—blue, violet, blue
business—blue, violet, blue

YELLOW
It is great to be financially secure. But to generate more wealth, money needs to stay in circulation. Stop hoarding and learn to share and your life will become significantly enriched.
Compatible combinations
love—blue, violet, violet
business—blue, gold, gold

GREEN
You value safety and security far too highly. This prevents you from exploring other opportunities where your business acumen could be developed even further.
Compatible combinations
love—blue, violet, magenta
business—blue, violet, gold

BLUE
You enjoy social activities but also appreciate the opportunity for quiet. You enjoy reading and writing and your sharp intellect has little difficulty grasping complex subjects.
Compatible combinations
love—blue, violet, orange
business—blue, violet, gold

INDIGO
You have much to contribute to improve world conditions. Don't allow others to take your ideas and use them for their own purposes.
Compatible combinations
love—blue, violet, gold
business—blue, gold, gold

VIOLET
It is very important for you to experience change. But this can lead to a dissipation of your energies so you need to learn how to channel your desires carefully.
Compatible combinations
love—blue, violet, yellow
business—blue, violet, gold

MAGENTA
The world stands to benefit a great deal from your quick mind and disarming pragmatism. A driver and an initiator, you would make a great entrepreneur or an inspiring politician.
Compatible combinations
love—lime, blue, violet
business—lime, gold, violet

GOLD
As the one and only method of exchange, money is part of the material world and not to be feared. Learn to accept this and use it wisely with compassion and discretion for the benefit of all.
Compatible combinations
love—blue, violet, indigo
business—blue, violet, gold

Sun sign color **ORANGE**

Destiny color **GREEN**

You are a champion of causes

With this combination you are given many opportunities to break free from routine. This is not easy for you as a part of you dislikes change. But your creativity could benefit from some kind of restraining influence. You have a strong sense of justice and care deeply about the rights of those less fortunate than yourself.

IF YOUR PERSONAL EXPRESSION COLOR IS:

RED
Grasp the opportunities and experiences you are being given, and find out what you are really capable of achieving. You never know what you can do until you try.
Compatible combinations
love—lime, blue, magenta
business—blue, gold, green

ORANGE
Your creative abilities know no bounds. Experience all that life has to offer you and see how your life begins to change and expand in new and exciting ways.
Compatible combinations
love—blue, red, blue
business—blue, red, gold

YELLOW
With so many changes going on in your life, you are becoming more and more successful. Ignore your natural inclination to feel guilty and start to really enjoy your achievements.
Compatible combinations
love—blue, red, violet
business—blue, gold, violet

GREEN
You are so concerned with restoring balance and harmony to the lives of others that your own needs become neglected. Try to devote more time to your own creative abilities, and don't be afraid to have fun.
Compatible combinations
love—blue, red, magenta
business—blue, magenta, gold

BLUE
Fairness and justice for all are noble values to be encouraged. Try to remain flexible when upholding such virtues, as you could have a tendency to become rigid and authoritarian.
Compatible combinations
love—blue, red, orange
business—blue, red, orange

INDIGO
You follow rules and regulations to the letter, forgetting that some rules were made to be broken. Question the world around you more as this will bring more exciting opportunities into your life.
Compatible combinations
love—blue, red, gold
business—blue, red, gold

VIOLET
Many changes have taken place in your life. Your spiritual values can help you let go of the fears that have so far held you back from new experiences.
Compatible combinations
love—blue, red, yellow
business—blue, red, gold

MAGENTA
The deep love you have for all living things helps you overcome your fears of insecurity. You are able to go into very distressing situations to bring comfort and hope to others whose lives have been changed through disaster.
Compatible combinations
love—lime, blue, magenta
business—lime, blue, gold

GOLD
You have overcome the challenges that change brings. With your loving, compassionate nature, you stand to bring out the best in others and to recognize latent talents that many others may overlook.
Compatible combinations
love—blue, red, indigo
business—blue, red, gold

YOUR THREE ESSENTIAL COLORS

42

You honor your word

This is a harmonious combination with the two colors complementing each other perfectly. Although your caring nature may get taken advantage of, others rely on you to see them through their problems, and you would make a wonderful parent or boss. Your creative abilities may not gain the recognition they deserve because you shun the limelight.

IF YOUR PERSONAL EXPRESSION COLOR IS:

RED
Your peaceful loving nature finds it difficult to cope with the overwhelming power of this color combination. Introduce some green into your life to feel more in control of your emotions.
Compatible combinations
love—blue, orange, green
business—blue, gold, green

ORANGE
You try very hard to get your talents recognized and your voice heard. Force alone will not make this happen. Having more trust and faith in your own inherent abilities will.
Compatible combinations
love—blue, orange, blue
business—blue, gold, blue

YELLOW
Your inner strength and cheerful nature work well to bring peace to volatile situations and to surprise your listeners into a new awareness. Express any negative feelings through creative or sporting pursuits.
Compatible combinations
love—blue, orange, violet
business—blue, orange, gold

GREEN
You are rather good at suppressing your real desires

in favor of accepted codes and rules of behavior. You need to give vent to your creative talents or your emotions could explode out of control.
Compatible combinations
love—blue, orange, yellow
business—lime, gold, magenta

BLUE
You know that meeting your creative needs is more important to you than outward glamor or success. The solitude you seek feeds this creativity. But be careful that you don't become too isolated and reclusive.
Compatible combinations
love—blue, orange, orange
business—blue, orange, gold

INDIGO
You have found deep peace and joy within yourself. Use

this peace and tranquillity to access your intuitive spiritual nature and to be guided in what your future possibilities might be.
Compatible combinations
love—blue, orange, gold
business—blue, gold, gold

VIOLET
The transformation of your physical nature into a more spiritual one creates deep changes on all levels. Learn to value these changes and your life's purpose will slowly be revealed.

Compatible combinations
love—blue, orange, red
business—blue, orange, gold

MAGENTA
Your loving nature tries to see the best in others, but people do not always behave in an ideal way. Learn to accept that nobody is perfect.
Compatible combinations
love—lime, blue, green
business—lime, orange, gold

GOLD
It takes a lot of courage and determination to bring peace into distressing situations. With your wisdom and cool detachment you would make an ideal parent or arbitrator.
Compatible combinations
love—blue, orange, indigo
business—blue, orange, gold

You are very perceptive

You are torn between a desire to be the life and soul of the party and the need to explore your spirituality. Opportunities will arise to help you broaden your mind and control your more selfish impulses. Your combination of intellectual curiousity and powers of intuition make you very perceptive.

IF YOUR PERSONAL EXPRESSION COLOR IS:

RED
Deep down you feel that there is much more to the world than meets the eye. You yearn to reach out into the unknown but are held back by your skepticism. Stop struggling and open your mind up to new and exciting possibilites.
Compatible combinations
love—blue, gold, green
business—blue, gold, green

ORANGE
Your creative talents are being used in many different ways. Stand back and observe what is happening, and use this awareness to influence your desires.
Compatible combinations
love—blue, gold, blue
business—blue, gold, gold

YELLOW
Your success is the result of your intellectual efforts. However, this has been at the expense of your keen intuition. Keep an open mind and explore other ways of being.
Compatible combinations
love—blue, gold, violet
business—blue, gold, violet

GREEN
Teaching others about the importance of conservation is a serious subject. Use your joyful, creative nature to bring more fun into your life.
Compatible combinations
love—blue, gold, red
business—blue, gold, red

BLUE
Your desire to constantly tell the truth is admirable. But others may not share your beliefs. Try to avoid unnecessary force when putting your arguments across to avoid becoming isolated.
Compatible combinations
love—blue, gold, orange
business—blue, gold, gold

INDIGO
Your methodical urges often get the better of you, and lead you to think along rather narrow and rigid lines. Loosen up and let your creative juices flow.
Compatible combinations
love—blue, gold, yellow
business—blue, orange, gold

VIOLET
Many different ways of seeing the world have opened up to you, and this has changed your perception of the world. Learn from your experiences and accept that your intuitive nature is an important part of your whole personality.
Compatible combinations
love—blue, gold, yellow
business—blue, gold, gold

MAGENTA
The best ideas come from imaginative minds. Don't be afraid to experiment and try out new ideas. The more you stand on the sidelines, the more you'll cut yourself off from any meaningful experiences.
Compatible combinations
love—lime, blue, gold
business—lime, gold, magenta

GOLD
You have great wisdom and understanding of how scientific and spiritual concepts work together. Use your love and compassion wisely to bring enlightenment to others.
Compatible combinations
love—blue, gold, indigo
business—lime, gold, magenta

You welcome change

You love challenges, and your natural vitality and energy mean that you seldom cry over spilt milk or dwell on past mistakes. You sometimes play the role of martyr however and find yourself sacrificing or suppressing your natural feelings and creative abilities in order to please others or conform to their idea of what they think you should be.

IF YOUR PERSONAL EXPRESSION COLOR IS:

RED
Distressing conditions affect you deeply. As you struggle to reconcile your spiritual values with physical needs, deep psychological changes will take place within you.
Compatible combinations
love—blue, yellow, green
business—blue, yellow, gold

ORANGE
Whatever you or others create has to be perfect. Accept that mistakes are opportunities for you to reassess and change what you are doing and life will be so much more enjoyable.
Compatible combinations
love—blue, yellow, blue
business—blue, gold, blue

YELLOW
You struggle constantly with your spiritual values and materialistic instincts. You need to learn the difference between financial generosity and generosity of the spirit.
Compatible combinations
love—blue, yellow, violet
business—blue, gold, violet

GREEN
Your spiritual values are very important to you. They help you to perceive change as the opporunity to face new challenges and to move on to higher and better things.
Compatible combinations
love—blue, yellow, red
business—blue, gold, magenta

BLUE
You are a very honest person and hate falsehoods of any kind. You fight for your deep spiritual beliefs. Learn not to impose your values on others' personal liberty.
Compatible combinations
love—blue, yellow, orange
business—blue, gold, orange

INDIGO
You accept everything you are told with blind faith. Learn to discriminate more between fact and fiction and you will not be led down the paths of false prophets.
Compatible combinations
love—blue, yellow, gold
business—blue, gold, gold

VIOLET
You like variety and thrive on uncertainty. However, the changes in your life are overwhelming and you need to introduce some green as a matter of urgency to create a more balanced lifestyle.
Compatible combinations
love—blue, yellow, yellow
business—blue, gold, green

MAGENTA
Your spiritual values embrace the concept of unconditional love for all life. Use this to empower others and to alleviate their suffering.
Compatible combinations
love—lime, blue, yellow
business—lime, blue, gold

GOLD
Your many life experiences have made you a wise, loving, and compassionate person. You are a true spiritual teacher and use your qualities to teach others how to overcome their own difficulties.
Compatible combinations
love—blue, yellow, indigo
business—blue, gold, yellow

You believe in miracles

You believe in the impossible and the unknown. This combination allows you to expand your beliefs and explore the world beyond the boundaries of scientific knowledge. Forgiveness is a strong characteristic of magenta and this helps you to be nonjudgmental of others. You are also very warm and engaging.

IF YOUR PERSONAL EXPRESSION COLOR IS:

RED
Your outgoing personality is suppressing your emotional needs. Find out what is driving you to rush around helping others and learn to give those around you more responsibility.
Compatible combinations
love—lime, blue, green
business—lime, blue, gold

ORANGE
Your are sometimes judgmental, and this makes you think that others need you. By recognizing strengths in others instead of weaknesses you will be able to let go of perceived responsibilities.
Compatible combinations
love—lime, green, blue
business—lime, gold, blue

YELLOW
Others are uplifted by your very cheerful nature. This may be hiding feelings of low self-esteem. Find a way to express these feelings and control your emotions and you will get more enjoyment out of life.
Compatible combinations
love—lime, blue, violet
business—lime, gold, violet

GREEN
In a team your critical appraisal is invaluable. To avoid hurting others make sure that the way you deliver your comments is constructive rather than destructive.
Compatible combinations
love—lime, blue, magenta
business—lime, gold, magenta

BLUE
You have a genuine, kind, and caring nature and a great determination to blow the whistle on injustice. This can sometimes make you unpopular when others don't share such strongly-held beliefs.

Compatible combinations
love—lime, blue, orange
business—lime, blue, gold

INDIGO
Your deep understanding of human behavior and motivation can be used to change judgmental attitudes and remove barriers of ignorance and bigotry.
Compatible combinations
love—lime, blue, gold
business—lime, magenta, gold

VIOLET
You strive for perfection in people and results and this can make you over-critical. Value yourself as a unique human being instead of

always striving for perfection, and you will create less stress in your life.
Compatible combinations
love—lime, blue, yellow
business—lime, blue, gold

MAGENTA
This is not an easy combination. As you experience discrimination and injustice in certain areas of your life, your feelings of low self-worth will be transmuted into an inner spiritual strength.
Compatible combinations
love—lime, blue, green
business—lime, magenta, gold

GOLD
Your experiences have given you courage, wisdom, and compassion. This helps you to speak out for others who are being oppressed and discriminated against, and you are very well suited to working for a charitable or religious organization.
Compatible combinations
love—lime, blue, indigo
business—lime, gold, indigo

You are a **wise** counselor

Sun sign color **ORANGE**
Destiny color **GOLD**

With this combination, all the physical energies of orange are being raised into the spiritual qualities of gold. You are blessed with the wisdom of Solomon and should seek opportunities to impart such profound understanding to others. You may sometimes come across as old beyond your years however, and may need to add some spark and vitality to your life.

IF YOUR PERSONAL EXPRESSION COLOR IS:

RED
What a wonderful combination! The spiritual qualities of gold are brought down to earth by the physical aspects of red. So, although your head may be in the heavens, your feet are planted firmly on the ground.
Compatible combinations
love—blue, indigo, green
business—green, indigo, turquoise

ORANGE
Your spiritual understanding brings you a great deal of joy and happiness. Don't be afraid to share your knowledge with others to help them become more aware of their spiritual nature.
Compatible combinations
love—blue, indigo, blue
business—gold, indigo, blue

YELLOW
Your life is in a constant state of flux. This is very exciting but if carried to extremes you could end up suffering from nervous exhaustion. Find ways of prioritizing and life will become more manageable.
Compatible combinations
love—blue, indigo, violet
business—red, gold, yellow

GREEN
You have an exceptional understanding of how the world of nature works. This is a difficult concept for others to grasp. Be more discerning about the people with whom you share this knowledge, or you may find yourself being ridiculed.
Compatible combinations
love—blue, indigo, red
business—lime, gold, magenta

BLUE
Instead of leaving projects half finished, you are learning to complete one before moving on to another. This brings greater stability and harmony into your life.
Compatible combinations
love—blue, indigo, orange
business—blue, indigo, gold

INDIGO
Your keen intuitive and spiritual instincts give your imagination tremendous freedom. This quality can work to produce artistic creations that are truly in a class by themselves.
Compatible combinations
love—blue, indigo, gold
business—blue, magenta, yellow

VIOLET
Having gained a certain measure of maturity, you are anxious to learn more. Use your creative nature to venture into greater depths of awareness, expanding your knowledge even more than before.
Compatible combinations
love—blue, indigo, yellow
business—blue, indigo, gold

MAGENTA
You have no illusions about the harsh realities of life and work tirelessly to open others' minds to the cruelty that exists in the world. You may well find yourself working for an activist movement.
Compatible combinations
love—lime, blue, indigo
business—lime, gold, magenta

GOLD
You succeed in almost everything that you do. You have released your fears and inhibitions and are now free to follow your chosen path, whatever this may be.
Compatible combinations
love—blue, indigo, indigo
business—blue, blue, indigo

The color gold

Derived from orange and yellow, gold gives us success in whatever we undertake. It links us to the highest spiritual qualities and generates feelings of warmth, love, and compassion, influencing all those who come within its radiant power. The full knowledge of all its attributes extends beyond our comprehension, which is where it can take us if we are willing to open our minds to its influence.

The complementary color to gold is indigo (see page 108) so if you find your chart exhibiting too much overawing gold energy you may want to consider introducing more indigo energy into your life. On the following pages you will find a personalized reading for each three-part combination with gold as the sun sign.

Physical health

Gold can influence the spleen, which links to one of the minor chakras giving vitality to the body. It influences the circulation and the body's skeletal system. In some homeopathic remedies, gold is used to treat depression; in conventional medicine it is used to treat various arthritic, rheumatic, and spinal problems. A good balance of gold in our life makes us feel on top of the world. Too much and we go over the top and wear ourselves out. Too little and our energies become depleted, leaving us feeling at times that life is not worth living.

Emotional health

With a good balance of gold in one's color chart, the emotions of love, compassion, power, self-esteem, courage, and passion will be under control and directed toward helping and sharing what we have with others. Too much and we become self-centered, seeking power for ourselves. Too little and we can become selfish and demanding, developing an unfortunate meanness of spirit.

Spiritual health

As a gold person, you spread joy and happiness wherever you go with no thought for your own comfort. Gold being the color of the spiritual teacher, you aim to transform the lower personality into the highest that can be attained and to help others do the same. Like the alchemists, you are trying to turn base metal into gold. When you have achieved this you will be operating from the crown chakra and know the true meaning of unconditional love. With your inner wisdom you will be using this for the benefit of all with whom you come into contact.

Relationships

GOLD WITH RED This relationship will work well, because your partner will keep your feet on the ground.

GOLD WITH SCARLET You will have to work hard at this relationship. The physical demands and desires of your partner may be too much for you.

GOLD WITH ORANGE If your partner can accept the advice you offer, this will inspire them to greater accomplishments.

GOLD WITH GOLD This can be a very loving and nurturing relationship and you can help each other to reach your spiritual goals.

GOLD WITH YELLOW Through your wisdom and understanding you will help your partner control their impetuous nature.

GOLD WITH LIME Your partner's inner fears may frustrate you, but your deep love and understanding can overcome this.

GOLD WITH GREEN You are both interested in nature and environmental issues, so this relationship will work well.

GOLD WITH TURQUOISE When you get confused and are not sure which way to go, your partner will help you to see more clearly and make the right decision.

GOLD WITH BLUE You will be compatible if you want a spiritual relationship and someone who is devoted to you and will do whatever you want without question.

GOLD WITH INDIGO With these colors complementing each other, you can work well together, benefiting from one another's abilities.

GOLD WITH VIOLET Both of you are aiming for spiritual goals. You will have to cope with your partner's love of change for this to work.

GOLD WITH MAGENTA Both of you are learning the true meaning of unconditional love and compassion. You will need to draw on each other's strength for this to be successful.

You have inner fire

With gold being the color of compassion and wisdom, you are blessed with sound judgment and great personal warmth. Red as your destiny color relates to the base chakra, and the emotional issues of safety, security, and survival that you need to overcome in your life. This will not be easy, and you will face many challenges along the way.

IF YOUR PERSONAL EXPRESSION COLOR IS:

RED
You have great strength and determination and follow anything you are involved with through to completion. Try not to get frustrated when others don't match your tenacity, measure for measure.
Compatible combinations
love—indigo, green, green
business—indigo, green, gold

ORANGE
You work hard to help others overcome their negative feelings. When this starts to get you down, go out and have some fun, and stop taking life so seriously.
Compatible combinations
love—indigo, green, blue
business—turquoise, indigo, gold

YELLOW
You are successful in whatever you do. Learn how to combine financial success with your spiritual values so that your material success doesn't go to your head and dominate your life.
Compatible combinations
love—indigo, green, violet
business—indigo, green, gold

GREEN
This combination imparts stability and harmony. Use it to complete projects that you start and never finish, and you will not feel as though you are going around in circles and getting nowhere.
Compatible combinations
love—indigo, green, magenta
business—indigo, magenta, gold

BLUE
Your deep faith overcomes all difficulties, but try not to let yourself be taken advantage of. Learn to trust your instincts and to draw the line when you feel someone is going too far.

Compatible combinations
love—indigo, green, orange
business—indigo, green, gold

INDIGO
Your spiritual development is restricted by rules and regulations, a great deal of them self-imposed. The answers you are seeking come from within and cannot always be scientifically explained.
Compatible combinations
love—indigo, green, gold
business—violet, blue, gold

VIOLET
This is an intense combination as you desperately seek a spiritual explanation for the many changes that have happened in your life. You have conquered hate and fear and know that you will find the answers you seek.
Compatible combinations
love—indigo, green, yellow
business—indigo, green, gold

MAGENTA
Emotionally vulnerable people come to you for wisdom and advice. Learn to detach yourself from their emotions and do not exploit them in any way.
Compatible combinations
love—lime, indigo, green
business—lime, indigo, gold

GOLD
Your strong spiritual beliefs give you all the determination you need. Remember this when you feel unable to see a project through to the end.
Compatible combinations
love—indigo, green, indigo
business—indigo, green, gold

You are a freethinker

With orange as your destiny color, you will be learning to release fears and inhibitions that hold you back from achieving your spiritual goals. Freedom of thought is of paramount importance to you. You hate restrictions, spiritual or intellectual, being placed on yourself or on others and fight tooth and nail to have them removed. You present a stable face to the world, but you love to flirt with danger.

IF YOUR PERSONAL EXPRESSION COLOR IS:

RED
It is sometimes necessary to be tough on others in order to achieve the results you require. But you need to temper this with the art of delegation or you could risk becoming controlling and overdemanding.
Compatible combinations
love—indigo, blue, green
business—indigo, gold, green

ORANGE
You are charming and diplomatic by nature. As a freethinker, you have little difficulty in welcoming others' ideas, and will move mountains to have them approved.

Compatible combinations
love—indigo, blue, green
business—indigo, blue, gold

YELLOW
Allow your need for freedom to be expressed creatively and release the fears that are holding you back from exploring your spiritual nature.
Compatible combinations
love—indigo, blue, violet
business—indigo, blue, gold

GREEN
You are torn between a desire to flout convention and an equally compelling need to follow rules and regulations to the letter. This tension can either feed your creativity or hamper it. You will have the final say.

Compatible combinations
love—indigo, blue, red
business—indigo, gold, red

BLUE
You have great integrity. Not everyone shares your values, and you may find your faith in others misplaced as a result. Wise up and temper your trust with realism.
Compatible combinations
love—indigo, blue, orange
business—indigo, blue, gold

INDIGO
The life of a mystic is definitely not for you. You need to get out into the real world if you are to develop your spiritual understanding to the utmost.
Compatible combinations
love—indigo, blue, gold

business—indigo, green, gold

VIOLET
Your deep love and understanding helps others to deal with the convulsions and changes in their lives. Perhaps you could use your natural talents in a professional capacity.
Compatible combinations
love—indigo, blue, yellow
business—indigo, blue, gold

MAGENTA
You are a realist and accept both positive and negative situations as opportunities for spiritual development. Try to have more patience with people less positive than you are.
Compatible combinations
love—lime, indigo, blue
business—lime, indigo, gold

GOLD
You know that the true expression of love, compassion, and humility lies in letting others take the glory and praise without feeling hurt or disappointed.
Compatible combinations
love—lime, magenta, indigo
business—lime, magenta, gold

You are astute

Financially you are very successful. This may cause internal conflict and you need to learn how to reconcile your material success with your spiritual values. You are a fast thinker and quickly find your way out of difficult situations. When others are feeling low, your optimistic nature raises their spirits and makes life more enjoyable for them. You have many friends and enjoy intellectual discussions, but you are easily bored with mundane conversation.

IF YOUR PERSONAL EXPRESSION COLOR IS:

RED
The desires of your physical nature take priority over your spiritual needs. Use all your abilities to their fullest potential for wholeness of body, mind, and spirit—not just for sexual gratification.
Compatible combinations
love—indigo, violet, green
business—indigo, gold, green

ORANGE
You are gregarious and multi-talented, and have something interesting to say about almost every subject under the sun. With your charm, you could probably get anyone to do anything.
Compatible combinations
love—indigo, violet, blue
business—indigo, gold, blue

YELLOW
Your intellectual success takes priority over your spiritual needs. You need to ask yourself where you would derive your inner strength from if you were to suddenly lose everything that you hold dear.
Compatible combinations
love—indigo, violet, violet
business—indigo, gold, violet

GREEN
A wonderful combination. You are a realist, and as you know, realism is very serene because it cannot be disturbed or surprised.
Compatible combinations
love—indigo, violet, red
business—indigo, violet, gold

BLUE
Despite your astuteness, your idealism sometimes leads you to think that you are somehow responsible for all the world's ills. Learn to put things in perspective, and to laugh at life a little more.
Compatible combinations
love—indigo, violet, orange
business—indigo, violet, gold

INDIGO
You have come to acknowlege the intuitive side of your nature and this works in harmony with your logical mind.
Compatible combinations
love—indigo, violet, gold
business—red, violet, gold

VIOLET
This is a harmonious combination. Your beliefs influence your life path toward a deeper understanding of spiritual values.
Compatible combinations
love—indigo, violet, yellow

business—indigo, violet, gold

MAGENTA
Financial success is not enough for you. Your logical mind and spiritual nature work together, developing deep love and compassion for others within your soul.
Compatible combinations
love—lime, indigo, violet
business—lime, indigo, gold

GOLD
You share your material success generously with others. Learn that love, wisdom, and compassion can often have a greater power than material gifts.
Compatible combinations
love—indigo, violet, indigo
business—indigo, violet, gold

You are a high-flyer

Green will bring peace and harmony into difficult situations, stabilizing emotions when they get out of control. Freedom for others and environmental issues are important to you and you learn to understand how nature works to restore balance and harmony in all things. You initiate change and enjoy the opportunity it gives for new experiences.

IF YOUR PERSONAL EXPRESSION COLOR IS:

RED
You throw yourself into new projects with vigor and force. Learn to empower others through methods of encouragement as this will relieve you of the burden of too much responsibility.
Compatible combinations
love—indigo, red, green
business—gold, red, green

ORANGE
Your enthusiasm and determination overcome many obstacles. Learn to control your emotions, which may at times threaten to overwhelm you.
Compatible combinations
love—indigo, red, blue
business—indigo, red, gold

YELLOW
You are releasing your fears and inhibitions, which prevent you from reaching your spiritual goal. New changes open your mind to exciting possibilities you once thought were beyond your reach.
Compatible combinations
love—indigo, red, violet
business—indigo, gold, violet

GREEN
You love being the initiator of new projects, but need to learn when to move on. If you stay too long in one situation, you can become uninterested, and then risk stifling the creative abilities around you.
Compatible combinations
love—indigo, red, red
business—indigo, red, gold

BLUE
You strive to emulate the beauty of nature and your love of beauty is reflected in the clothes that you wear and the furnishings you surround yourself with. This can only enhance your spiritual wisdom and growth.
Compatible combinations
love—indigo, red, orange
business—indigo, red, gold

INDIGO
You have a natural ability to understand others. This can be developed into a career in psychology. Increased knowledge can be used to empower others to recognize their potential.
Compatible combinations
love—indigo, red, gold
business—blue, red, gold

VIOLET
Connection to your spiritual nature helps you understand the real meaning of life. Look to the natural world for

further enlightenment and sustenance.
Compatible combinations
love—indigo, red, yellow
business—indigo, red, gold

MAGENTA
What a wonderful world it would be if hate and fear were absent. Try not to strive too hard to achieve this state of affairs in your own life and you will be less frequently disillusioned.

Compatible combinations
love—lime, indigo, magenta
business—lime, indigo, gold

GOLD
You are warm and caring, and spread happiness wherever you go. Remember to recognize and value change as a time to reflect on your spiritual growth.
Compatible combinations
love—lime, magenta, indigo
business—lime, magenta, gold

You are very trusting

Sun sign color **GOLD**

Destiny color **BLUE**

You are a beautiful person and strive to help everyone you meet. Such a quality may be unfairly exploited by others, and you should avoid the temptation to withdraw into your shell to avoid getting hurt. You need to learn how to contact your spiritual, intuitive nature and to develop your natural healing abilities.

IF YOUR PERSONAL EXPRESSION COLOR IS:

RED
You can empower others to find their own inner strengths. Don't forget that you also need time for introspection so that you can recharge your own energies.
Compatible combinations
love—indigo, orange, green
business—indigo, gold, green

ORANGE
This is a good combination. You are full of fun and laughter, which protects you from disillusionment and maintains harmony and balance in all areas of your life.
Compatible combinations
love—indigo, orange, blue
business—indigo, gold, blue

YELLOW
You have the courage to let go of emotional fears and inhibitions that are restricting your spiritual development. Learn the value of exchanging energy, whether through money or payment in kind for the service you give to others. We all need to live!
Compatible combinations
love—indigo, orange, violet
business—lime, magenta, gold

GREEN
You have a great deal of time and energy to give to others. Your wide-ranging interests dissipate your energies. More stability will give you time to reflect on life's deeper purpose.
Compatible combinations
love—indigo, orange, red
business—lime, gold, magenta

BLUE
This combination may make you feel depressed, leaving you with little motivation to do the many things you so desperately want to do. Bring some orange into your life as a matter of urgency to help you move on.

Compatible combinations
love—indigo, orange, orange
business—gold, orange, gold

INDIGO
You are a deep thinker, searching constantly for answers to questions that have bedeviled philosophers for centuries. Learn to help others with their spiritual development.
Compatible combinations
love—indigo, orange, gold
business—indigo, orange, gold

VIOLET
Your gift of helping others by sacrificing your own needs and desires helps you to achieve your spiritual goal of transformation.

Help yourself 10 cents an apple

Compatible combinations
love—indigo, orange, yellow
business—indigo, orange, gold

MAGENTA
You have a natural understanding of the emotional power of love and know the harm that can come from the absence of love in an individual's life.
Compatible combinations
love—lime, indigo, green
business—lime, indigo, gold

GOLD
As a leader, you are respected for your fairness and conscientious attitude. You expect from others only what you expect from yourself. You work to improve conditions for all, seeking no reward for yourself.
Compatible combinations
love—lime, indigo, orange
business—lime, gold, magenta

You are altruistic

You have the inner resources to make this world a better place to live in. Having a great deal of love to give, you think nothing of sharing your possessions with those in need. Although you do not seek financial reward, you do expect your commitment to be reciprocated, and when this is not forthcoming you can turn against those you have helped.

IF YOUR PERSONAL EXPRESSION COLOR IS:

RED
You are dedicated to helping others, and share all you have with those experiencing personal disaster. Don't expect commitment and loyalty in return, since this may not be forthcoming.
Compatible combinations
love—violet, gold, green
business—indigo, gold, green

ORANGE
You are as sweet as honey. By spreading happiness around you, you help others to see the potential for joy in their own lives and to discover their hidden capacity for good will.
Compatible combinations
love—indigo, gold, blue
business—indigo, gold, blue

YELLOW
You are coming to terms with your intellectual and philosophical nature. Make sure you don't neglect your physical health, because all parts of your being have to function together for harmonious balance.
Compatible combinations
love—indigo, gold, violet
business—red, orange, violet

GREEN
Believing in tried and tested ideas limits your capacity to expand your understanding. Learn to free your mind from the boundaries of conventional thought and become an initiator instead of a follower.
Compatible combinations
love—indigo, gold, red
business—indigo, gold, orange

BLUE
You often struggle to make sense of life's cruelty. Inner reflection has its place and so does actively doing something to bring about change. Stop sitting on the fence and believe in the strength of your convictions.
Compatible combinations
love—indigo, gold, orange
business—gold, gold, red

INDIGO
You want to do whatever you can for all who seek your help. To do this you must make enough time for your own quiet, inner reflection.
Compatible combinations
love—indigo, gold, gold
business—lime, magenta, gold

VIOLET
Learn to understand how physical desires cannot be separated from other aspects of your nature. This acceptance is what spiritual transformation is all about.
Compatible combinations
love—indigo, gold, yellow
business—indigo, gold, gold

MAGENTA
You are a tower of strength. You have few illusions about the harsh realities of life, and are wise enough not to become emotionally involved with those who seek your help, however much you would like to.

Compatible combinations
love—lime, indigo, gold
business—lime, gold, magenta

GOLD
You have developed your spiritual awareness and are helping others to do the same. Celebrate your spirituality even more through your creative talents, which bring joy and happiness to the lives of others.
Compatible combinations
love—blue, indigo, indigo
business—gold, indigo, gold

You seek self-knowledge

Sun sign color **GOLD**

Destiny color **VIOLET**

You are endlessly curious and are prepared to make huge emotional sacrifices to achieve your goal of self-knowledge and spritual self-fulfillment. Others may interpret your subversiveness for eccentricity, but you are blessed with supreme self-confidence and spend little time worrying about what others think of you.

IF YOUR PERSONAL EXPRESSION COLOR IS:

RED
You have a strong desire to understand spiritual issues. This is almost like a cry for help as you seek answers to who you are, what you are doing here, and what your life's purpose is. As your spirituality develops the answers will come to you.
Compatible combinations
love—indigo, yellow, green
business—indigo, gold, green

ORANGE
You are using all your creative gifts to develop your spiritual nature, which is slowly unfolding. Give your imagination more freedom and your spiritual awareness will grow even more.
Compatible combinations
love—indigo, yellow, blue
business—indigo, gold, blue

YELLOW
Your intellectual ability is leading you in the right direction in your quest for spiritual knowledge. True spiritual development comes, however, from direct experience.
Compatible combinations
love—indigo, yellow, violet
business—indigo, gold, violet

GREEN
You can learn much more about your spiritual nature from your love of the natural world than through the acquisition of dry academic knowledge. The answers to what you are seeking are around and within you.
Compatible combinations
love—indigo, yellow, red
business—lime, indigo, magenta

BLUE
You are very lucky. Although outwardly thick-skinned and confident, you are also sensitive and perceptive. With such a mix of attributes you could be succesful in almost anything you set your mind to.

Compatible combinations
love—indigo, yellow, orange
business—indigo, yellow, gold

INDIGO
You find ways for science and spirituality to work together. As both your intellectual and spiritual understanding develops, the answers become clearer.
Compatible combinations
love—indigo, yellow, gold
business—violet, yellow, red

VIOLET
As you become more aware of your own spiritual needs, you help others to understand theirs. This brings emotional change for all. Don't expect too much of yourself or others.
Compatible combinations
love—indigo, gold, yellow
business—indigo, red, yellow

MAGENTA
Look for the spark of spirituality in all things, and learn to see the dualistic concepts of positive and negative as part of life's complex fabric. We need both to exist.
Compatible combinations
love—lime, indigo, yellow
business—lime, indigo, gold

GOLD
Lack of self-love can be the hardest emotion to overcome. If this is still an issue, find the courage and determination to release it and reach your spiritual goal.
Compatible combinations
love—lime, magenta, indigo
business—green, magenta, indigo

Sun sign color **GOLD**

Destiny color **MAGENTA**

You overcome all obstacles

With magenta as your destiny color you have an admirably wide perspective and see possibilities that others cannot even begin to imagine. By learning to take risks, you will achieve terrific results. However, you are also a realist and others heed your wise counsel when considering new projects and their likely practical applications.

IF YOUR PERSONAL EXPRESSION COLOR IS:

RED
Like David confronting Goliath, you are much stronger than you seem, and by looking back over all the periods of insecurity in your life, you realize how these have made you the resilient person you are today.
Compatible combinations
love—lime, indigo, green
business—lime, indigo, gold

ORANGE
So many things are possible. Until you try them, you will never know what you can achieve. You have learned to tolerate others' faults but find it difficult to tolerate your own and to move on.
Compatible combinations
love—lime, indigo, blue
business—lime, indigo, gold

YELLOW
Don't let your fear of success prevent you from using your considerable talents to generate prosperity for others.
Compatible combinations
love—lime, indigo, violet
business—lime, gold, violet

GREEN
Your interest in the natural world opens your mind to wider possibilities. Learn how the energies of light and color resonate in harmony with every part of the body, mind, and spirit.
Compatible combinations
love—lime, indigo, magenta
business—lime, gold, magenta

BLUE
The blue in your reading mitigates against the wilder excesses of gold and magenta. You are discerning and have the knowledge and wisdom to choose your battles wisely.
Compatible combinations
love—lime, indigo, orange
business—lime, indigo, gold

INDIGO
This is a wonderful combination. You fashion realities from abstract ideas, and your scientific mind analyzes the results. To make life a bit more exciting, introduce some orange.
Compatible combinations
love—lime, orange, gold
business—lime, magenta, gold

VIOLET
You enjoy exploring the realms of fantasy and imagination. Learn to keep your feet on the ground or you will become spiritually unbalanced.
Compatible combinations
love—lime, indigo, yellow
business—lime, magenta, gold

MAGENTA
Although sensitive to pain and suffering, you have the faith to accept this as part of the natural cycle of things. With this awareness, you work hard to improve conditions for all—sacrificing your own needs if necessary.
Compatible combinations
love—lime, indigo, green
business—lime, indigo, gold

GOLD
This is the color combination of the true healer who is learning the power of love to work miracles. Use the knowledge wisely for the benefit of all, not just for self-gratification.
Compatible combinations
love—lime, magenta, indigo
business—lime, magenta, gold

YOUR THREE ESSENTIAL COLORS

You are an enigma

Sun sign color GOLD
Destiny color GOLD

This combination will help you achieve your spiritual goal. As you link to the higher spiritual energies, it is understandable that experiences and opportunities will test your resolve of transformation. Through these tests, both the physical and emotional aspects of your nature will be transformed, and you will make sense of your life.

IF YOUR PERSONAL EXPRESSION COLOR IS:

RED
Your goal is to transform your sexual nature into the spiritual qualities of unconditional love. Not everyone has this goal, so you must be careful not to subdue others' sexuality.
Compatible combinations
love—indigo, indigo, green
business—indigo, gold, green

ORANGE
This combination teaches you the important role that every experience has in your spiritual development. When you laugh and are happy, something magical happens inside you—trust to this and the power of love, and you will work wonders.
Compatible combinations
love—turquoise, indigo, blue
business—turquoise, gold, indigo

YELLOW
Your life is not easy. You have a very strong spiritual nature, which has developed through overcoming many emotional traumas.
Compatible combinations
love—indigo, red, green
business—indigo, gold, violet

GREEN
Your deep love and wisdom guides young people in their spiritual development, and you both learn from each other. Seek the peace and quiet of natural surroundings when life gets too tough.
Compatible combinations
love—indigo, indigo, red
business—lime, indigo, magenta

BLUE
You accept nothing but the truth, trusting others implicitly, and get hurt if deceived. Learn to accept less and forgive more, and this will stop happening.
Compatible combinations
love—indigo, indigo, orange
business—indigo, indigo, gold

INDIGO
Outwardly you are a conformist, seemingly destined for a life spent in suits and top-level board meetings. Inwardly, you yearn to find the time to discover your spiritual side.
Compatible combinations
love—indigo, orange, gold
business—violet, red, gold

VIOLET
You cannot shut yourself off from the physical realities of life. Overcome your fear: there is no place for this in your spiritual goal.

Compatible combinations
love—indigo, indigo, yellow
business—indigo, indigo, gold

MAGENTA
Your emotions are under control, and you can work in the most distressing conditions to restore health and healing to others wherever it is needed.
Compatible combinations
love—lime, indigo, gold
business—blue, indigo, red

GOLD
You are an enlightened soul and true spiritual teacher. Your opportunities and experiences have given you the wisdom, compassion, and humility to teach and heal others.
Compatible combinations
love—lime, magenta, indigo
business—red, magenta, indigo

The color yellow

A powerful primary color, yellow links to logic and the intellect. It is a hot, expansive color that makes us feel happy and optimistic. It gives us the freedom to do and be what we like. It can also sometimes leave us feeling confused and spaced out. It helps us surmount obstacles and get rid of emotional blockages that may be restricting our personal development. With this color in your reading you will either have plenty of money or very little of it but you will never be destitute.

The complementary color to yellow is violet (see page 118) so if you find your chart exhibiting too much shrill yellow energy you may want to consider introducing more violet into your life. On the following pages you will find a personalized reading for each three-part combination with yellow as the sun sign.

Physical health

Yellow affects the nervous system and related illnesses so if there is an excess of yellow in your color reading, there may be times when you find that rest and relaxation are needed. Skin conditions such as eczema and acne benefit from yellow as it is an excellent purifier of the whole body and, by extension, the skin. It also influences the pancreas and diabetes. Its connection to the gall bladder and liver can be seen in the hallmark yellow color of jaundice. All the organs of the digestive system, including the stomach, duodenum, and eliminative functions, are influenced by it. Yellow is particularly good for treating constipation and has even been known to trigger a change in insulin requirements.

Emotional health

The emotions associated with a good balance of yellow are cheerfulness, expansiveness, and motivation. Its positive qualities of expansiveness can free blocked psychic energies or inhibitions, and allow us to face our inner fears and enhance our personal development. But if yellow is overactive, certain negative qualities can come to the fore: an inability to focus on any one thing at a time, a critical attitude, and a tendency to psychological bullying. A shortage of yellow energy can cause us to to feel isolated and deprived of self-worth.

Spiritual health

Yellow links to the solar plexus chakra, which is central to our awareness of the self and power to be individual. It also celebrates our connection to the rest of humanity. The higher qualities of yellow are also to be found in the wisdom of gold, so the spritual goal of the yellow person should be to harness and understand these powerful energies and use them to stimulate his or her awareness of the capacities and talents of other souls.

Relationships

YELLOW WITH RED This relationship can work provided that your more cerebral nature can cope with your partner's physical demands.

YELLOW WITH SCARLET If you can appreciate the benefits of your partner's wide and varied interests then this relationship can work.

YELLOW WITH ORANGE Your partner will help you to discover that there is more to life than just the acquisition of knowledge.

YELLOW WITH GOLD You can only benefit and gain strength from one another's love and compassion.

YELLOW WITH YELLOW For this relationship to be successful you will both have to work together to overcome your fears of failure.

YELLOW WITH LIME This could be a very happy pairing as your partner will tame some of your restlessness and give you the stability to grow.

YELLOW WITH GREEN Your partner will bring stability and harmony to your life and awaken your interest in nature's beauty.

YELLOW WITH TURQUOISE Your partner will take you into unexplored territory and give you complete freedom to be yourself.

YELLOW WITH BLUE This partnership will work well because you are both seekers of knowledge.

YELLOW WITH INDIGO This can be a very enriching experience. Your partner will help you see and explore life's deeper mysteries.

YELLOW WITH VIOLET You will be in perfect harmony, complementing one another in all that you do.

YELLOW WITH MAGENTA Your natural expansiveness may clash with your partner's pragmatism. But this could make your partnership a fascinating one for both of you.

You are very academic

Both yellow and red are primary colors, which together create orange, so all these colors will have an influence in your life. Others draw on your vitality, and you know how to help them without depleting your own energy reserves. You are deeply intellectual and like to be at the forefront of new discoveries. The driving force of red spurs you on to ever greater success but your fears of financial insecurity prevent you from achieving your fullest potential.

IF YOUR PERSONAL EXPRESSION COLOR IS:

RED
You have great drive and are blessed with boundless energy and optimism. But if you push yourself too hard, you may end up with some form of nervous exhaustion. Bring some green into your life to counterbalance your energies.
Compatible combinations
love—violet, green, green
business—gold, green, green

ORANGE
You have great creative ability. Combined with your intellectual skills, they could make you an exceptional graphic or interior designer. However, you would thrive in any creative environment.
Compatible combinations
love—violet, green, blue
business—violet, green, blue

YELLOW
Your intellectual needs tend to take priority over your physical demands. Don't neglect your physical health and well-being as this ultimately has an impact on your clarity of thought.
Compatible combinations
love—violet, green, violet
business—violet, green, gold

GREEN
You work hard and are very successful in almost everything that you do. By giving yourself more time for peace and relaxation you will bring more stability and control into your life.
Compatible combinations
love—violet, green, red
business—violet, green, gold

BLUE
A perfect combination of the three primary colors. All colors work beautifully to create everything you need to sustain a happy and successful life.
Compatible combinations
love—violet, green, orange
business—violet, green, gold

INDIGO
This is an intense combination and your intellectual abilities are continually stretched to breaking point. The result, though, is a profound awareness on your part of the ways of the world.
Compatible combinations
love—violet, green, gold
business—violet, green, gold

VIOLET
Matters of the soul figure strongly in your personal make-up. Your glorious imagination and need for profundity and meaning in your life make you a truly inspirational person to be around.
Compatible combinations
love—violet, green, yellow
business—violet, green, gold

MAGENTA
Your constant desire to help others leaves you wide open to emotional manipulation. Learn to protect yourself from the negative feelings and controlling tendencies of others.
Compatible combinations
love—lime, violet, green
business—lime, violet, gold

GOLD
Your intellect is continually challenged by your spiritual values. Words are all very well but actions often speak louder than words.
Compatible combinations
love—violet, green, indigo
business—violet, green, gold

Sun sign color **YELLOW**
Destiny color **ORANGE**

You turn dross into gold

You have many in-born skills and use them cleverly to create a successful and fulfilling lifestyle. There are so many different things you want to do that at times you find it difficult to keep your feet on the ground. You must learn to pace yourself so that you are not overwhelmed by too many demands on your time and energy.

IF YOUR PERSONAL EXPRESSION COLOR IS:

RED
This is a stimulating combination of colors. You need to learn successful assertiveness techniques if you are to resist demands on your time without causing any offense.
Compatible combinations
love—violet, blue, green
business—violet, gold, green

ORANGE
You are the soul of generosity, frequently giving your time to help others without much reward. Wise up and use your considerable intellect to get something in return for your efforts.
Compatible combinations
love—violet, blue, blue
business—violet, blue, gold

YELLOW
Warm and extroverted, you generate feelings of joy and happiness wherever you go. Your intellectual strengths are put constantly to good use in new and constructive projects. Remember, you also need time for relaxation and meditation.
Compatible combinations
love—violet, blue, violet
business—violet, blue, gold

GREEN
The brakes are being applied, enough to slow you down but not enough to stifle your creativity. When too many demands are made on you, "escape" to the countryside (a place you love) to relax and unwind.
Compatible combinations
love—violet, blue, red
business—violet, gold, red

BLUE
You are a free spirit and dislike being tied down by rules and regulations. You also hate mindless, repetitive jobs that leave little scope for the imagination.

Compatible combinations
love—violet, blue, orange
business—violet, blue, gold

INDIGO
You would make an ideal manager as you combine initiative with drive and self-discipline. But your creative abilities may be in danger of being suppressed by your need to control.
Compatible combinations
love—violet, blue, gold
business—violet, green, gold

VIOLET
All your skills and natural spiritual gifts are used to the utmost as you delve deeply into life's mysteries. As you become more aware of your spiritual nature, many emotional changes will take place within you.
Compatible combinations
love—violet, blue, yellow
business—violet, blue, gold

MAGENTA
You are a realist and recognize that it is impossible to fulfill all the demands made on you without some prioritization on your part. But you are also a skillful diplomat as you know how to say no without offending others.
Compatible combinations
love—lime, violet, blue
business—lime, violet, gold

GOLD
The perfect combination of intellect and wisdom. You dream the biggest dreams and reach for the furthest goals. Only past emotional fears and your need for financial security may be holding you back.
Compatible combinations
love—violet, blue, indigo
business—lime, magenta, gold

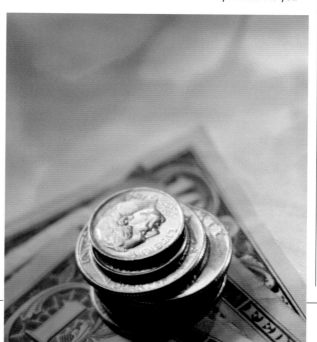

You are fearless

With this double combination of yellow in your reading all the color's qualities and influences are amplified. Life to you is for the taking and you make use of every opportunity to live it to the full. But in spite of your jovial manner, there is nothing frivolous about your inner nature. You are courageous and intellectual in equal measure, and you rarely shy away from challenging your most strongly held values and beliefs.

IF YOUR PERSONAL EXPRESSION COLOR IS:

RED
You are active and energetic, with tremendous drive and stamina. But your physical demands often take priority over all your other needs. Introduce some violet to create more balance and harmony for yourself.
Compatible combinations
love—violet, violet, green
business—violet, gold, green

ORANGE
Your unquestioned courage notwithstanding, you shy away from exploring your spiritual side. This is a pity because you stand only to enrich your world and deepen your experiences by seeing them differently.
Compatible combinations
love—violet, violet, blue
business—violet, gold, blue

YELLOW
This is a potentially explosive combination. If you don't introduce some complementary colors into your life as a matter of urgency, you may end up with severe mental or nervous exhaustion.

Compatible combinations
love—violet, green, blue
business—violet, gold, blue

GREEN
You have worked hard to clear away the dead wood of old and destructive emotions and feelings in your life. The future can only get better.
Compatible combinations
love—violet, violet, red
business—lime, magenta, gold

BLUE
Tact is not one of your strong points, and even your friends are sometimes taken aback by your shocking honesty. Learn how to communicate effectively with others and you will be less affected by their negative reactions.

Compatible combinations
love—violet, violet, orange
business—violet, violet, gold

INDIGO
Because you feel and care deeply for others, you are easily affected by pain and suffering. It is important that you continually find new ways of protecting yourself, or you will be of no use to anyone, including yourself.
Compatible combinations
love—indigo, violet, gold
business—indigo, violet, gold

VIOLET
You have developed an understanding of your spiritual nature through your intellectual rather than your psychic ability. This is wonderful, because it is less likely that you will encounter negative psychic influences against which you will need to protect yourself.
Compatible combinations
love—violet, violet, yellow
business—violet, violet, gold

MAGENTA
You have few illusions about most things. Although kind and dreamy, your super-sensitivity makes you highly attuned to the world around you, and you intuitively know how to improve conditions for others in need.
Compatible combinations
love—lime, violet, violet
business—lime, violet, gold

GOLD
Your sharp intellect is a strong support for your spiritual beliefs. This keeps you on an even keel and frees you from the fears that prevent others from developing their own spirituality.
Compatible combinations
love—violet, violet, indigo
business—violet, violet, gold

You need space

You are one of life's free spirits, a rolling stone in the truest sense of the word. When you don't give yourself the space to breathe, you become lethargic and unhappy. But you have the necessary resources of courage and determination to shake yourself out of any self-imposed rut.

IF YOUR PERSONAL EXPRESSION COLOR IS:

RED
You are stuck in the same old rut, unable to change what you are doing because of your fears of insecurity. By accepting that changes are needed, you will be surprised at the changes this will make to your life.
Compatible combinations
love—violet, red, green
business—gold, red, green

ORANGE
You have a natural flair for color and design. Learn to overcome your emotional fears, which only succeed in suppressing your full creative potential and restricting your personal development.
Compatible combinations
love—violet, red, blue
business—violet, red, gold

YELLOW
Freedom is wonderful thing but too much of it can create chaos. If we live in a society we need boundaries to sustain some semblance of stability. Once you can accept this, your life will become considerably easier.
Compatible combinations
love—violet, red, violet
business—violet, indigo, gold

GREEN
Others are unaware of how talented you are because you do not push yourself forward. You remain in the background and create changes by motivating others to take action.
Compatible combinations
love—violet, indigo, red
business—violet, red, gold

BLUE
Your emotional fears keep you handcuffed to a life of rules and regulations. Have you ever thought what you would do if you learned to break free?

Compatible combinations
love—violet, red, orange
business—violet, red, gold

INDIGO
You are wonderfully at ease with yourself and this makes you a delightful companion and friend. Sometimes you can be too laid back, in which case more red in your life may be called for.
Compatible combinations
love—violet, red, gold
business—violet, red, gold

VIOLET
This is a harmonious combination. Your mind, body, and soul are fully in tune and you have a great deal of joy and calm to share with others.
Compatible combinations
love—violet, red, yellow
business—violet, red, gold

MAGENTA
Yellow and green create lime, which is complementary to magenta, and makes for a good combination. Your emotional issue is self-love and you may have had a childhood experience of a *lack* of love. By releasing this fear, your loving nature will be free to express itself.
Compatible combinations
love—lime, violet, magenta
business—lime, violet, gold

GOLD
With love and compassion you have released all your emotional fears. This gives you the freedom and space you need to concentrate on your spiritual development.
Compatible combinations
love—lime, magenta, violet
business—lime, magenta, gold

You are very adaptable

This combination gives you wide resources of flexibility. With yellow as your sun sign color, you may be in danger of frittering your energies on a multitude of different projects at once. But your destiny color of blue acts as a check to such lack of direction, giving you the peace and calm to be highly adaptable in all that you do.

IF YOUR PERSONAL EXPRESSION COLOR IS:

RED
This is a perfect combination of all three primary colors. So your life will be both stimulating and exciting and very successful, and there will also be times of quiet spiritual contemplation.
Compatible combinations
love —violet, orange, green
business—violet, gold, green

ORANGE
There are many ways of expression, not just the spoken word. Learn to use the power of communication through your creative, artistic abilities, such as art therapy to improve your life and the lives of others.
Compatible combinations
love—violet, orange, blue
business—violet, gold, blue

YELLOW
This combination can make you feel dazed or spaced-out. So you need some rules and boundaries in your life. If you can learn to channel your emotions you will make a great healer.

Compatible combinations
love—violet, orange, violet
business—violet, magenta, gold

GREEN
Too much stability does not allow your progressive nature to move forward. You need more fun and spontaneity to get you moving in new directions.
Compatible combinations
love—violet, orange, red
business—violet, gold, red

BLUE
You use your spiritual energies ceaselessly to make this a better world for others. Your progressive nature is stimulated by your intellect, helping you to move forward in life with aplomb.
Compatible combinations
love—violet, orange, orange
business—violet, orange, gold

INDIGO
You search deeply to find the physical and spiritual connection to life. This involves you in scientific research projects as you search for the evidence to change outmoded attitudes.

Compatible combinations
love—violet, orange, gold
business—violet, orange, gold

VIOLET
Spiritually and intellectually, you are communicating your beliefs to others. It takes courage to do this and gradually you will achieve success in what you are trying to accomplish.
Compatible combinations
love—violet, orange, yellow
business—violet, orange, gold

MAGENTA
As a realist you accept that life is not perfect. Hearing no ill of anyone, you look for the causes behind negative behavior. Your non-judgmental attitude sets an example for others to follow.
Compatible combinations
love—lime, violet, orange
business—lime, violet, gold

GOLD
You welcome others into your life, irrespective of who they are or what they have done. These are the qualities of one who has overcome personal prejudice and is capable of expressing unconditional love.
Compatible combinations
love—violet, orange, indigo
business—lime, indigo, magenta

You are an investigator

You are a philosopher, drawing on the knowledge of the ages to add your own interpretations. This opens your mind to new and exciting revelations. Your search for the truth takes you into the realms of fantasy and imagination as you listen to your intuition.

IF YOUR PERSONAL EXPRESSION COLOR IS:

RED

Too much activity in your life has a detrimental effect on your studies and required periods of introspection. Learn to find more time for yourself.

Compatible combinations
love—violet, gold, green
business—violet, gold, green

ORANGE

You are in love with all the good things in life: music, food, and the arts. With your philosophical tendencies, you can push the boundaries of these interests ever outward.

Compatible combinations
love—violet, gold, blue
business—violet, gold, blue

YELLOW

Your intellect dominates your life. You believe that everything has to be proved, and that nothing happens by chance. This is not compatible with your more philosophical tendencies and leads to tensions and contradictions.

Compatible combinations
love—violet, gold, violet
business—blue, gold, violet

GREEN

The analytical and intuitive aspects of your nature work well together. You have new ways of conveying spiritual truths to people and they respect your honest, open attitude.

Compatible combinations
love—violet, gold, red
business—violet, gold, orange

BLUE

Deep down you have great faith, but it is hard to remain cheerful when others constantly challenge your beliefs. Just stick to your beliefs and the truth will become apparent.

Compatible combinations
love—violet, gold, orange
business—violet, gold, orange

INDIGO

Your intuitive nature is stifled by your constant need for knowledge. You need to introduce more physical activity to stay healthy in mind and body.

Compatible combinations
love—violet, gold, gold
business—violet, orange, orange

VIOLET

This is a harmonious combination as violet and yellow are very compatible. Indigo informs your philosophical nature and all three colors work in favor of your spiritual nourishment.

Compatible combinations
love—violet, gold, yellow
business—violet, gold, gold

MAGENTA

When you apply yourself, you can put your philosophical and analytical talents to work together extremely well.

Compatible combinations
love—lime, violet, gold
business—lime, gold, magenta

GOLD

After many trials and disappointments, you are now nearer to achieving your spiritual goals. Others are also more willing to believe what you say.

Compatible combinations
love—violet, gold, indigo
business—gold, indigo, gold

Your instincts are unnerving

You have an uncanny knack of knowing when things are not right and your accuracy can be unnerving. You do not always act on your intuition, however, and learn to have discretion over your choice of companions. With yellow as your sun sign color and its link to your power to be individual, it is particularly important to protect yourself from negative influences.

Sun sign color **YELLOW**
Destiny color **VIOLET**

IF YOUR PERSONAL EXPRESSION COLOR IS:

RED
This is an intense combination. Your deep spiritual beliefs are continually tested and it is good to have more discretion and to question what you are told before making decisions.
Compatible combinations
love—violet, yellow, green
business—violet, gold, green

ORANGE
You want to be a friend to everyone and welcome all to share your ideas and beliefs. Learn to have more discretion in what you disclose to others to prevent the development of negative feelings.
Compatible combinations
love—violet, yellow, blue
business—violet, gold, blue

YELLOW
It is better to be wise before the event than to make a mistake and suffer the consequences later. Learn to have more patience and to trust in your instincts before making a decision.

Compatible combinations
love—violet, yellow, violet
business—violet, gold, violet

GREEN
You often let your heart rule your head. Let your logical mind into your heart and don't allow your feelings to blind you to the faults of others. You may be the cause of others' jealousy no matter how hard you try not to be.
Compatible combinations
love—violet, yellow, red
business—violet, indigo, magenta

BLUE
Learn to have more discretion. When relying on others, you can be easily deceived by their good intentions. View their offers with more realism and you will not have to pick up the pieces afterward.
Compatible combinations
love—violet, yellow, orange
business—violet, yellow, gold

INDIGO
Your thirst for spiritual

knowledge leads you to explore psychic phenomena. This is where you need to exercise discretion and to be a little less trusting in the assumed goodness of others.
Compatible combinations
love—violet, yellow, gold
business—violet, yellow, orange

VIOLET
Past negative experiences have given you more discretion in your choice of spiritual activities. Separate the real from the unreal and transform your prosaic energies into more spiritual ones.
Compatible combinations
love—violet, gold, yellow
business—violet, gold, yellow

MAGENTA
Be discreet about who you share your innermost thoughts with. Others sometimes take advantage of your gentle, loving nature.
Compatible combinations
love—lime, violet, yellow
business—lime, violet, gold

GOLD
Your compassionate, generous nature allows you to recognize the faults and failings of others, but you have the strength, courage, and discretion to deflect all negative feelings.
Compatible combinations
love—lime, magenta, violet
business—lime, magenta, violet

You need unconditional love

You need to face up to unresolved emotional issues in your life, and to transform them into the higher spiritual energies of love and compassion. Some of your problems may be linked to feelings of disempowerment or past neglect. In dealing with your own problems, you can help others to overcome theirs. Either way, you need unconditional love.

IF YOUR PERSONAL EXPRESSION COLOR IS:

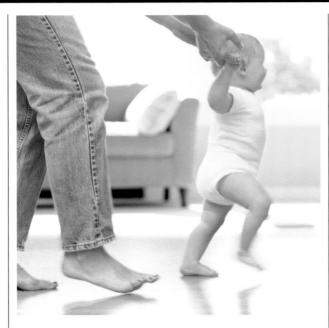

RED
You have experienced intense emotional pain in your past. This needs to be resolved as it is preventing you from leading a full and active life. With the right love and attention, you have a great deal of love to give in return.
Compatible combinations
love—lime, violet, green
business—lime, violet, gold

ORANGE
There has been a pattern in your life of failed relationships and lost loves. But you are an incurable optimist and continue to believe in happy endings.
Compatible combinations
love—lime, violet, blue
business—lime, violet, gold

YELLOW
You are afraid of forming long-lasting relationships for fear of getting hurt. Learn to live for today and to let tomorrow take care of itself. Welcome anyone who comes into your life, and learn from what they can teach you.
Compatible combinations
love—lime, violet, violet
business—lime, gold, violet

GREEN
This is a complementary combination, bringing balance and harmony into your life, and helping you to cope with the loss that change brings.

Compatible combinations
love—lime, violet, magenta
business—lime, violet, magenta

BLUE
You continue to let others use you because you are afraid of saying no. Find the cause of your passive behavior and seek help to resolve it.
Compatible combinations
love—lime, violet, orange
business—lime, violet, gold

INDIGO
Don't put others on a pedestal. Abuse of power is a fact and cannot be denied. Ignoring it doesn't help the

abuser or prevent it from happening again.
Compatible combinations
love—lime, violet, gold
business—lime, violet, gold

VIOLET
You push yourself hard to help others. This is not always appreciated and leaves you drained of emotional energy. Why do you let this continue?
Compatible combinations
love—lime, violet, yellow
business—lime, violet, gold

MAGENTA
Having had first-hand experience of the abuse of power in both your personal and working life, you can now help others release their fears and move on to a better life.
Compatible combinations
love—lime, violet, green
business—lime, violet, gold

GOLD
You understand the qualities of unconditional love and, although it is not easy, seek to live by putting this principle into practice in your daily life.
Compatible combinations
love—lime, magenta, indigo
business—lime, magenta, gold

You can be master of all

Your sun sign color of yellow links to your nervous system and imposes a personal responsibility on you to master and control your emotions. You can be master of all once you have identified the negative aspects of your feelings and released any unresolved emotional issues manifesting in your life. Once in control, you can be as fearless as a lion.

Sun sign color YELLOW

Destiny color GOLD

IF YOUR PERSONAL EXPRESSION COLOR IS:

RED
A magnificent combination. You have drive, talent, wisdom, and vision. Your main weakness may be a tendency to ignore the wishes of others.
Compatible combinations
love—violet, indigo, green
business—violet, gold, green

ORANGE
You have a very happy, joyful nature but are too reliant on others for approval. Learn to be more assertive and less dependent on others by coming to terms with, and releasing, your fears of failure.
Compatible combinations
love—violet, indigo, blue
business—violet, gold, indigo

YELLOW
You are very popular and thrive on praise and admiration. When this is not

forthcoming you become impatient and intolerant of both yourself and others.
Compatible combinations
love—violet, gold, violet
business—violet, gold, violet

GREEN
Nothing will stop you from getting what you want. But holding a gun to someone's head won't help you get it. It is worth remembering that it takes strength to be kind.

Compatible combinations
love—violet, indigo, red
business—lime, indigo, magenta

BLUE
You have great faith and trust. If this gets shaken, however, you can become lazy, apathetic, self-indulgent, and totally irresponsible.
Compatible combinations
love—violet, indigo, orange
business—violet, indigo, gold

INDIGO
You are a reformer seeking to broaden others' minds. If your efforts are not recognized, you may become intolerant, and, instead of empowering them, start interfering in their lives.
Compatible combinations
love—yellow, blue, indigo
business—gold, blue, indigo

VIOLET
With this color combination in your reading you strive for perfection in all you do. This means transmuting your physical nature into more spiritual pursuits.
Compatible combinations
love—violet, indigo, yellow
business—violet, indigo, gold

MAGENTA
You care deeply about others but do not look after yourself. You are difficult to get close to, demand a lot of yourself and others, and can sometimes become a bully, dominating and controlling others to get what you want.
Compatible combinations
love—lime, violet, indigo
business—lime, violet, gold

GOLD
You have very high ideals. When they cannot be realized, you can get very discouraged and disappointed and become selfish and possessive of others and everything around you.
Compatible combinations
love—violet, indigo, indigo
business—lime, magenta, violet

The color lime

Lime is the result of mixing yellow and green so both these colors should be considered in your reading. Lime gives us a marvelous feeling of anticipation. It allows us to be perceptive and non-judgmental, helping us to clear our minds of clutter and negative thoughts. Too much lime and we may become unbalanced, too little and we may feel hateful and envious.

The complementary color to lime is magenta (see page 128) so if you find your chart exhibiting too much purifying lime energy you may want to consider introducing more magenta energy into your life. On the following pages you will find a personalized reading for each three-part combination with lime as the sun sign.

Physical health

Specific parts of the physical body vibrate to the dominant color energies of their associated chakras. Since lime is a combination color of yellow and green, both these colors have an influence on your health. Lime is a cleansing color so it helps clean our body of any accumulated toxins. On the physical level, this relates to food and diet, and toxins of all kinds such as certain drugs, smoking, and alcohol. All these may be very pleasant at the time they are being taken but can cause toxicity later. The color lime affects the liver, kidneys, and colon. It also helps cleanse the bloodstream and the sinuses of allergic reactions.

Emotional health

The color lime makes us feel excited, motivated, and uplifted. It gives us a tremendous feeling of anticipation making us feel ready to take on the world. Too much and we feel sick with excitement and are emotionally unbalanced. Too little and emotions of fear, anger, jealousy, and even hatred will become manifest.

Spiritual health

Lime is a very special spiritual color, because it helps clear away emotional and spiritual toxicity, giving an individual protection from negative influences. It helps us recognize spiritual truths and let go of religious dogmas. The spiritual goal of a lime person should be to raise their physical and emotional energies from the solar plexus and heart chakras into the throat chakra, where they can be purified and expressed through other levels of their being. Once this has been achieved they will be able to operate from a point of unconditional love, working for the highest good for themselves and others.

Relationships

LIME WITH RED If you want this partnership to work you will have to accept that you share some of your partner's negative qualities.

LIME WITH SCARLET This relationship could be a very exciting and challenging one, as you can help one another overcome the darker side of your sexual natures.

LIME WITH ORANGE A good combination. You will encourage, motivate, and support one another to reach for better things.

LIME WITH GOLD Your partner will stand by you and give you all the courage and strength you need. He or she will help you set aside religious dogma and encourage your individuality.

LIME WITH YELLOW This is a risky combination. Your partner may stir up emotions in you of envy and jealousy, which you may have thought were well and truly buried.

LIME WITH LIME This is a potentially difficult relationship and could lead to a great deal of unhappiness.

LIME WITH GREEN Although your partner is very solid and reliable, you will have to work hard to deal with their feelings of envy if you are successful.

LIME WITH TURQUOISE If you work closely with your partner, you will learn from their clarity of thought.

LIME WITH BLUE This relationship will work well. Your partner will support everything you do and you will be very successful.

LIME WITH INDIGO Your partner will teach you to understand and accept the darker aspects of your personality.

LIME WITH VIOLET When you are overwhelmed by lack of confidence and feelings of panic, your partner will encourage and reassure you.

LIME WITH MAGENTA A perfect combination. You will give one another exactly what is needed to maintain a strong and happy relationship.

You need change

Your sun sign color of lime gives you the capacity to clear away unwanted influences in your life to make room for new and vital energies. But you need to learn to accept that the darker side of your nature is also a part of your personality. This acceptance will allow you to let go of your inner fears and to move forward.

IF YOUR PERSONAL EXPRESSION COLOR IS:

RED
"Off with the old and on with the new" is a saying that could be applied to you. Build on the best parts of the old though, and don't discard them completely on the grounds that they are useless to you.
Compatible combinations
love—magenta, green, green
business—magenta, green, gold

ORANGE
You may harbor feelings of guilt about your sexuality. For a well-balanced life, you must pay attention to all your needs and requirements, physical as well as mental and spiritual.
Compatible combinations
love—magenta, green, blue
business—magenta, green, orange

YELLOW
Your awareness of the seasonal fluctuations of the natural world helps you embrace the inevitability of change. This leaves the way open for new and exciting things to happen for you.
Compatible combinations
love—magenta, green, violet
business—magenta, green, yellow

GREEN
It was long in coming but the purpose of your life is gradually unfolding before you. Instead of envying others their success, learn how they have achieved this and, by emulating what you learn, you can be successful, too.
Compatible combinations
love—magenta, green, gold
business—magenta, blue, gold

BLUE
It is noble of you to strive constantly for purity and all that is good, but as you are human and not divine you must stop blaming yourself when you fail.
Compatible combinations
love—magenta, green, orange
business—magenta, green, gold

INDIGO
You are slowly discovering the darker side of your nature. This is something to be welcomed by others, because it confirms that you are human like the rest of us.
Compatible combinations
love—magenta, green, gold
business—magenta, blue, gold

VIOLET
Each time there is a change in your life you can get rid of all your clutter and create a space to absorb new and exciting ideas and concepts.
Compatible combinations
love—magenta, green, yellow
business—magenta, green, orange

MAGENTA
With this combination you need to clear out negative thought patterns of lack of self-love. If they're not cleared, you could become ill.
Compatible combinations
love—magenta, green, green
business—magenta, green, gold

GOLD
Courage and compassion take you forward on your path in life and help you to recognize both the positive and negative sides of yourself and of others.
Compatible combinations
love—magenta, green, indigo
business—magenta, green, magenta

You initiate change

Your destiny color of orange makes you a great initiator. Aware of the dangers of outdated concepts and attitudes, you deal readily with unresolved issues and as a result move forward all the time in your personal development. Visualization techniques can restore health and harmony to your body and to your creative mind.

IF YOUR PERSONAL EXPRESSION COLOR IS:

RED
This is a very strong combination. You give free rein to your passionate nature and enjoy a happy and rewarding sexual life.
Compatible combinations
love—magenta, blue, green
business—magenta, gold, green

ORANGE
Your interest in exercise ensures that you are physically fit. But to attain total health you also need to nurture your spiritual and emotional needs. Discard anything that prevents you from achieving this.
Compatible combinations
love—magenta, blue, blue
business—magenta, blue, gold

YELLOW
Outwardly you are ever the court jester. But inwardly you suffer because of feelings of doubt and uncertainty in yourself. Learn to become less dependent on what others think of you.

Compatible combinations
love—magenta, blue, violet
business—magenta, blue, gold

GREEN
Your insecurity and reserve makes you envy others' spontaneity and happiness. Experience this for yourself by releasing the fears that are holding you back from expressing your wonderful, creative nature.
Compatible combinations
love—magenta, blue, red
business—magenta, gold, red

BLUE
It is very admirable that you will not hear a bad word said about anyone. Malign thoughts can be just as harmful as destructive actions so learn to guard against having any.
Compatible combinations
love—magenta, blue, orange
business—magenta, blue, gold

INDIGO
You are enslaved to the material world, and cannot conceive of a single day spent away from your telephone, television, or automobile. Take some time out to break free from modernity and to find inner peace.
Compatible combinations
love—magenta, blue, gold
business—magenta, green, gold

VIOLET
You know you can create heaven or hell for others. When you create hell it is often because of emotional problems that are dominant in your own life. Learn to see this situation coming and your life will become more heavenly.
Compatible combinations
love—magenta, blue, yellow
business—magenta, blue, gold

MAGENTA
This color combination points to a problem of dependency. You often look to others for approval instead of drawing on your own resources of inner strength.
Compatible combinations
love—magenta, gold, blue
business—magenta, blue, gold

GOLD
Your spiritual development is progressing giving you a deeper awareness of other energetic levels of life.
Compatible combinations
love—magenta, gold, indigo
business—magenta, gold, indigo

You are clear-headed

Sun sign color **LIME**

Destiny color **YELLOW**

This combination makes it unlikely that you will ever suffer from muddled thinking. You cut right to the heart of any problem and can be ruthless in your determination to achieve your goals. But you also have the courage and clear-sightedness to take enormous risks and you always face your adversaries head-on.

IF YOUR PERSONAL EXPRESSION COLOR IS:

RED
It is good that you stand up for what you believe in. But if taken to extremes this attitude can make you aggressive. Find out what is causing this, release it, and learn to be more diplomatic.
Compatible combinations
love—magenta, violet, green
business—magenta, gold, green

ORANGE
You are very individualistic and flamboyant, and others may think of you as being a little eccentric. Continue to lead instead of following the herd and your talents will be recognized.
Compatible combinations
love—magenta, violet, blue
business—magenta, gold, blue

YELLOW
You are very generous and share everything you have with others. This will not stop others from feeling envious of you. Learn to accept envy as being a part of human nature and to deal with similar feelings in yourself.
Compatible combinations
love—magenta, green, blue
business—magenta, gold, blue

GREEN
You are kind, trusting, and generous, and all the qualities of a sound and healthy body, mind, and spirit are to be found in this color combination.
Compatible combinations
love—magenta, violet, red
business—magenta, violet, gold

BLUE
Your spiritual values have changed with your life experiences. By expanding your awareness further you could become a fantastic teacher, guide, or mentor.
Compatible combinations
love—magenta, violet, orange
business—magenta, violet, gold

INDIGO
Some of the rules in your life that you have obeyed without question are no longer of benefit to you. Keep those that still work and discard the ones that do not.
Compatible combinations
love—magenta, violet, gold
business—magenta, violet, gold

VIOLET
All the colors in this combination are working together to change your ideas. Your need for absolute perfection in your life will be resolved when you have discovered the cause for this and eliminated it.
Compatible combinations
love—magenta, violet, yellow
business—magenta, violet, gold

MAGENTA
You have too much going on in your life and are unable to prioritize. Magenta can help you create realities from abstract ideas, but you need to change your thought processes if you want to be successful.
Compatible combinations
love—magenta, violet, green
business—magenta, violet, gold

GOLD
Your loving, wise, compassionate nature makes it possible for new things to come into your life. Welcome and accept them as opportunities and experiences for spiritual growth.
Compatible combinations
love—magenta, violet, indigo
business—magenta, violet, gold

You encourage growth

Your life often moves in stops and starts. One moment it seems exciting, the next it appears dull and uninteresting. But, like a gardener tending to your plants, you learn to clear away the dead wood in your life and to deal with emotional issues that have prevented you from living the life you want to live.

IF YOUR PERSONAL EXPRESSION COLOR IS:

RED
Like a parent at a new birth, you are excited by all the changes that come into your life. As the excitement wears off you tend to settle into a routine. Try to bottle up some of the excitement, or your life may become a little dull.
Compatible combinations
love—magenta, red, green
business—magenta, red, blue

ORANGE
You are prepared to take risks to get what you want. This is fine if you are the only likely loser. It's not so good if others could lose out as well.
Compatible combinations
love—magenta, red, blue
business—magenta, red, gold

YELLOW
You are frightened of nothing and no one. You need to apply such courage of spirit to your emotional life if you are to reach your spiritual goal and release your inner fears.
Compatible combinations
love—magenta, red, violet
business—magenta, indigo, gold

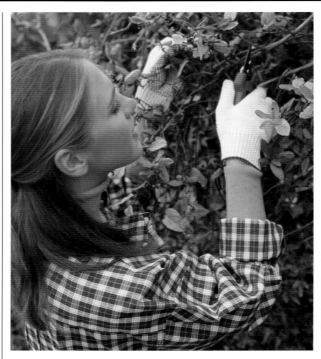

GREEN
Your life is currently ruled by unresolved feelings of anger, jealousy, and insecurity. Do something about this quickly by introducing magenta into your life.
Compatible combinations
love—magenta, indigo, red,
business—magenta, red, gold

BLUE
Thoughts as well as words have enormous power to heal or harm, so combat any negative thoughts as soon as you have them and learn the glorious power of positive thinking.
Compatible combinations
love—magenta, red, orange
business—magenta, red, gold

INDIGO
You are frightened of letting go of old values in case there is nothing to replace them. Rest assured that fresh values and beliefs will fill the space created when you release the old ones.
Compatible combinations
love—magenta, red, gold
business—magenta, red, orange

VIOLET
You love reading and learning about different religions. Separate dogma from real spirituality and you will see that all faiths ultimately embrace the same values of transforming darkness into light.
Compatible combinations
love—magenta, red, yellow
business—magenta, red, gold

MAGENTA
This is a very harmonious combination. Love is said to make the world go around and you have been able to clear out a great deal of emotional clutter in a loving, gentle way and are helping others to do the same.
Compatible combinations
love—magenta, red, green
business—magenta, red, gold

GOLD
By having the courage to face and resolve emotional issues, you have given your spiritual nature more room to develop.
Compatible combinations
love—magenta, red, indigo
business—magenta, red, gold

You have a gentle touch

You are a healer and so well aware of the power of thought and prayer. You believe strongly that thoughts precede and affect the realm of physical matter. In your case, you have only to think something for it to happen. Think of the positive and negative aspects of such a power and you will begin to understand the need to be vigilant.

Sun sign color **LIME**

Destiny color **BLUE**

IF YOUR PERSONAL EXPRESSION COLOR IS:

RED
You express your feelings very strongly. If you want to be a good healer you must learn to be more compassionate toward others and to think before you speak.
Compatible combinations
love—magenta, orange, green
business—magenta, gold, green

ORANGE
This combination will continually help you clear your mind of negative influences. By learning the power of spiritual healing, you can enhance this even more.
Compatible combinations
love—magenta, orange, blue
business—magenta, gold, blue

YELLOW
There is too much routine in your life, which stifles your intellect and actually makes your life more difficult. Try to break the mold and to live your life in a whole new way.
Compatible combinations
love—magenta, orange, violet
business—magenta, magenta, gold

GREEN
Your clear mind and emotional control make you a great communicator. Your skills lie in teaching young children.
Compatible combinations
love—magenta, orange, red
business—magenta, gold, red

BLUE
There is too much blue in this reading, which could leave you feeling tired and wasted. Bring some vibrant orange into your life to unleash the wild, impulsive side to your character.

Compatible combinations
love—magenta, orange, orange
business—magenta, orange, gold

INDIGO
Through relaxation and meditation techniques, you are learning to control the power of thought. These techniques direct your thoughts inward by opening a window to your imagination.
Compatible combinations
love—magenta, orange, gold
business—magenta, orange, gold

VIOLET
If anyone has the willpower to rid themselves of an unhealthy addiction or way of life it is you. However, striving for a pure and healthy mind, although very laudable, is really not very realistic. Learn to live with your dark side.
Compatible combinations
love—magenta, orange, yellow
business—magenta, orange, gold

MAGENTA
A loving thought can work miracles. For proof of this, study the acts of great spiritual teachers. They healed and created great changes through the power of unconditional love. In a small way you can do the same.
Compatible combinations
love—magenta, orange, green
business—magenta, gold, green

GOLD
Healers are taught the importance of emotional and physical cleanliness. This combination will help you to clear any accumulated static energy in your life. As a healer, you could easily become egocentric. This is a trait you need to watch in yourself.
Compatible combinations
love—magenta, orange, indigo,
business—magenta, gold, indigo

You are very modest

Your sun sign color of lime gives you the humor and lightness of touch to handle most of life's vicissitudes with a smile. But with indigo as your destiny color, you are also destined to delve into matters of life and death, and to seek answers to life's deepest mysteries. You are very knowledgable, but you hide your talents behind a veil of modesty.

IF YOUR PERSONAL EXPRESSION COLOR IS:

RED
You have an aura of mystery that attracts others to you. This gives you great power, which if used wrongly can manipulate and destroy, so respect it and use it wisely.
Compatible combinations
love—magenta, gold, green
business—magenta, gold, blue

ORANGE
The dark side of your personality has a purpose in your life. Learn what it is teaching you and work with it, not against it.
Compatible combinations
love—magenta, gold, blue
business—magenta, gold, blue

YELLOW
You understand how all aspects of your personality work together. This allows you to maintain balance and harmony in your life.
Compatible combinations
love—magenta, gold, violet
business—magenta, gold, indigo

GREEN
The in-born teacher in you wants to share all your knowledge with others. Be careful how you do this when dealing with children, since young minds are very impressionable.
Compatible combinations
love—magenta, gold, red
business—magenta, gold, orange

BLUE
You do so much for others. This does not allow you time to examine your innermost thoughts and feelings. If fear about what you might discover is causing this, let it go.

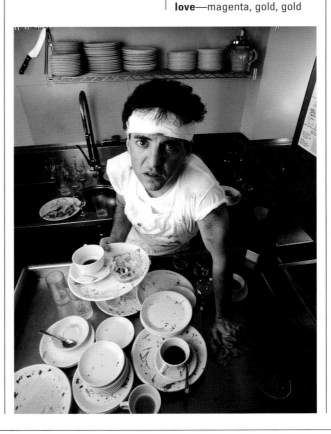

Compatible combinations
love—magenta, gold, orange
business—magenta, gold, red

INDIGO
The inner recesses of the mind hold dark thoughts and secrets. This is part of who you are. The difference between you and many others is that you know how to control your emotions and they do not.
Compatible combinations
love—magenta, gold, gold

business—magenta, gold, gold

VIOLET
Don't underestimate the power of negative working conditions to drain you of your emotional and spiritual health. Learn to look after yourself, and to listen to your inner voice when you are weary.
Compatible combinations
love—magenta, gold, yellow
business—magenta, gold, gold

MAGENTA
You have experienced many losses in your life. This has not been easy but you are now helping others in similar situations to overcome their trauma and grief.
Compatible combinations
love—magenta, violet, gold
business—magenta, gold magenta

GOLD
A very wise soul, you are learning the secrets of the universe and sharing them with wisdom and love to help others.
Compatible combinations
love—magenta, gold, indigo
business—magenta, indigo, gold

You have authority

Sun sign color **LIME**

Destiny color **VIOLET**

In your life you have been drawn to many different spiritual organizations, each with their own set of dogmas and beliefs. You are learning to differentiate between those you want to accept and those you don't, and to discern the basic truths and beliefs that underlie all faiths. Others therefore turn to you for their spiritual guidance.

IF YOUR PERSONAL EXPRESSION COLOR IS:

RED
Your faith is being tested by the intense wants and needs of others. You are drawn to spiritual organizations that work to relieve these wants and needs and may not always be in agreement with their decisions.
Compatible combinations
love—magenta, yellow, green
business—magenta, gold, green

ORANGE
You have no need for the apparent security of religious icons and dogmatic beliefs. Your spiritual sustenance comes from the beauty of nature and the kind thoughts and actions of others.
Compatible combinations
love—magenta, yellow, blue
business—magenta, gold, blue

YELLOW
Having discarded religious dogma, you have a better understanding of what is true and what is false. The intellectual and spiritual aspects of your nature work in harmony for your health and well-being.
Compatible combinations
love—magenta, yellow, violet
business—magenta, gold, violet

GREEN
Residues of past religious beliefs are still very strong in your life, and they hold you back from achieving your full potential. By breaking free you will be able to follow your heart and learn your own inner truths.
Compatible combinations
love—magenta, yellow, red
business—magenta, yellow, magenta

BLUE
You hate conflict and are quite content to live in an environment that controls your life through strict rules and regulations. This gives you few choices in life and if continued will lead to the stagnation of your whole personality.
Compatible combinations
love—magenta, yellow, orange
business—magenta, yellow, gold

INDIGO
Ridding yourself of the religious clutter in your life gives you more choice to explore your spirituality. Learn to accept that so-called premonitions can be a link to your higher consciousness.
Compatible combinations
love—magenta, yellow, gold
business—magenta, yellow, orange

VIOLET
You have experienced many changes in your search for spiritual knowledge. This has given you the opportunity to examine others' beliefs and practices at close quarters, and to build up your own set of beliefs as a result.
Compatible combinations
love—magenta, gold, yellow
business—magenta, red, yellow

MAGENTA
You are drawn to the breathtaking serenity and beauty of nature for your spiritual nourishment. This sustains you in times of need and gives you the strength to help others find inner peace.
Compatible combinations
love—magenta, yellow, green
business—magenta, yellow, gold

GOLD
You are a very loving, compassionate person, with your own unique beliefs and values. Others are drawn to you for spiritual guidance. Do not impose your beliefs on them unless they are ready and willing to accept them.
Compatible combinations
love—magenta, yellow, indigo
business—magenta, gold, indigo

You are nobody's fool

This is a very harmonious combination with both colors complementing each other. Magenta gives you the realism to see behind the masks others wear to hide their inner fears and to confront your own inner demons. You believe in the power of unconditional love, and this belief will continually be tested by your experiences and relationships.

IF YOUR PERSONAL EXPRESSION COLOR IS:

RED
Your principles of unconditional love are tested by the passionate and driven nature of others. Learn self-empowerment and be more assertive about your own needs.
Compatible combinations
love—magenta, green, gold
business—magenta, gold, green

ORANGE
Your deep love and compassion for others is healing your own emotional scars and traumas. Self-empowerment will come from this and make you even stronger.
Compatible combinations
love—magenta, green, blue
business—magenta, green, gold

YELLOW
Your mask of fear is being discarded as you grow in wisdom and understanding.

Learn to be the master of your emotions and take back your personal power.
Compatible combinations
love—magenta, green, violet
business—magenta, gold, violet

GREEN
By detaching yourself from others' emotions you allow them to take personal responsibility for themselves. Learn to love and believe in yourself and you will grow in confidence.
Compatible combinations
love—magenta, green, gold
business—magenta, green, orange

BLUE
You are very sensitive to others' energies and understand both their positive and negative qualities. To protect yourself from negative energies, you need to develop a tough outer shell or you could find yourself feeling exposed and vulnerable.
Compatible combinations
love—magenta, green, orange
business—magenta, green, gold

INDIGO
Most people have done something they regret, and you are no exception. Thoughts and actions, although not deliberate, can cause unhappiness. Learn self-forgiveness and stop punishing yourself.
Compatible combinations
love—magenta, green, gold
business—magenta, blue, gold

VIOLET
Through the deep love and compassion in your heart, you devote your life to serving others. If taken to an extreme, this can actually be harmful. Perhaps you need to find out why you are really doing this.
Compatible combinations
love—magenta, green, yellow
business—magenta, green, gold

MAGENTA
In times of deep emotional trauma your quiet inner strength shines through, bringing comfort and compassion to those in need of emotional support.
Compatible combinations
love—magenta, green, green
business—magenta, green, gold

GOLD
Your inner strength and courage have been earned through many difficult experiences. You radiate love, joy, and hope, and these influence everything you do and everyone you meet.
Compatible combinations
love—magenta, green, red
business— magenta, green, gold

You radiate love

Everything that you have learned since you were born—and possibly even before then—is stored in your unconscious mind. You draw on this in times of need and like great spiritual teachers or saints, you have a pulsating energy within you that can help you overcome all your fears and give you the strength to survive the toughest situations.

IF YOUR PERSONAL EXPRESSION COLOR IS:

RED
This is the combination of a very wise and powerful leader. You are learning to recognize all aspects of your personality, good and bad, and changing them whenever necessary.
Compatible combinations
love—magenta, indigo, green
business—magenta, gold, green

ORANGE
This is a terrific combination. You are vibrant and energetic and always take a fresh, optimistic view of any given situation by mentally cleansing yourself of negative thoughts and repressive emotions.
Compatible combinations
love—magenta, indigo, blue
business—magenta, gold, indigo

YELLOW
You are very successful in all that you do. Once you have learned that there is more to life than money, and that real power resides in gentleness and humility, you will stand to gain even more.
Compatible combinations
love—magenta, indigo, violet
business—magenta, indigo, gold

GREEN
You attach great importance to your personal hygiene. If you also learn to clean out your emotional blockages and accept change as the opening for new opportunities, your life will take on a new focus.
Compatible combinations
love—magenta, indigo, red
business—magenta, indigo, gold

BLUE
Great opportunities are at hand for you to brush any cobwebs out of your mind. Open your eyes to the new truths you are being shown.
Compatible combinations
love—magenta, indigo, orange
business—magenta, indigo, gold

INDIGO
Your emotional fears are of your own making. They are holding you back from exploring your intuitive nature. Release them and you will become happier and more enlightened.
Compatible combinations
love—magenta, indigo, gold

VIOLET
This is a powerful combination that can give you the courage to venture into situations unknown and achieve the seemingly impossible. Use it with care.
Compatible combinations
love—magenta, indigo, yellow
business—magenta, indigo, gold

MAGENTA
Your strength lies in your deep compassion. This shines from you like a light that clears the darkness in the lives of others.
Compatible combinations
love—magenta, indigo, green
business—magenta, indigo, gold

business—magenta, indigo, gold

GOLD
This is such a powerful combination. With your very high ideals you seek constantly to release anything that is harmful to you and others.
Compatible combinations
love—magenta, indigo, indigo
business—magenta, indigo, gold

The color green

Green is the color of nature and renewal. It balances our energies and brings peace and harmony into our lives. You have only to consider the natural world to witness its awesome power: imagine flowers and plants devoid of green. The color of healing and of hope, green can give us stability and direction and awaken greater friendliness and faith—too much of it and our energies slow down and we stand the risk of becoming slow and lethargic.

The complementary color to green is red (see page 18) so if you find your chart exhibiting too much placid green energy you may want to consider introducing more red into your life. On the following pages you will find a personalized reading for each three-part combination with green as the sun sign.

Physical health

The color green influences the heart, lungs, breast, and immune and circulatory systems. It is associated with the thymus and the lymph glands, and is the dominant color of the heart chakra. It also cools the blood, lowers blood pressure, and animates the nerves. As it balances and harmonizes all body systems, it can be used where other colors cannot.

Emotional health

Green links to the heart chakra and your emotions. A good balance of green in your color chart makes you feel content and satisfied with life. It fills you with optimism and confidence. An excess of green in your chart can make you overdemanding, critical, jealous, moody, and depressed. A shortage of green energy can cause you to become apathetic and fearful of rejection.

Spiritual health

Greens sustain a strong faith in the notion of a mysterious, inexplicable force guiding all of nature. As a green, you never fail to wonder at the power and beauty of the natural world and delight in even the tiniest flower. Your intuitive and artistic powers are at their height in the spring because of the intimate connection you feel to new life. Green is the color of the heart chakra, the central chakra within the seven-fold system. It mediates between the worlds of spirit and matter. The spiritual goal of the green person should be to raise their physical and emotional energies from the solar plexus and heart chakras and transform emotions of fear into pure divine love expressed through the throat chakra.

Relationships

GREEN WITH RED This partnership will work well if you are prepared to become more active and motivated.

GREEN WITH SCARLET You will have to learn to accept your partner's demanding and excitable nature for this relationship to work.

GREEN WITH ORANGE If you can deal with the challenges of your partner's self-indulgent and flamboyant nature this twosome will work.

GREEN WITH GOLD Your partner will understand and respect your need for harmony and stability and gently encourage you to try new things.

GREEN WITH YELLOW With both of you having a young, fresh approach to life, your days will be full of new ideas and excitement.

GREEN WITH LIME This may be just what you need. Your partner will stir things up and get you to face your buried emotions.

GREEN WITH GREEN Although this relationship will work because you are so alike, you will both find it difficult to maintain a routine and ordered existence.

GREEN WITH TURQUOISE Your partner will free you of your illusions and help you to see what others are not willing to tell you.

GREEN WITH BLUE This relationship will work well. It will be a stable and lasting partnership built on firm foundations.

GREEN WITH INDIGO You work well together. There will be a deep understanding between you and you will learn a lot from each other.

GREEN WITH VIOLET You will have to make some sacrifices and overcome your instinctive fear of change for this combination to work.

GREEN WITH MAGENTA This will be a loving, caring relationship You will constantly be learning to take on new ideas and put them into practice.

You have great emotional stability

Sun sign color **GREEN**
Destiny color **RED**

This is a good combination, with each color in perfect harmony with the other. Your coolness and calm are matched by a warm, loving nature. Your love of the natural world and your respect for the delicate balances that govern it mean that you are deeply interested in issues of conservation, and are likely to fall into this line of work.

IF YOUR PERSONAL EXPRESSION COLOR IS:

RED
Life is not easy for you. In spite of your day-to-day emotional calm, you often struggle to control your deeper need for security. Find ways of releasing your pent-up anxieties: take up a sport or an exciting hobby.
Compatible combinations
love—lime, magenta, green
business—lime, magenta, gold

ORANGE
You bring peace and harmony from pain and despair. But keeping a cheerful face can sometimes be an emotional strain for you. Relax and look after yourself more.
Compatible combinations
love—turquoise, red, gold
business—turquoise, red, gold

YELLOW
You have a wonderful ability to make others feel safe and secure. Try to let go a little and let others do the same for you for a change.
Compatible combinations
love—red, green, violet
business—red, green, gold

GREEN
There is too much day-to-day routine in your life, which suppresses your sunny personality. Use your love of gardening and the natural world to find outlets for your pent-up feelings.
Compatible combinations
love—lime, magenta, gold
business—red, green, gold

BLUE
You have a strong sense of justice and often get angry if the world doesn't live up to your high expectations. Learn to let go and forgive a little. Nobody's perfect.
Compatible combinations
love—red, green, orange
business—red, green, gold

INDIGO
You are outwardly calm but can also be fickle and capricious. You unknowingly leave a trail of broken hearts and promises behind you wherever you go. Step back sometimes and try to think before you act.
Compatible combinations
love—red, green, gold
business—red, green, gold

VIOLET
You are very much in touch with your emotions but sometimes find it difficult to relax and live with life's uncertainties. Try and trust that everything around you is working to a purpose.
Compatible combinations
love—red, green, yellow
business—red, green, gold

MAGENTA
Your sense of insecurity comes from an overwhelming need to know without a doubt that you are loved for yourself and not for your possessions. Learn to believe in yourself more.
Compatible combinations
love—lime, red, green
business—lime, red, gold

GOLD
Like the forces of the natural world, you are very strong and powerful. Learn to harness this power and transform it into the unconditional love of yourself and of others.
Compatible combinations
love—red, green, indigo
business—red, green, gold

Sun sign color GREEN

Destiny color ORANGE

You have the innocence of a child

Your nature is a warm, happy combination of attributes. Feelings of joy and optimism radiate from you. Your sense of wonderment at the world around you is like the innocence of a child. You have inborn creative abilities, but do not seek acclaim or reassurance from others. Make sure that your open nature is not taken advantage of.

IF YOUR PERSONAL EXPRESSION COLOR IS:

RED
The way you live your life is reflected in the enjoyment and fun you create for others. You hate to see anything wasted, and recycle anything you can. Others may mistake this for miserliness.
Compatible combinations
love—turquoise, red, gold
business—green, scarlet, yellow

ORANGE
You are deeply creative and have oodles of initiative. With your instinctive awareness of color and design, and your love of nature, any gardens you attempted to design would be truly magnificent.
Compatible combinations
love—red, blue, blue
business—red, blue, gold

YELLOW
Listening to pessimists about the state of the world is not for you. Both your optimism and joy in the power of nature to renew itself overcome any fears of the world you may have.
Compatible combinations
love—red, blue, violet
business—red, blue, gold

GREEN
You are one of life's nurturers and would work very well with children or in horticulture. But your lack of confidence often holds you back. Don't be afraid to go out and grab life by the horns.
Compatible combinations
love—red, blue, red
business—red, gold, red

BLUE
You have an instinctive love of both nature and the arts and have a vast well of inspiration to draw on. You can raise others' awareness of how they can make the world a better place.
Compatible combinations
love—red, blue, orange
business—red, blue, gold

INDIGO
You love reading and are fascinated by the history and arts of ancient civilizations. By combining this knowledge with your love of nature, you can help raise other people's consciousness of the beauty in their own lives.

Compatible combinations
love—red, blue, gold
business—red, blue, gold

VIOLET
This combination of colors gives you the emotional and spiritual serenity to make this a beautiful world for others to live in. And you are yourself continually open to spiritual learning and growth.
Compatible combinations
love—red, blue, yellow
business—red, blue, gold

MAGENTA
You want to protect all living things and get upset at the merest hint of wanton destruction. You have a great affinity with nature and would make an excellent healer of animals and plants.
Compatible combinations
love—lime, red, blue
business—lime, blue, gold

GOLD
You are the gentlest of people. All natural things thrive in your care, especially plants and animals. But woe betide anyone who mistakes your compassion for weakness.
Compatible combinations
love—red, blue, indigo
business—red, gold, indigo

YOUR THREE ESSENTIAL COLORS

You excel in new initiatives

With this color combination you are aware of the need to be diplomatic when trying to convince others of your ideas. Your intellect and experience also give you the wisdom to recognize that life and death are simply part of the natural cycle of things. This gives you the courage to follow your heart and go where others fear to tread.

IF YOUR PERSONAL EXPRESSION COLOR IS:

RED
Your forceful nature often compels others to accept your ideas. You can achieve a great deal more by making sure you know what you are talking about and getting your message over firmly but quietly.
Compatible combinations
love—red, violet, green
business—red, gold, green

ORANGE
Your concern for the well-being of the planet is very commendable. Don't let others frighten you into giving up on this very worthwhile cause. By overcoming your fears you can help others overcome theirs.

YELLOW
Your financial success and material possessions generate feelings of envy and jealousy in others. You can't stop others feeling jealous but you can channel all your quick wit and energy into a worthwhile cause.
Compatible combinations
love—red, violet, violet
business—red, gold, violet

GREEN
Don't let emotional fears get in the way of your success. By learning to keep a cool head, you can say what you want with courage and conviction.
Compatible combinations
love—red, violet, red
business—red, violet, gold

BLUE
You can see that the world around you is governed by natural rhythms and seasons. Try to apply this wisdom to your personal life and to learn to accept that there are certain things that you simply cannot change.
Compatible combinations
love—red, violet, orange
business—red, violet, gold

INDIGO
Your life is very full and exciting. It is also confusing, because it seems that, as soon as you take on one project something else more exciting comes up to replace it. Learn to pace yourself a little and go with the flow.
Compatible combinations
love—green, magenta, gold
business—red, violet, gold

VIOLET
You are deeply idealistic and sometimes feel as though you are getting nowhere when trying to get your thoughts and ideas across to others. Don't be discouraged; have faith in what you believe in and you will succeed.
Compatible combinations
love—red, violet, yellow
business—red, violet, gold

MAGENTA
You are a natural leader. With green and yellow making lime, the complementary color to magenta, this is a very harmonious combination. You can improve conditions in poverty-stricken areas around the world.
Compatible combinations
love—lime, red, violet
business—lime, violet, gold

GOLD
Your have the wisdom and self-discipline to make a real difference to anything you set your mind to. But try not to let others take advantage of your caring nature.
Compatible combinations
love—red, violet, indigo
business—red, violet, gold

You are a loner

With this double dose of green in your reading, don't be surprised if your life sometimes grinds to a halt. You dislike change of any kind, and your fears of abandonment can make you cling to what is familiar. You need to learn to take more risks and to challenge your fears. Remember, you can only control yourself, not others.

IF YOUR PERSONAL EXPRESSION COLOR IS:

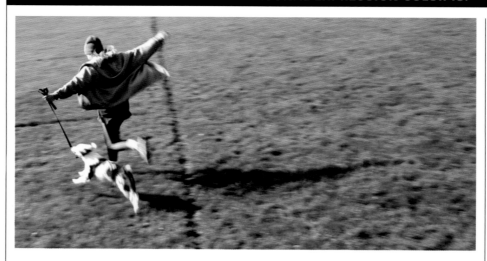

RED
Your perfectionist traits often drive everyone else mad. Learn to be a bit more understanding of others' needs and to give praise where praise is due.
Compatible combinations
love—lime, magenta, gold
business—lime, magenta, gold

ORANGE
You have an exceptionally good eye for detail and are happiest in ordered environments. But you need to break out a little more if you are to tap into your considerable creative talent.
Compatible combinations
love—red, red, blue
business—red, gold, blue

YELLOW
Like the flowers and plants of the natural world, you have it in you to grow and blossom. Learn to overcome your fear of change and to let your life move forward.
Compatible combinations
love—red, red, violet
business—red, gold, violet

GREEN
You frequently fail to live up to the expectations you set yourself, and often feel that something is holding you back. You need to introduce yellow and magenta into your life as a matter of urgency to kick-start your dreams and move on.
Compatible combinations
love—lime, magenta, yellow
business—lime, magenta, gold

BLUE
Many of the great leaders of history were loners too. But sometimes you need to force yourself out of your shell and make contact with the human race. The world isn't half as frightening as you think it is.
Compatible combinations
love—red, yellow, orange
business—red, gold, orange

INDIGO
You are a sensitive, warm-hearted soul, but struggle constantly with deep feelings of insecurity. Bring some vibrant, reckless red into your life to redress the balance.
Compatible combinations
love—red, red, gold
business—lime, magenta, gold

VIOLET
In spite of your tendency to cling to the past—and to old friends and lovers—you are aware that change is inevitable and work all the time to take yourself out of any self-imposed confinement.
Compatible combinations
love—red, red, yellow
business—red, red, gold

MAGENTA
You are deeply creative and hard-working but your low self-esteem prevents you from achieving your true potential. By building up your self-confidence you can take on the world and win.
Compatible combinations
love—lime, red, red
business—lime, red, gold

GOLD
The world would be a much poorer place without your wise, compassionate take on life. You also excel at turning ideas into reality. But you need to keep a check on your conservative tendencies as they could stifle your best creative efforts.
Compatible combinations
love—lime, magenta, indigo
business—lime, magenta, gold

YOUR THREE ESSENTIAL COLORS

You are very flexible

Sun sign color **GREEN**

Destiny color **BLUE**

This combination of colors creates turquoise, which helps you to trust your gut instincts. You are a healer and would do well in the field of natural therapy. Because you are very flexible, you can fit in anywhere. This is both a strength and a weakness as you can sometimes be blown off course.

IF YOUR PERSONAL EXPRESSION COLOR IS:

RED
You are confident, energetic, and adaptable. But you need to temper your energies if you are to empower those less fortunate than yourself and teach them the power of positive thinking.
Compatible combinations
love—red, orange, green
business—red, gold, green

ORANGE
Your ideals mean a great deal to you, but you have also learned to be a little dispassionate about the causes dearest to you. This is fine as long as it isn't an excuse to stand back and do nothing.
Compatible combinations
love—red, orange, blue
business—red, gold, blue

YELLOW
You are very kind and caring, but often let your heart rule your head. This makes you mistrust the intentions of others. Learn to cool down and let your sharp logic and intellect guide your actions.
Compatible combinations
love—red, orange, violet
business—lime, magenta, gold

GREEN
You are deeply protective, especially of those less fortunate than yourself, and often speak out on their behalf. Let them fight their own battles for a change by teaching them what you know.
Compatible combinations
love—red, orange, red
business—red, gold, red

BLUE
You work tirelessly to improve the lives of others through your acquisition of knowledge. But academic learning isn't all there is to life. Learn to trust in the powers of your intuition and you will be amazed at what you can achieve.
Compatible combinations
love—red, orange, orange
business—red, orange, gold

INDIGO
Stubborn and willful, you want the best for everyone and believe you know exactly what that is. Being very knowledgeable can help, but only if you use all that experience and intelligence to help others make their own decisions.
Compatible combinations
love—red, orange, gold
business—red, orange, gold

VIOLET
Beneath that stern, forbidding exterior of yours lies a heart of pure gold. Learn to let your guard down and you will become more approachable and much happier with it.
Compatible combinations
love—red, orange, yellow
business—red, orange, gold

MAGENTA
You are always keen to nurture and sustain, not just with empathy and compassion, but by teaching people how to have faith in their own talents and abilities.

Compatible combinations
love—red, orange, green
business—red, gold, green

GOLD
A wonderful combination. You are hugely approachable and have just the right combination of confidence and wisdom to help others take charge of their own lives and make the most of their talents.
Compatible combinations
love—red, orange, indigo,
business—red, gold, indigo

You inspire children

Although you are essentially shy and retiring, your true skills lie in the teaching and education of young children. You need to overcome the temptation to withdraw when the headlong rush of people and events gets to be too much for you, and to enthuse the world with your unorthodox teaching methods and wonderful way with young people.

IF YOUR PERSONAL EXPRESSION COLOR IS:

RED
Your are blessed with leadership skills and can use them to empower young people. But remember to respect young minds, because *they* have a great deal to teach *you*.
Compatible combinations
love—red, gold, green
business—green, indigo, red

ORANGE
Children love to express their creativity. Give them encouragement instead of simply being critical and you stand to bring out the very best in them. Not only will their life become richer but so will yours.
Compatible combinations
love—red, gold, blue
business—red, yellow, red

YELLOW
Intellectually you have a great understanding of life. Find new and exciting ways to convey your knowledge to children and young people. Be more confident and others will want to be with you and learn from your example.
Compatible combinations
love—red, gold, violet
business—red, gold, blue

GREEN
You are a natural teacher of life. Adults understand this more easily than children, because they can match their own experiences to what you try to convey. Learn how to use this natural talent with children and young people.
Compatible combinations
love—red, gold, red
business—red, gold, orange

BLUE
All of the work you do builds the future. If you continue to compromise your beliefs for the sake of established order and routine, this will empower those in authority and disempower others.
Compatible combinations
love—red, gold, yellow
business—red, gold, orange

INDIGO
You are stuck in a routine and ordered existence, and need desperately to break free. Use your child's heart and free-wheeling imagination to bring some excitement into your life.
Compatible combinations
love—red, red, yellow
business—red, gold, gold

VIOLET
Children need spiritual guidance too. By helping them to understand the beauty and wonder of nature, you can ignite the spark of their spiritual life and help them see the world in even richer colors.
Compatible combinations
love—red, gold, yellow
business—red, gold, gold

MAGENTA
Children learn what they live. Your encouragement, praise, fairness, and respect teach them acceptance of themselves and others and give them more control over what is happening in their lives.
Compatible combinations
love—red, violet, gold
business—red, gold, magenta

GOLD
You are very kind, compassionate, and caring. You are also very wise. As a parent or carer of children, you learn to nurture them and allow them freedom to make their own choices.
Compatible combinations
love—red, gold, indigo
business—red, indigo, gold

You are a conformist

You overflow with ideas and initiative, but your inner fears often steer you toward a life of respectability and material security. But with violet as your destiny color, you are aware that it is time to fight for, and speak out about, the things you believe in. Deep down you know that real security has little to do with secluded working environments.

IF YOUR PERSONAL EXPRESSION COLOR IS:

RED
Although your first instincts are to curl up and hide at the merest whiff of change, you are also pulled time and again to challenging and dangerous situations. Remember, what doesn't kill you makes you stronger.
Compatible combinations
love—red, yellow, green
business—red, gold, green

ORANGE
Your are a strange mixture of the arch-conservative and fire-eating radical. Both a realist and an idealist, you often veer between extremes and need to bring the calming colors of blue and gold into your life to prevent things from running out of control.
Compatible combinations
love—red, yellow, blue
business—red, gold, blue

YELLOW
This is a happy balance of colors. The intellectual, emotional, and spiritual aspects of your nature work very well to create for you a balanced and healthy lifestyle.
Compatible combinations
love—red, yellow, violet
business—red, gold, violet

GREEN
You care deeply about others but find it difficult to overcome your shyness for long enough to express your feelings. But you also have the spiritual strength and inner resources to fight this tendency in yourself and to discover the emotions that cause it.
Compatible combinations
love—red, yellow, red
business—red, yellow, magenta

BLUE
You are a very private person and tend to shut people out. How can you expect to get close to others if you don't drop your guard sometimes and admit you need their help and attention?
Compatible combinations
love—red, yellow, orange
business—red, yellow, gold

INDIGO
Your emotional urges are in danger of swamping the rich potential of your spiritual life. Don't despair when things don't go your way, and learn to trust your inner strengths.

Compatible combinations
love—red, yellow, gold
business—red, yellow, gold

VIOLET
You would make a good public speaker and are given ample opportunity to convey your knowledge to others. But you are inhibited by your strong perfectionist traits. Accept that you don't have all the answers, and life will become so much easier.
Compatible combinations
love—red, gold, yellow
business—red, gold, blue

MAGENTA
You survive in bleaker conditions than most because you can push all physical and emotional indulgences aside in favor of a sustaining spiritual strength.
Compatible combinations
love—lime, red, yellow
business—lime, red, gold

GOLD
Your conformist tendencies are more than offset by your profound understanding of the human condition. Wise and compassionate, you are an innovator when it comes to the ways of the human heart.
Compatible combinations
love—red, yellow, indigo
business—red, gold, indigo

Sun sign color **GREEN**

Destiny color **MAGENTA**

You are a trail blazer

The power of your destiny color links to your spiritual well-being. You believe in the deep, mystical unity of all things, great and small, and your interests reach beyond your immediate physical environment to encompass not just this planet but the cosmos as a whole. Others may ridicule your views but inside you know that you are a true visionary.

IF YOUR PERSONAL EXPRESSION COLOR IS:

RED
You like to get your own way and stubbornly refuse to accept new ideas. Don't reject new ideas or colleagues. Think what you could learn from the knowledge that others are willing to share with you.
Compatible combinations
love—green, yellow, gold
business—lime, gold, green

ORANGE
You are a little devil—a veritable laugh a minute—and play outrageous pranks simply to generate mirth and happiness around you. If you want to be taken more seriously, think before you act, and consider the image that you create.
Compatible combinations
love—green, yellow, blue
business—lime, gold, blue

YELLOW
Your keen intellect is more than matched by your powers of perception. Given your leadership qualities, you could probably solve all the world's problems at one time.

Compatible combinations
love—green, yellow, violet
business—lime, gold, violet

GREEN
You know what is right for you. Learn to listen to your body more by tuning in to its changing energies, and prevent discord before it happens. The same applies to day-to-day situations. Try to anticipate difficulties and work to avoid them.
Compatible combinations
love—green, yellow, red
business—lime, red, gold

BLUE
You value truth and beauty over the baser aspects of life. But it is often difficult for you to communicate such meaning to others. This can lead to feelings of loneliness and isolation on your part. Try to balance your insight with laughter and humor.
Compatible combinations
love—green, yellow, orange
business—lime, gold, orange

INDIGO
You tend to channel your powerful imagination into the acquisition of knowledge. This can be rewarding, but you need to find your own sources of inner strength.

Compatible combinations
love—green, yellow, gold
business—green, orange, yellow

VIOLET
Your life is a constant whirlwind of social engagements, and you are always eager to meet everyone's needs. By becoming more attuned to the natural world, you may find an even richer source of inner peace and happiness.
Compatible combinations
love—green, yellow, yellow
business—green, yellow, gold

MAGENTA
You are an ocean of calm. People often turn to you in distressing situations

because of your quiet strength and air of magesterial authority. But sometimes you need to just let go and live a little.
Compatible combinations
love—green, yellow, gold
business—green, yellow, gold

GOLD
You are undeterred by small upsets and define your whole life in terms of a long journey of learning. Others are drawn to you because of your in born wisdom and compassion.
Compatible combinations
love—red, red, orange
business—green, gold, indigo

YOUR THREE ESSENTIAL COLORS

Your goal is self-empowerment

With this combination of green and gold in your reading, you are blessed with practicality and compassion. With the right motivation, you are capable of moving mountains, but you are sometimes held back by your deep fears and anxieties. You need to conquer your fears and venture all the time into new horizons and experiences.

IF YOUR PERSONAL EXPRESSION COLOR IS:

RED
A winning combination of colors. You are capable of achieving great things, not just for yourself but for others as well. But you need to overcome any lingering feelings of low self-worth before you can do this.
Compatible combinations
love—red, indigo, green
business—red, gold, green

ORANGE
You are deeply spiritual. With your instinctive love of music and the arts and your glorious compassion, you have the tools at hand to enrich your spiritual life even more.
Compatible combinations
love—red, indigo, blue
business—red, gold, indigo

YELLOW
Beneath your timid manner is an extremely clever mind and very high standards. Let your intellect help you overcome the odds against you and you will become truly unstoppable.
Compatible combinations
love—red, indigo, violet
business—red, indigo, gold

GREEN
You are very kind and caring but live in constant fear of

rejection. Bring some vibrant red into your life to help diffuse those anxieties. Let others see what a wonderful person you are.
Compatible combinations
love—red, indigo, red
business—red, indigo, gold

BLUE
You strive for balance in all areas of your life. You recognize the strengths of others and this helps you value and improve your own skills and inner resources.
Compatible combinations
love—red, indigo, orange
business—red, indigo, gold

INDIGO
You are gracious, considerate, and immensely practical. With the knowledge you have culled from your vast knowledge of human experience, you stand only to improve your own life and the lives of others.
Compatible combinations
love—red, indigo, gold
business—green, magenta, gold

VIOLET
Your qualities of balanced judgment make you an excellent thinker. Others turn to you all the time to diffuse potential disputes. But peace

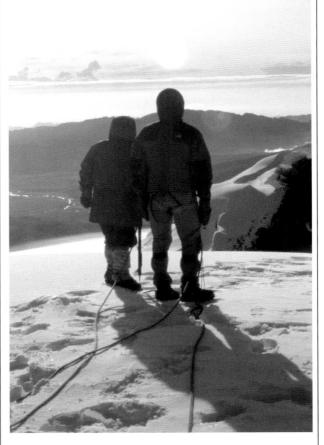

at any price is not always the wisest course of action.
Compatible combinations
love—red, indigo, yellow
business—red, red, yellow

MAGENTA
You appear reserved, but your emotional responses are intensely acute. Don't stand on the sidelines. Learn to follow the deep, dark twists of your heart.

Compatible combinations
love—red, indigo, green
business—red, indigo, gold

GOLD
A wonderful blend of colors. You are warm and gracious and few people are able to do without your remarkable kindness and wisdom.
Compatible combinations
love—red, indigo, indigo
business—red, indigo, gold

The color turquoise

Turquoise lies between blue and green on the color wheel and is considered to be the gateway to our spiritual consciousness. It is a very relaxing color, giving us clarity of thought and promoting our intuition. Native Americans believe strongly in its protective power and use turquoise stone in their jewelry. Too much turquoise and we become over-analytical, fussy, and egocentric. Too little, and we become secretive and possibly even paranoid.

The complementary color to turquoise is scarlet (see page 28) so if you find your chart exhibiting too much other-wordly turquoise energy you may want to consider introducing more scarlet into your life. On the following pages you will find a personalized reading for each three-part combination with turquoise as the sun sign.

Physical health

Turquoise is a very cooling color and helps with any inflammatory conditions, reduces temperatures, and lowers blood pressure. It helps to boost the immune system, especially against viral or bacterial infections and stress-related disorders. Lying between the heart and the throat chakras, it has an influence on both. So chest problems, breathing difficulties, and asthmatic conditions can all be helped. It also influences the testes, spleen, kidneys, and lymphatic system.

Emotional health

A good balance of turquoise will help you feel calm, peaceful, and relaxed but with a clear head and in charge of your emotions. Too much turquoise and your mind will be overactive and will tend to rule your life. Too little and you will be secretive and confused about your direction in life, and may suffer from paranoia.

Spiritual health

Turquoise marks the gateway to your spiritual aspect, and the beginning of your quest for your spiritual being. As you begin your search, the spiritual energy is like a spark that begins to grow throughout your life into your own inner light, until you reach your goal of spiritual illumination. When you reach this stage in your development, you will have transformed your lower chakra energies into your higher spiritual energies and will live through your spiritual consciousness.

Relationships

TURQUOISE WITH RED Your partner will keep you firmly grounded and you will not be able to indulge your secret nature.

TURQUOISE WITH SCARLET This will be a very compatible relationship, as you complement each other perfectly.

TURQUOISE WITH ORANGE Your partner will bring joy into your life and help you to speak up for yourself.

TURQUOISE WITH GOLD Just what you need. A warm, compassionate, loving partner with great wisdom and understanding.

TURQUOISE WITH YELLOW Your partner will stimulate your intellect and spirituality. This will bring new direction into your life.

TURQUOISE WITH LIME You both think clearly. For this to work you will have to accept that both of you are capable of making decisions.

TURQUOISE WITH GREEN You have your own way of doing things. This will work only as long as your partner accepts this and doesn't change your routine.

TURQUOISE WITH TURQUOISE With both of you up in the air, this will work only if you can find a way to keep your feet more on the ground.

TURQUOISE WITH BLUE As long as you don't get too lost in your own world, this will work, because you will care about one another's needs.

TURQUOISE WITH INDIGO You will have to work hard at this. Neither of you finds it easy to get close to the other.

TURQUOISE WITH VIOLET You are both interested in the same things. You will help and encourage one another's spiritual development.

TURQUOISE WITH MAGENTA Your partner will be willing to accept everything about you, including your faults and failings.

You are thick-skinned

Sun sign color **TURQUOISE**

Destiny color **RED**

You are stubborn and hate being pushed into doing something you do not want to do. You are also quite guarded and do not allow others to get close to you. This may be part of the reason why you are so resilient, but with red as your destiny color, you will be drawn ever more into the limelight and into becoming more involved with others' lives.

IF YOUR PERSONAL EXPRESSION COLOR IS:

RED
You often feel forced to do things against your will. Instead of doing the usual thing of suppressing your feelings, learn to be more assertive so that you can create win-win outcomes for all concerned.
Compatible combinations
love—red, orange, green
business—red, orange, gold

ORANGE
A perfect combination. All aspects of your life are in perfect harmony. You will be successful in whatever you do.
Compatible combinations
love—scarlet, green, blue
business—scarlet, green, gold

YELLOW
The power of those aspects of your nature governed by intellect and physical desire are gradually being subdued by the development of your spiritual nature.
Compatible combinations
love—scarlet, green, violet
business—scarlet, green, gold

GREEN
You are afraid of getting hurt and protect yourself by withdrawing from difficult situations. Others interpret this as secrecy and mistrust your intentions.
Compatible combinations
love—scarlet, green, red
business—scarlet, green, gold

BLUE
You find yourself pulled in two directions. Your spiritual nature has not developed enough for you to deny your physical desires. Learn to value all aspects of your personality.
Compatible combinations
love—scarlet, green, orange
business—scarlet, green, gold

INDIGO
You have become much more aware of your spiritual needs. This makes you more introverted and your life is out of balance. Try to incorporate your spiritual values into your social life.
Compatible combinations
love—scarlet, green, gold
business—scarlet, blue, gold

VIOLET
If there is a god, why are there so many disasters? This is the question you want answers to. You may find the answer by helping others recover from the pain of separation and death.
Compatible combinations
love—scarlet, green, yellow
business—scarlet, green, gold

MAGENTA
Your cool head hides inner frustrations. Learn to rise above destructive gossip and petty squabbles by recognizing the spark of spirituality in all things.
Compatible combinations
love—scarlet, green, yellow
business—scarlet, green, gold

GOLD
You hide your thoughts and feelings behind your legendary thick skin. This is being gently challenged, so stop being defensive and let others get closer to you.
Compatible combinations
love—scarlet, green, indigo
business—scarlet, green, gold

Sun sign color **TURQUOISE**

Destiny color **ORANGE**

You are clairvoyant

This combination awards you a profound awareness of your spiritual side. You are blessed with the gift of clairvoyance and are able to help others through the messages you receive. You learn to accept your psychic gifts and, through meditation and visualization, develop the higher aspects of your personality into a strong spiritual consciousness.

IF YOUR PERSONAL EXPRESSION COLOR IS:

RED
A perfect combination. All aspects of your life are in harmony with each other, working together for your spiritual development.
Compatible combinations
love—scarlet, blue, green
business—scarlet, blue, gold

ORANGE
You are in danger of being egocentric at times. Learn to transmute the energies of your sacral chakra to your throat chakra to raise your spiritual awareness and increase your powers of self-expression.
Compatible combinations
love—red, orange, blue
business—red, orange, gold

YELLOW
You are making a living out of your mediumistic abilities. This is not very reliable and could be taken from you at any time. Change your psychic values to spiritual ones and you can still earn a living.
Compatible combinations
love—scarlet, blue, violet
business—scarlet, blue, gold

GREEN
Don't let others' jealousy restrict your life. It is easy for you to continue doing what you have always done, but this will not change your spiritual values.
Compatible combinations
love—scarlet, blue, red
business—scarlet, blue, gold

BLUE
Through meditation and visualization you get in touch with the spiritual side of your personality. Your imagination is the tool you have been given to access altered states of consciousness.
Compatible combinations
love—scarlet, blue, orange
business—scarlet, blue, gold

INDIGO
You have pondered life's mysteries since childhood. Now, with time to yourself, and your ability to see things more clearly, you are able to access your spiritual consciousness, which is having a profound effect on your life.

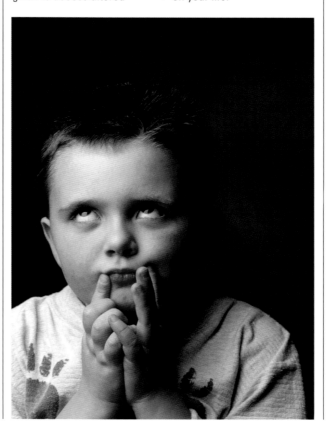

Compatible combinations
love—scarlet, blue, gold
business—scarlet, blue, gold

VIOLET
You have a great understanding of the spiritual side of life. This is expressed through your creativity and inspires others in their spiritual search.
Compatible combinations
love—scarlet, blue, yellow
business—scarlet, blue, gold

MAGENTA
Through your own experiences, you believe strongly in the survival of the soul after death. This spiritual knowledge helps others face their fear of death.
Compatible combinations
love—scarlet, green, yellow
business—scarlet, green, gold

GOLD
You make contact with your spiritual consciousness, which raises your awareness of the beauty and wonderful creations within the higher planes of life.
Compatible combinations
love—scarlet, blue, indigo
business—scarlet, gold, indigo

YOUR THREE ESSENTIAL COLORS

You are motivated

Sun sign color **TURQUOISE**

Destiny color **YELLOW**

This is a wonderfully uplifting combination. You know what you want and where you are going and are motivated to enjoy life in whatever way you can. Intellectually, you are very strong. Emotionally, you are like the sea as you are by turns calm and stormy. You normally accept what others say, but when you do disagree, you can be very stubborn.

IF YOUR PERSONAL EXPRESSION COLOR IS:

RED
You will do anything rather than admit you have made a mistake. Being aggressive does not help the situation: it only makes it worse. It is human to make mistakes and divine to admit to them.
Compatible combinations
love—scarlet, violet, green
business—scarlet, gold, green

ORANGE
You have worked out a way to overcome your embarrassment. You do this through humor by ridiculing yourself, which saves others from having to do it for you.
Compatible combinations
love—scarlet, violet, blue
business—scarlet, gold, blue

YELLOW
It's all right to make one or even two mistakes as long as you learn from them. When you go on repeating them, the situation gets out of hand and you need to introduce some violet to rebalance your life.
Compatible combinations
love—scarlet, violet, violet
business—scarlet, gold, violet

GREEN
You are learning to control your tendency to have mood swings. You have much more clarity about where you are going and what you will do to create a happy and successful life.
Compatible combinations
love—scarlet, violet, red
business—scarlet, violet, gold

BLUE
You have overcome your feelings of shyness and express yourself very well. Your life is successful and progresses in the way you want it to. You learn from your mistakes to improve what you do.
Compatible combinations
love—red, violet, orange
business—red, violet, gold

INDIGO
Your intellectual knowledge is transformed into spiritual understanding and wisdom. This means that you work not only with your mind but also with your heart.
Compatible combinations
love—scarlet, violet, gold
business—scarlet, violet, gold

VIOLET
You are a very busy person with many interests. With the development of your spiritual nature, you are aware of many changes that are happening to all aspects of your personality and your life.
Compatible combinations
love—scarlet, violet, yellow
business—scarlet, violet, gold

MAGENTA
By being confident and overcoming feelings of low self-esteem, you create success in what you do. Now that you are aware of how negative feelings can hold you back, you will be even more successful.
Compatible combinations
love—lime, red, orange
business—lime, red, gold

GOLD
You are a well-adjusted person. The intellectual, emotional, and spiritual aspects of your nature work very well together. You feel good about yourself and this is reflected in all that you do.
Compatible combinations
love—scarlet, violet, indigo
business—scarlet, violet, gold

You are a traditionalist

You are a traditionalist and if things don't go your way, you become insecure and fight to keep things the way they are. Turquoise as your sun sign color means that there will be no magical spiritual experiences to heighten your senses, just a steady development of your spiritual nature. This is good as true spiritual awareness should proceed slowly.

IF YOUR PERSONAL EXPRESSION COLOR IS:

RED
Your qualities of leadership could do with some improvement. When things go your way, everything is fine. If not, you become a bully and control others to get your own way.
Compatible combinations
love—scarlet, red, green
business—scarlet, red, gold

ORANGE
You use your skills of arbitration to reconcile differences. This is not easy for you, because you find it difficult to see both sides of any situation. Learn to put yourself in others' places and you may gain more insight.
Compatible combinations
love—scarlet, red, blue
business—scarlet, red, gold

YELLOW
Your emotional fears of insecurity cloud your judgment. Find out what is causing these and resolve them if you want a happy and successful life.
Compatible combinations
love—scarlet, red, violet
business—scarlet, gold, violet

GREEN
You have a very routine and ordered life and your inability to make changes and accept new and different ideas stifles your spiritual development.
Compatible combinations
love—red, orange, red
business—scarlet, red, gold

BLUE
You care deeply about the needs of others. This concern vanishes when you cannot get your own way and you become demanding and unbearable to live with. If this continues you will end up alone and isolated.
Compatible combinations
love—scarlet, red, orange
business—scarlet, red, gold

INDIGO
It is wonderful that you have a philosophical mind. Why not put it to good use and find out what prevents you from listening to others' views, controlling rather than empowering them?
Compatible combinations
love—scarlet, red, gold
business—scarlet, magenta, gold

VIOLET
You gradually learn to accept the wonderful opportunities that can come with change. This takes you into new spiritual experiences, developing that side of your personality.
Compatible combinations
love—scarlet, red, yellow
business—scarlet, red, gold

MAGENTA
With unconditional love in your heart, you help others to initiate new ideas. As you recognize the benefits of this, your need for routine and order changes, and you are able to see others' points of view.
Compatible combinations
love—lime, red, orange
business—lime, red, gold

GOLD
You still like to get your own way. Because you recognize this trait, you are able to do something about it before the situation becomes uncontrollable. Now you are on your way to becoming a spiritual teacher.
Compatible combinations
love—scarlet, red, indigo
business—scarlet, red, gold

You are a firefighter

You are an exceptional communicator with a deep understanding of others' needs and would do well in public relations or a caring profession. Your cool head makes you invaluable in an emergency because you are able to cut out any emotions and see right to the heart of a problem. You also have a wonderful imagination, which can at times get out of control.

Sun sign color **TURQUOISE**

Destiny color **BLUE**

IF YOUR PERSONAL EXPRESSION COLOR IS:

BLUE
There is too much blue in this combination. This could lead to a depressive illness if you do not introduce some orange into your life.
Compatible combinations
love—scarlet, orange, orange
business— scarlet, orange, gold

INDIGO
You have a great understanding of the needs of others and choose your words carefully. Through your negative experiences, you know the harm that can be caused by others' lack of sensitivity.
Compatible combinations
love—scarlet, orange, gold
business—scarlet, orange, gold

VIOLET
It is very noble that you sacrifice your own needs to be of service to others. Your arrogance may prevent you from learning how harmful words can be if you don't think before you speak.
Compatible combinations
love—scarlet, orange, yellow
business—scarlet, orange, gold

MAGENTA
Working from the point of love within your heart, you are very aware of what you say. If others do not accept your words, find other ways to help them understand what you are trying to convey.
Compatible combinations
love—scarlet, orange, green
business—scarlet, gold, green

RED
You are very good at expressing yourself. This is not always of benefit to others, since they may not be able to accept what you are saying. You can be more diplomatic by choosing your words carefully.
Compatible combinations
love—scarlet, orange, green
business—scarlet, gold, green

YELLOW
Your knowledge comes from your intellectual mind. Learn to use your intuitive abilities more. Words come naturally to you, and when talking with others you know exactly what to say.
Compatible combinations
love—scarlet, orange, violet
business—scarlet, orange, gold

ORANGE
For some people, illustrations can be even more powerful than words, and more acceptable. Learn to use your skills of creativity professionally to access the emotional feelings of others.
Compatible combinations
love—scarlet, orange, blue
business—scarlet, gold, blue

GREEN
Despite your innate powers of communication you sometimes lose confidence and find it difficult to express yourself. Learn to relax and to trust in your intuition.
Compatible combinations
love—scarlet, orange, red
business—scarlet, gold, red

GOLD
You have overcome your need to rush in and help others before thinking about how you are going to do this. You choose your words carefully so as not to offend anyone.
Compatible combinations
love—scarlet, orange, indigo,
business—scarlet, gold, indigo

You have a holistic view of life

With your vivid imagination, you have little difficulty accessing higher states of consciousness. You learn to integrate your physical and spiritual interests, giving you a holistic view of life, and a deep feeling of inner security. As you develop, your tolerance and understanding draw others to you for help and guidance.

IF YOUR PERSONAL EXPRESSION COLOR IS:

RED
You overcome your need for physical safety and security. However, you find it difficult to understand your inner spiritual guidance. Learn to accept that your life is unfolding as it should.
Compatible combinations
love—scarlet, gold, green
business—red, gold, green

ORANGE
You see the positive and negative effects in all of nature, with each relying on the other for balance and harmony. The same is true in your own life, and you need rain to make the flowers grow.

Compatible combinations
love—scarlet, gold, blue
business—orange, gold, blue

YELLOW
Your intellectual mind has difficulty in grasping the deeper mysteries of life. A higher intelligence guides your life, which can be found only through personal experience.
Compatible combinations
love—scarlet, gold, violet
business—scarlet, gold, blue

GREEN
You find it difficult to take criticism and this prevents you from making good use of

the excellent advice that comes your way. Learn to be less defensive and you will stand to be a great deal more successful.
Compatible combinations
love—scarlet, gold, red
business—scarlet, gold, orange

BLUE
There is too much blue in this combination and, if you continue to live in a world of your own, there is a likelihood that you may become mentally unstable. Bring some orange or gold into your life.
Compatible combinations
love—scarlet, gold, orange
business—scarlet, gold, red

INDIGO
The only thing developing in your life at the moment is your spiritual awareness. You are letting your imagination get the better of you and need to introduce some gold to ground you in more wisdom.
Compatible combinations
love—scarlet, gold, gold
business—scarlet, gold, gold

VIOLET
You sacrifice your physical needs for your spiritual

development. Listen to your inner wisdom and your body; accept what you are being told, and change what you are doing.
Compatible combinations
love—scarlet, gold, yellow
business—scarlet, gold, gold

MAGENTA
Your spiritual consciousness has a wise and loving understanding of all your needs. It makes sure that no harm comes to you. Although it is sometimes difficult, accept that everything has a purpose.
Compatible combinations
love—scarlet, violet, gold
business—scarlet, gold magenta

GOLD
You are a very wise, compassionate counselor and many come to you for spiritual understanding and knowledge. Help them to access their own spiritual consciousness.
Compatible combinations
love—scarlet, gold, indigo
business—scarlet, indigo, gold

You respect all life

With both these colors influencing your spiritual nature, there will be a continuous development of your spiritual strength and self-knowledge. You have great spiritual strength, self-respect, and dignity. With turquoise as the gateway to your spirituality, you start to learn about spiritual love and what this really means.

Sun sign color **TURQUOISE**

Destiny color **VIOLET**

IF YOUR PERSONAL EXPRESSION COLOR IS:

to ignore their hurtful remarks and help them to overcome their inner fears.
Compatible combinations
love—scarlet, yellow, blue
business—scarlet, gold, blue

YELLOW
You achieve amazing results in everything you do. This generates feelings of discontent from those who are not so fortunate. Instead of feeling guilty about this, try to give them the same opportunities that you have.

Compatible combinations
love—scarlet, yellow, violet
business—scarlet, gold, violet

RED
This is a very intense combination with all aspects of your sexual nature being challenged. You learn not to discriminate against others because of their sexual orientation, gender, behavior, and lifestyle.
Compatible combinations
love—scarlet, yellow, green
business—scarlet, gold, green

ORANGE
Not everyone likes your exuberant, flamboyant nature or your psychic ability. The fault if any lies with them and not you. Learn

GREEN
You are honest, loyal, and hardworking, and you try very hard to be fair at all times. But sometimes you need to accept that you are as human and fallible as the rest of us.
Compatible combinations
love—scarlet, yellow, red
business—scarlet, gold, magenta

BLUE
There is discrimination in all walks of life and you are passionate in your desire to speak out on behalf of people who lack the mental or physical health to speak with their own voice.
Compatible combinations
love—scarlet, yellow, orange
business—scarlet, yellow, gold

INDIGO
You have a tremendous sense of justice. This makes you aware of the harm that can come from inferior discriminatory remarks and attitudes from others in positions of power.
Compatible combinations
love—scarlet, yellow, gold
business—scarlet, yellow, gold

VIOLET
Although compassionate and sensitive, you are also blessed with sound common sense and you would do well to put your insight to practical use.
Compatible combinations
love—scarlet, gold, yellow
business—scarlet, gold, orange

MAGENTA
You are caring and compassionate and are drawn instinctively to help people less fortunate than yourself. You would make an ideal doctor or nurse.
Compatible combinations
love—lime, red, orange
business—lime, red, gold

GOLD
Through following your example of unconditional love, others are learning the principle of equal opportunities for all. This is the meaning of true spiritual love and takes you closer to your spiritual goal.
Compatible combinations
love—scarlet, yellow, indigo
business—scarlet, gold, indigo

THE COLOR TURQUOISE

You are an idealist

Although you are capable of being loving and affectionate, you are not easily understood because you rarely allow yourself to be vulnerable in front of others. But with magenta as your destiny color, your aim is to improve conditions for all humanity and not just for yourself. You have ample amounts of energy and drive to carry this through.

IF YOUR PERSONAL EXPRESSION COLOR IS:

RED
Improving conditions for all is more important to you than socializing and having fun. By learning to be more approachable, you can gain a wider circle of friends and acquaintances.
Compatible combinations
love—lime, red, orange
business—lime, red, gold

ORANGE
Your spiritual values are incorporated into your social activities. This creates a more harmonious lifestyle for you and others.
Compatible combinations
love—lime, red, blue
business—lime, gold, blue

YELLOW
Releasing your emotional fears makes you easier to get along with. Everyone is benefiting from your openness and honesty.
Compatible combinations
love—lime, red, violet
business—lime, gold, violet

GREEN
Nothing stops you from achieving what you really want. You restore balance and harmony to chaotic conditions. If your security is threatened, you are capable of extreme measures, and

may even resort to violence.
Compatible combinations
love—lime, red, orange
business—lime, red, gold

BLUE
You learn to trust others' abilities and allow them to get closer to you. This relaxed attitude improves conditions for all, and you are not so isolated.
Compatible combinations
love—lime, red, orange
business—lime, gold, orange

INDIGO
You do need times of quiet reflection and relaxation. But if you take this to extremes, you may become unapproachable. This,

combined with your secretive nature, creates difficult conditions for all.
Compatible combinations
love—green, red, gold
business—lime, red, orange

VIOLET
Your lifestyle and interests give you a negative attitude. Life is meant to be enjoyed and adopting an optimistic attitude has been known to change negative outcomes into positive ones.
Compatible combinations
love—lime, red, orange
business—lime, red, gold

MAGENTA
Your understanding of deep spiritual love helps your

spiritual development. To improve this even more, learn to recognize the uniqueness of each and every living being and to overcome your need for isolation.
Compatible combinations
love—lime, red, orange
business—lime, red, gold

GOLD
Your spiritual values transform your emotional fears. This allows you to improve conditions for all, whether you are helping individuals or groups.
Compatible combinations
love—lime, red, orange
business—lime, red, indigo

You have vision

Sun sign color **TURQUOISE**

Destiny color **GOLD**

This is a wonderful combination. With your clear-headed intellect and unbeatable self-belief, you are undaunted in your desire to give life and practical substance to your dreams and to change the lives of others for the better. You have infinite patience, and will stay the course of a seemingly intractable plan or project in order to achieve your aims and ideals.

IF YOUR PERSONAL EXPRESSION COLOR IS:

RED
Although you are very sensitive you also fight tooth and nail for what you believe in and never give up in your desire to make this world a better place to live in.
Compatible combinations
love—scarlet, indigo, green
business—scarlet, gold, green

ORANGE
You have a very positive attitude to life and believe strongly that faith can move mountains. This can be annoying to those who have no experience of how beliefs can change outcomes. Learn different ways of teaching, in order to expand their knowledge.
Compatible combinations
love—scarlet, indigo, blue
business—scarlet, gold, blue

YELLOW
Success creates its own difficulties. Learn to be more compassionate and understanding when things go wrong for others seemingly more fortunate than yourself.
Compatible combinations
love—scarlet, indigo, violet
business—scarlet, indigo, gold

GREEN
Restoration of balance and harmony in the natural world is your main focus in life. The wonder of this world helps you to get closer to the source of all life. Learn to tune in to this for guidance and personal understanding.
Compatible combinations
love—scarlet, indigo, red
business—scarlet, indigo, gold

BLUE
Not everyone understands their spiritual nature and has the same beliefs as you. Create different teaching methods to reach all levels of understanding.
Compatible combinations
love—scarlet, indigo, orange
business—scarlet, indigo, gold

INDIGO
This is the color combination of a true spiritual teacher. Your need for praise and admiration has been transformed through your wish to see wisdom and knowledge for all, not just the minority.
Compatible combinations
love—scarlet, indigo, gold
business—scarlet, indigo, gold

VIOLET
You enjoy the many opportunities you have to help others' spiritual development. You inspire them to reach greater heights of achievement.
Compatible combinations
love—scarlet, indigo, yellow
business—scarlet, indigo, gold

MAGENTA
Through the deep love in your heart you enable others to get in touch with their spiritual nature in whatever way is appropriate for them.
Compatible combinations
love—scarlet, indigo, green
business—scarlet, indigo, gold

GOLD
This is a combination of spiritual leader and teacher. You teach the true meaning of spirituality through values of unconditional love and lead by example.
Compatible combinations
love—scarlet, indigo, indigo
business—scarlet, indigo, gold

The color blue

Blue is the color of the heavens, the illusory, and the unreal. It is a cooling color, bringing peace, tranquillity, and faith in oneself and others. Blue helps with communication and self-expression, and opens our minds to realities beyond the physical senses. It stimulates our appreciation of music and the arts and can help us break away from order and routine. Too much of it and we become dogmatic, negative, and self-centered. Too little and we become stubborn and resistant to change.

The complementary color to blue is orange (see page 38), so, if you find your chart exhibiting too much melancholy blue energy, you may want to consider introducing more orange into your life. On the following pages you will find a personalized reading with blue as the sun sign.

Physical health

With its cooling properties, blue takes the heat out of inflammatory conditions, reduces fevers, and temperatures, and lowers blood pressure. Its dominant chakra is the throat chakra and associated gland the thyroid gland. It influences any disorders linked to the throat and respiratory system, such as sore throats, simple goiter, asthma, and overactive thyroid. Certain heart conditions respond to blue and blue light is now used in hospitals to treat new-born babies with jaundice. Don't use it to treat anyone with a depressive illness, low blood pressure, colds, or paralysis of the muscles.

Emotional health

An individual with a well-balanced influence of blue in his or her color chart will feel inspired, calm, and at peace with the world around them. But if blue is overactive, negative qualities of arrogance, self-centeredness, self-righteousness, and dogmatism will come to the fore. A shortage of blue energy can cause an individual to withdraw from the world, and become frightened, timid, manipulative, and unreliable.

Spiritual health

Blue is the color of the throat chakra, the chakra known esoterically as the center of the will. It gives us the free will to either expand our spiritual awareness to the level of the soul or deny our soul's existence. A good balance of blue in an individual's color chart imparts them with high ideals, and faith and trust in spiritual understanding. The spiritual goal of the blue person is to recognize the existence of their soul and to work toward integrating it into all aspects of their spirituality.

Relationships

BLUE WITH RED You like a quiet, peaceful life and your partner's excitable nature may be too much for you.

BLUE WITH SCARLET You will have to accept your partner's carefree and irreverent attitude to life for this partnership to work.

BLUE WITH ORANGE You complement each other perfectly and can create a wonderful life together.

BLUE WITH GOLD A wonderful partnership. Just think of the blue sky and golden sun to see how well you go together.

BLUE WITH YELLOW Individually you are both very strong characters. Together you can create peace and harmony.

BLUE WITH LIME This partnership will work but it won't be very exciting, because you both like a quiet, peaceful life.

BLUE WITH GREEN As long as you feel you can trust your partner and that they are loyal to you, this partnership will work.

BLUE WITH TURQUOISE You can help keep your partner from straying off into a world of their own.

BLUE WITH BLUE You both care so much for others that you may have very little time left for each other.

BLUE WITH INDIGO Spiritually you will be inspired to reach new heights of awareness. Both of you need to keep your feet on the ground for this partnership to work well.

BLUE WITH VIOLET It's fortunate that you're adaptable. You'll need to be to cope with the changes your partner will bring into your life.

BLUE WITH MAGENTA This will work well. You are loyal and will support one another steadfastly through any difficulties.

You have hidden talents

You are quiet, unassuming, and strong. Blue as your sun sign color gives you the tranquillity and calm to handle the most difficult situations, but with red as your destiny color you are also capable of motivating others and getting them to follow you. You actively fight for the rights of others, even if this runs against your instinctive dislike of conflict.

Sun sign color **BLUE**
Destiny color **RED**

IF YOUR PERSONAL EXPRESSION COLOR IS:

RED
Being passive in nature, you usually carry orders without question. Imagine what a shock people would have if you learned to be assertive and refused to do this.
Compatible combinations
love—orange, green, green
business—orange, green, gold

ORANGE
There are always two sides to any argument. Learn to see both sides of the coin and to learn from all parties to a dispute.
Compatible combinations
love—orange, green, blue
business—red, green, blue

YELLOW
This is a lovely combination including all the primary colors. You have a happy and harmonious lifestyle and are capable of achieving almost anything you want.
Compatible combinations
love—orange, green, violet
business—orange, green, gold

GREEN
You quickly calm down explosive situations with your gentle diplomacy. To improve things even more, learn to recognize the danger signs and diffuse a possible conflict before it even happens.
Compatible combinations
love—orange, green, red
business—orange, green, gold

BLUE
You have a wonderful caring nature, are very calm, never get flustered, and remain impartial in difficult situations. Are you aware that others feel let down when you don't come to their rescue?
Compatible combinations
love—orange, green, orange
business—orange, green, gold

INDIGO
This combination gives you the power to speak up for yourself and others. You learn not to avoid conflict and to respect the rights of others to have opinions, even if you don't agree with them.
Compatible combinations
love—orange, green, gold
business—red, green, gold

VIOLET
There is an intensity of power in this combination. Be very careful how you use it, because it could backfire and have the opposite effect to what you had intended.
Compatible combinations
love—orange, green, yellow
business—orange, green, gold

MAGENTA
You are very self-sacrificing and would do anything to help others, even if it meant putting your own interests at risk. You need to think of yourself more and channel your red energies into helping yourself.
Compatible combinations
love—orange, green, yellow
business—orange, green, gold

GOLD
You are very wise and compassionate and change your behavior and attitude to prevent conflict from happening. Stick to your guns and learn to do this without compromising your values.
Compatible combinations
love—orange, green, indigo
business—orange, green, gold

You are exacting

These colors are complementary, so yours is a happy, well-balanced life. You have a love of beauty, reflected in whatever you create. You enjoy the best of both worlds: your social life is full, yet when necessary you make time for peace and relaxation. The area of your life that needs attention is your inability to form lasting relationships. You expect a great deal from those who are close to you and find it difficult to overlook their mistakes.

IF YOUR PERSONAL EXPRESSION COLOR IS:

RED
Before you can forgive others, you have to forgive yourself. Learn what prevents you from doing this and resolve it, and your life will be more rewarding.
Compatible combinations
love—orange, blue, violet
business—turquoise, orange, gold

ORANGE
You have a very generous nature, always giving to others in need. This alone cannot buy love and friendship and assuage feelings of guilt. If you are too generous it can embarrass others and make them over-dependent on you.
Compatible combinations
love—orange, blue, blue
business—orange, green, gold

YELLOW
You are very successful. This is not easy and you have lost friends and feel very hurt as a result. Don't let the situation worsen. You can't change the past, but you can resolve your feelings and get on with the rest of your life.
Compatible combinations
love—orange, blue, green

business—orange, green, gold

GREEN
You are very calm and peaceful on the outside but inside your emotions are in turmoil. You have been hurt so often and have closed your heart so that this doesn't happen again. If you continue to do this your health will suffer.

Compatible combinations
love—orange, blue, red
business—yellow, blue, gold

BLUE
You have a wonderfully forgiving nature. Whatever others do, you make excuses for them and turn the other cheek. Learn to be more realistic about people and you will not get hurt as often.
Compatible combinations

love—orange, blue, orange
business—scarlet, blue, gold

INDIGO
Although you can learn a lot from books, sometimes you have to trust your intuition to give you the right answers. It's amazing what can happen when you begin to do that.

Compatible combinations
love—orange, blue, gold
business—yellow, blue, gold

VIOLET
You are a true and loyal friend and demand these qualities in return. When this is not forthcoming you end relationships and try to move on. Learn to be more forgiving and you will feel less isolated.
Compatible combinations
love—orange, blue, yellow
business—red, blue, gold

MAGENTA
True spiritual love is unconditional, recognizing and accepting all the faults and failings of both yourself and others. When this is the case, then the word "forgiveness" simply ceases to exist.
Compatible combinations
love—lime, orange, blue
business—lime, gold, blue

GOLD
People are drawn to you because of your deep love and compassion, which is nonjudgmental despite all their failings. Learn not to push them away out of fear of rejection.
Compatible combinations
love—orange, blue, indigo
business—orange, indigo, gold

YOUR THREE ESSENTIAL COLORS

You encourage independence

This is a lovely combination. You have a warm, caring nature and are generous to a fault. You create feelings of laughter and happiness wherever you go, living your life to please others. Your generosity can create feelings of dependency however. You are aware of this and learn how even well-intentioned actions can create negative feelings in others. Your calm and serenity allow you to help others find their feet and so encourage their independence.

IF YOUR PERSONAL EXPRESSION COLOR IS:

RED
This is an inspiring combination. With all the primary colors in your reading you have the ability to do and be anything you want. It can create or destroy, so use it wisely.
Compatible combinations
love—orange, violet, green
business—magenta, blue, green

ORANGE
You are a very wise and generous person and work hard not to create feelings of jealousy in others. Learn to accept that no matter how hard you try there will always be others who are envious of your talents.
Compatible combinations
love—orange, violet, blue
business—orange, violet, gold

YELLOW
Your financial success makes others dependent on you for their livelihood. Respect and trust don't just happen, but have to be earned. This applies to both the giver and the receiver.
Compatible combinations
love—orange, violet, violet
business—orange, violet, gold

GREEN
The natural world is a complex web of mutual interdependence. This also applies to the world of human relationships. But human beings have feelings too, and you have to be aware of the negative effect your emotions can have.
Compatible combinations
love—orange, violet, red
business— orange, violet, gold

BLUE
Even the best intentions don't always work. Learn to overcome your feelings of despondency when your generosity is rejected. The good thing is that others are not dependent on you.

RETURN TO SENDER

Compatible combinations
love—orange, violet, orange
business—orange, violet, orange

INDIGO
If others are in need, you will if necessary share your home and life with them. This creates dependency and feelings of jealousy instead of appreciation. Learn to be more discerning about how you do this.
Compatible combinations
love—orange, violet, gold
business—orange, violet, orange

VIOLET
You care deeply about others' spiritual needs. Instead of inflicting your beliefs on them, empower them to find their own paths and watch their spiritual natures develop.
Compatible combinations
love—orange, violet, yellow
business—orange, violet, orange

MAGENTA
You have great wisdom, love, and compassion for others.

Others receive the confidence from you to express their thoughts and overcome negative emotions. This encourages their independence and improves their lives.
Compatible combinations
love—lime, orange, violet
business—lime, orange, gold

GOLD
Distancing yourself from the emotional needs of others enables them to find their own solutions to problems. This can give the mistaken impression of an uncaring attitude.
Compatible combinations
love—orange, violet, indigo
business—orange, violet, gold

You have a balanced perspective

Together these two colors make turquoise, the color of clarity and communication. Green as your destiny color teaches the importance of balance and equilibrium in everything you do. You learn how to keep a balance between your physical and spiritual needs and your ultimate goal is the holistic integration of all parts of your personality.

IF YOUR PERSONAL EXPRESSION COLOR IS:

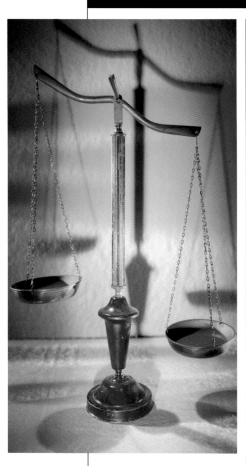

ORANGE
Your personal warmth shines like a beacon to help others in need. Your nurturing qualities come from your spiritual nature, or some would say your soul. Learn how to contact this for inner guidance.
Compatible combinations
love—orange, red, blue
business—orange, red, gold

YELLOW
You relate instinctively to others' needs. You help them get rid of negative feelings that may be blocking their personal development, by restoring balance and harmony to their lives.
Compatible combinations
love—orange, red, violet
business—orange, red, gold

RED
The physical, emotional, and spiritual aspects of your nature work together to give you a very balanced perspective on life. You are also centrally aware of how the slightest change can alter your equilibrium.
Compatible combinations
love—orange, red, green
business—orange, scarlet, green

GREEN
You remain calm and unruffled as long as no one upsets your routine or threatens your peace of mind. You need to learn to welcome change as an opportunity to improve your life, and not a threat to overturn it.
Compatible combinations
love—orange, red, red
business—orange, red, gold

BLUE
Through your psychic awareness you have touched the soul essence of others. Learn to touch this within yourself and expand your spiritual self-awareness.
Compatible combinations
love—orange, red, orange
business—orange, red, gold

INDIGO
You have a great interest in philosophy and the social sciences. This controls the way you live your life. Remember that nobody has all the answers. What is true today may be ridiculed tomorrow.
Compatible combinations
love—orange, orange, gold
business—orange, red, gold

VIOLET
It is very noble to give your time and effort selflessly to so many projects. This makes you a very interesting person. Listen when your intuition is telling you to slow down and restore your energies.
Compatible combinations
love—orange, red, yellow
business—orange, red, gold

MAGENTA
Selfless love doesn't mean giving and giving to your own detriment. If you continue to do this, you will become ill, and that will help no one, including yourself.
Compatible combinations
love—orange, red, green
business—lime, orange, gold

GOLD
You have a deep spiritual awareness, which you cannot explain in rational terms. This is your soul and once you accept its existence, your life will take on a new meaning and will move in a new direction.
Compatible combinations
love—orange, red, indigo
business—orange, red, gold

You have a powerful sixth sense

Sun sign color **BLUE**

Destiny color **BLUE**

You have an instinctive interest in esoteric matters. With your clear grasp of facts and general knowledge you make an excellent instructor. You are able to see and understand all aspects of a problem and make the right decision. You are very intuitive and receive information like flashes of inspiration or brainwaves.

IF YOUR PERSONAL EXPRESSION COLOR IS:

RED
You have an amazing sixth sense, which guides you in your life and lets you know if you are in danger. This fascinates you and drives you to learn more about the part it plays in your and others' lives.
Compatible combinations
love—orange, orange, green
business—orange, orange, gold

ORANGE
Your psychic abilities have been transformed into spiritual self-awareness. This has opened your mind to higher levels of consciousness and the possible existence of your soul.
Compatible combinations
love—orange, orange, blue
business—orange, orange, gold

YELLOW
An understanding of your exceptional sixth sense cannot be found in books. True understanding comes from the realization that life is eternal and there is no such thing as separation and death, only transformation.
Compatible combinations
love—orange, orange, violet
business—orange, orange, gold

GREEN
You have a very strong belief in reincarnation. This would explain the *déjà vu* experiences you have. On the other hand, they could be the product of your imagination. Learn to differentiate between the two.
Compatible combinations
love—orange, orange, red
business—orange, orange, gold

BLUE
There are low energies in this reading and you need to introduce some orange and gold as a matter of urgency.

Failure to do so could lead to feelings of depression.
Compatible combinations
love—orange, gold, orange
business—orange, gold, orange

INDIGO
You are a dazzling live-wire, constantly on the receiving end of all manner of knowledge and information. You need to slow down and balance your energies.
Compatible combinations
love—orange, orange, gold
business—red, orange, gold

VIOLET
You are very aware of your sixth sense and higher consciousness, although you may call this your gut instinct. In the world of business it is the part of you that instinctively knows the right decision to make.
Compatible combinations
love—orange, orange, yellow
business—orange, orange, gold

MAGENTA
In spite of your natural powers of clairvoyance you are also capable of being down-to-earth and practical. Such realism can sometimes prevent you from nurturing your soul.
Compatible combinations
love—lime, orange, orange
business—lime, orange, gold

GOLD
You have overcome the part of you that would like to ignore your psychic powers. Your compassion for others helps the development of their souls and your own.
Compatible combinations
love—orange, orange, indigo,
business—orange, orange, violet

You are a mentor

You seek new ways to open up your mind and expand your conscious awareness of realities beyond the physical senses. The development of your soul through the opening of your chakras is a sensitive process taking years to perfect. If forced or rushed, it could lead to instability. But you are wise enough to know this and help others seek enlightenment too.

IF YOUR PERSONAL EXPRESSION COLOR IS:

RED
The materialist in you keeps your feet firmly on the ground and controls your mind. At least this prevents you from experimenting with the powerful energy of your base chakra and blowing your mind.
Compatible combinations
love—orange, gold, green
business—orange, gold, gold

ORANGE
You are very interested in the paranormal. Your psychic abilities award you glimpses of other realities. Do not be tempted to expand your knowledge without the wisdom and guidance of a true spiritual teacher.
Compatible combinations
love—orange, gold, blue
business—red, orange, blue

YELLOW
Your unquestioned intellect and interest in realities beyond the physical senses make you a fascinating person to be around.
Compatible combinations
love—orange, gold, violet
business—orange, gold, indigo

GREEN
You are a very organized person and stick to routine and order. You dislike anything new or different. This prevents the expansion of your mental faculties and stifles your spiritual development.
Compatible combinations
love—orange, gold, orange
business—orange, blue, red

BLUE
Your rational thinking tends to dominate your life. Your physical and emotional needs tend to take second place and your life is out of balance as a result. Introduce some orange and gold to change the situation.
Compatible combinations
love—orange, gold, orange
business—orange, gold, orange

INDIGO
Your interest in parapsychology drives you to expand your experiential knowledge even more. This can be unwise, and if taken to extremes may take the form of an obsession.
Compatible combinations
love—orange, magenta, gold
business—orange, gold, gold

VIOLET
You know the harm that can be caused to initiates on the spiritual path when they are expanding their unconscious awareness. You may find yourself involved with others who have become addicted to the power of the mind.
Compatible combinations
love—orange, gold, yellow
business—orange, gold, yellow

MAGENTA
You are a seeker of divine truth no matter how much you like to tell yourself that you are not. Let the love in your heart guide you in all that you do and you will not be disappointed.
Compatible combinations
love—lime, orange, gold
business—green, red, gold

GOLD
You are a wise and loving counselor. With your knowledge and guidance, you can help others develop their intellectual abilities or spiritual awareness, depending on which path you choose to take.
Compatible combinations
love—orange, gold, indigo
business—orange, gold, indigo

You have an artist's heart

With your destiny color of violet, you are innately sensitive to your surroundings and easily upset by shows of cruelty or vulgarity. You seek the best in everything and everyone, striving to create tranquil environments for yourself and for others. You strive for a perfect world and are disappointed when real life does not live up to your romantic ideals.

Sun sign color **BLUE**

Destiny color **VIOLET**

IF YOUR PERSONAL EXPRESSION COLOR IS:

BLUE
Your whole life is focused on spiritual matters. This is not a realistic state of affairs and creates an imbalance in your life. Bring some orange into your life to help you venture out and socialize more.
Compatible combinations
love—orange, gold, orange
business—orange, gold, orange

INDIGO
You have an inquiring, philosophical mind, which inspires you to explore different spiritual concepts and realities. There are

limitations on what your mind can absorb. Learn to accept this.
Compatible combinations
love—orange, yellow, gold
business—scarlet, yellow, gold

VIOLET
You are very tenacious and keep going long after others have given up. This is not easy on your physical body, but spiritually it can be enormously rewarding.
Compatible combinations
love—orange, yellow, yellow
business—orange, yellow, gold

MAGENTA
There are no limitations to the love you give to others. How about giving some of this to yourself?
Compatible combinations
love—lime, orange, yellow
business—lime, orange, gold

GOLD
You are a great spiritual teacher but need to remember that only saints can attain the complete integration of all facets of their personality.
Compatible combinations
love—orange, yellow, indigo
business—orange, gold, indigo

RED
You may have had to face painful and distressing issues in your past. This impels you to find the answer to your soul's existence and the possibility of life after death.
Compatible combinations
love—orange, yellow, green
business—orange, gold, green

ORANGE
You are sensitive and creative and these qualities lead you to seek answers to life's eternal mysteries. You must be careful though as you could take things too far in this respect. Learn to respect your own limitations.
Compatible combinations
love—orange, yellow, blue
business—orange, gold, blue

YELLOW
Unlike many others you see no inherent conflict between your solid intellect and equally powerful spiritual needs. This combination leads you to expand your awareness and open your mind to realities beyond your experience.
Compatible combinations
love—orange, yellow, violet
business—orange, gold, violet

GREEN
Children adore you and you have a tremendous amount to give them in terms of spiritual awareness. But be sensitive to their individual needs and impressionable minds.
Compatible combinations
love—orange, yellow, red
business—orange, gold, red

You are saint-like

Composed of red and violet, magenta gives you both the physical and spiritual strength you need in your life. As a higher spiritual energy, magenta's qualities of unconditional love are exceptional. They are akin to the qualities of love attributed to saints. You learn to harness this power and to use it for the greater good.

IF YOUR PERSONAL EXPRESSION COLOR IS:

RED
In its purest form, red is the power that makes us survive in times of greatest difficulty. Learn to recognize and love this tremendous force so that it can empower you to achieve the very best in life.
Compatible combinations
love—lime, orange, green
business—lime, orange, gold

ORANGE
Your life is held back by others being dependent on you. Recognize the freedom needed by everyone to grow, and learn to let go of the feelings that prevent your spiritual development.
Compatible combinations
love—lime, orange, blue
business—lime, orange, gold

YELLOW
Your love and compassion inspire others to follow in your footsteps. This brings with it a heavy burden, so be careful that you don't turn your spiritual success into a way of procuring financial gain. Disillusionment leaves deep scars on the soul.
Compatible combinations
love—lime, orange, violet
business—lime, gold, violet

GREEN
You care deeply about others' needs. Your love encompasses all things, including animals and the natural world. With your loving qualities you would make an excellent healer.
Compatible combinations
love—lime, orange, red
business—lime, gold, red

BLUE
You trust in a divine plan, believing that everything will turn out for the best. This is the outcome of both your spiritual faith and your firm grounding in reality.
Compatible combinations
love—lime, orange, gold
business—blue, orange, gold

INDIGO
We are all capable of deep feeling and compassion, no matter how difficult our lives have been. Apply this knowledge to your own life and you will be amazed by how you can better the lives of others.

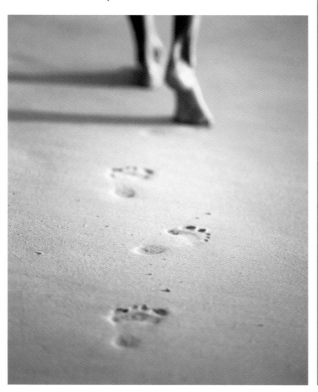

Compatible combinations
love—lime, orange, gold
business—green, red, gold

VIOLET
The strict rules and obligations of orthodox religion are definitely not for you. But there are many other ways and means of exploring your spirituality.
Compatible combinations
love—lime, orange, gold
business—lime, orange, gold

MAGENTA
You are warm and generous. You have a great belief in the abilities of others and empower them by giving them confidence and encouragement to move forward in their lives.
Compatible combinations
love—lime, orange, green
business—lime, gold, green

GOLD
You have great courage and inner determination. Others are drawn to your compassion and find it difficult to leave the net of your love.
Compatible combinations
love—lime, orange, indigo
business—lime, gold, indigo

You are luminous

Sun sign color BLUE
Destiny color GOLD

Like the sun, you generate feelings of warmth around all those with whom you come into contact. You can live in the worst or best of conditions, because you have risen above your basic, primitive needs and desires. Others may project negative feelings toward you that you will not even be aware of, so they will have no effect.

IF YOUR PERSONAL EXPRESSION COLOR IS:

RED
The saying, "Beauty is in the eye of the beholder" could be applied to you. You see beauty everywhere, even in the most wretched and distressing conditions.
Compatible combinations
love—orange, indigo, green
business—magenta, indigo, green

ORANGE
Others are uplifted by your unfailingly cheerful disposition. You recognize the spark of divine fire in every soul, and encourage others to grow and find happiness in their lives.
Compatible combinations
love—orange, indigo, blue
business—orange, orange, indigo

YELLOW
You light up the lives of others by spreading the beauty of life through the fun and happiness you give.
Compatible combinations
love—orange, indigo, violet
business—orange, indigo, gold

GREEN
Nothing could be more beautiful than the natural world. Remember that, on a rainy day, there is always the possibility of a rainbow, and on a cloudy day, a silver lining.
Compatible combinations
love—orange, indigo, red
business—orange, indigo, red

BLUE
You are endlessly patient and stay the course long after others have given up. The only thing you may be lacking is a little confidence. Learn to stand tall and speak up for yourself a little more.
Compatible combinations
love—orange, indigo, orange
business—orange, indigo, gold

INDIGO
With indigo the complementary color to gold, you lead a happy and contented life. You have found peace within yourself and are not perturbed by the ugliness in others because you are at one with the world as it is.
Compatible combinations
love—orange, indigo, gold
business—orange, blue, yellow

VIOLET
You are outwardly cool and calm, but can be cutting and acerbic when the situation demands it. This is not a bad thing if it prevents others from taking advantage of your legendary compassion.
Compatible combinations
love—orange, indigo, yellow
business—orange, indigo, gold

MAGENTA
You are very charming and charismatic and can get people to do almost anything for you as a result. Try not to let this go to your head.
Compatible combinations
love—lime, orange, indigo
business—lime, orange, gold

GOLD
The upheavals in your life have taught you that failure is simply success turned inside out. This makes you very strong and wise, but you sometimes need to let go and play the fool for a change.
Compatible combinations
love—orange, indigo, indigo
business—orange, indigo, gold

THE COLOR BLUE

The color indigo

Indigo is the result of mixing blue and violet, so the attributes of all these colors should be considered in a reading. Indigo is a very deep blue, sometimes called midnight blue. It is the color of pure knowledge, both esoteric and exoteric, and it is a very powerful and dignifying color to wear. It links to the level of the subconscious mind and our power to intuit things for which we have no concrete evidence. It is also the color of mystery and of magic.

The complementary color to indigo is gold (see page 48) so if you find your chart exhibiting too much introverted indigo energy you may want to consider introducing more gold into your life. On the following pages you will find a personalized reading for each three-part combination with indigo as the sun sign.

Physical health

Indigo influences the eyes, ears, and sinuses. It is also used to treat head pains, muscular strains, and tension in the shoulders, angina pain, and inflammatory pain in the small intestine and joints. It has the power to control pain but needs to be used with caution, because pain can be an indicator of an underlying physical cause. Its dominant chakra is the brow chakra. Its associated gland is the pituitary gland together with the entire endocrine system. Indigo should not be used to treat anyone with a depressive illness or with low blood pressure, obsessive mental illnesses, or paranoia.

Emotional health

This color influences one's mental state. A good balance of indigo in one's chart imparts feelings of confidence, security, peace, and self-belief. It puts an individual in command of his or her body and makes them eager to expand their knowledge. If indigo is overactive, negative qualities of pride, manipulation, dogmatism, and egoism will become manifest. A shortage of indigo energy can make an individual oversensitive to others' feelings, afraid of success, and undisciplined. They may withdraw into their own world of fantasy and imagination.

Spiritual health

The brow chakra is a very powerful spiritual energy center located in the middle of the forehead just above the eyebrows. Esoterically it is the seat of spiritual power and knowledge and as such can open the mind to ancient hidden knowledge and wisdom from the past. This can surface in dreams or meditations, or when an individual is in deep reflective mode. Indigo imparts intuitive powers bordering on the telepathic and prophetic. A good balance of indigo in one's chart will make them unafraid of death as they will have transformed their emotional fears through spiritual self-awareness.

Relationships

INDIGO WITH RED This can be a very rewarding relationship. You will inspire one another in your quest for the truth.

INDIGO WITH SCARLET You must work hard to make this relationship work as your quiet, studious nature may clash with your partner's more physical requirements.

INDIGO WITH ORANGE This relationship can work very well as you both thrive on creativity and spontaneity.

INDIGO WITH GOLD You will enjoy a strong mutual rapport as your partner will warm instinctively to your spiritual, artistic nature.

INDIGO WITH YELLOW Your lack of interest in material success may prove very frustrating to your partner.

INDIGO WITH LIME This will be a very successful partnership. Your partner will give room and freedom to your wide-ranging spiritual needs.

INDIGO WITH GREEN This partnership will work well, because your partner will give you the security and stability to expand your spiritual knowledge.

INDIGO WITH TURQUOISE Your partner will open your mind to realities beyond the present moment, expanding your spiritual awareness even more.

INDIGO WITH BLUE This relationship may work very well, although you might find your partner a little too tranquil for your soaring spirituality.

INDIGO WITH INDIGO This is a relationship of potentially awesome power, and you will both need to ensure that you use such power wisely and constructively.

INDIGO WITH VIOLET If spiritual empowerment is what you want, this partnership will work and its energies will be tremendous.

INDIGO WITH MAGENTA Your partner's deep love and compassion will be of great comfort to you in whatever you do.

You command respect

This is an intense combination of colors. With indigo as your sun sign color, you are blessed with acute powers of intuition. Indigo and red make purple, intensifying the qualities of dignity and command already manifest in your life with indigo as an outward indicator of your innermost being. You also have a powerful feel for the past and ancient wisdom.

IF YOUR PERSONAL EXPRESSION COLOR IS:

RED
There is tremendous physical and mental power in this color reading. Although you make a natural leader, others may find you dogmatic and controlling. Bring some green into your life to balance your energies.
Compatible combinations
love—gold, green, green
business—gold, green, gold

ORANGE
You are often torn between a desire to travel and socialize, and an equally compelling need to settle down to a life of academic respectability. Try to find a happy medium between the two.
Compatible combinations
love—gold, green, blue
business—gold, green, blue

YELLOW
The physical, mental, and intellectual aspects of your nature are all working together. As your knowledge expands, you are able to face and release your inner fears of life-and-death issues.
Compatible combinations
love—gold, green, violet
business—gold, green, violet

GREEN
Your personal expression color of green enhances the qualities of power and command already manifest in your reading. Your enormous empathy would you make you an ideal healer or counselor.
Compatible combinations
love—gold, green, red
business—gold, green, gold

BLUE
Although quiet and introspective, you have an instinctive understanding of what makes people tick and others often welcome your wry, humorous assessment of their lives and of the world in general.
Compatible combinations
love—gold, green, orange
business—gold, green, gold

INDIGO
Because of your unique ability to cut to the heart of a problem or crisis, you can sometimes appear cold and unfeeling. But with red as your destiny color you know that nothing could be further from the truth.
Compatible combinations
love—gold, green, gold
business—gold, green, gold

VIOLET
This combination intensifies the tendency to deep introspection already manifest in your life. But with red as your destiny color, you also believe that anything is possible and this will help you find the answers you seek.
Compatible combinations
love—gold, green, yellow
business—gold, green, gold

MAGENTA
You are reaching your spiritual goal of transforming your physical desires into the soul qualities of unconditional love. This does not mean controlling your emotions by suppressing them however.
Compatible combinations
love—lime, gold, green
business—lime, gold, green

GOLD
A fantastic combination. Your intuition gives you the power to access inner states of consciousness that others can only begin to dream about.
Compatible combinations
love—gold, green, indigo
business—gold, green, gold

You acquire knowledge

With orange as your destiny color, you are moved along by an irrepressible desire to seek and understand the world around you. You seek answers only to the biggest and most fundamental questions about the meaning of life and have a distaste for the minutiae of day-to-day detail. Time spent worrying about the future is time wasted as far as you're concerned.

IF YOUR PERSONAL EXPRESSION COLOR IS:

ORANGE
You delight in exploring unseen worlds and ancient mysteries. No epoch or era is too vast or complicated for your inquiring mind and inspirational creativity.
Compatible combinations
love—gold, blue, blue
business—gold, blue, gold

YELLOW
You are naturally impatient with restraints and rigid frameworks. You have traveled vast distances in your mind. Now it's time to match reality to theory.
Compatible combinations
love—gold, blue, violet
business—gold, blue, gold

GREEN
Your personal expression color has a potentially restraining influence on your wilder flights of intellectual fancy. This is not a bad thing, but you need to watch that your mental and physical faculties don't become too stagnant.
Compatible combinations
love—gold, blue, red
business—gold, blue, gold

RED
Others love your company because of your cheerful, happy-go-lucky nature. But you may sometimes need to find time to yourself to recharge your batteries and gain some spiritual equilibrium.
Compatible combinations
love—turquoise, gold, blue
business—turquoise, gold, green

BLUE
With your deep intuition about people and your tranquil, soothing manner, you would make an excellent teacher or nurse.
Compatible combinations
love—gold, blue, orange
business—gold, blue, gold

INDIGO
You have so much knowledge at your disposal that you're like a walking encyclopedia. If you manage

to rid yourself of your inhibitions and develop presentation skills, this would be fantastic.
Compatible combinations
love—gold, blue, gold
business—gold, blue, gold

VIOLET
You are afraid to develop your spiritual nature because of past religious experiences. Learn to let go of any irrational fears and to explore different spiritual paths with the guidance of a good spiritual teacher.
Compatible combinations
love—gold, blue, gold
business—gold, blue, gold

MAGENTA
It is very noble that you work toward your spiritual goals. This keeps you very busy, leaving very little time for anything or anyone else. You need to change this, or else your relationships will suffer.
Compatible combinations
love—lime, gold, blue
business—lime, gold, blue

GOLD
You are very open-minded and continually broadening your experiences to enhance and enrich your spiritual self-awareness. Don't let such seriousness prevent you from expressing your sense of humor though.
Compatible combinations
love—gold, blue, indigo
business—gold, blue, indigo

You have an expansive mind

You are very versatile, able to juggle and manage a varied lifestyle with remarkable ease and good grace. Yellow as your destiny color gives you the mental and emotional freedom to do anything you choose to do, and you love to spread your wings to try out new projects and enterprises. You have difficulty concentrating your mind on any one project however and need to find ways of bringing some routine into your life.

Sun sign color INDIGO
Destiny color YELLOW

IF YOUR PERSONAL EXPRESSION COLOR IS:

RED
Few people can crack a witticism or spot a fault faster than you. But you sometimes come across as a little tactless, and may need to learn the power of diplomacy.
Compatible combinations
love—gold, violet, green
business—gold, violet, green

ORANGE
You are fun and exciting to be with and spread joy wherever you go. Your interest in the subconscious and the deeper mysteries of life can only be enhanced by your creative imagination.
Compatible combinations
love—gold, violet, blue
business—gold, violet, blue

YELLOW
You believe strongly in being in total command of all your emotions. If you want others to open up to you, you have to learn to be a little less guarded.
Compatible combinations
love—gold, violet, violet
business—gold, violet, gold

GREEN
This is a combination which could prove a little stifling.

Too much control and routine in your life could lead to stagnation. Bring some red into your life to free up any latent energies.
Compatible combinations
love—gold, violet, red
business—gold, violet, red

BLUE
You are a very warm and loving person. Your quest for knowledge has been strengthened through your own emotional experiences. Now you begin to find out who you really are.
Compatible combinations
love—gold, violet, orange
business—gold, violet, orange

INDIGO
You are almost too good to be true. Sensitive and loyal, you are committed to the cause of truth and beauty, and thrive in any situation that calls upon your caring qualities.
Compatible combinations
love—gold, violet, gold
business—gold, violet, gold

VIOLET
You are broad-minded and care deeply about spiritual matters. You may be

hampered by bouts of self-doubt however and may need to introduce some blue to give you some serenity and peace of mind.
Compatible combinations
love—gold, violet, yellow
business—gold, violet, yellow

MAGENTA
You believe in the power of angels to help make your dreams a reality. Ideas that seem outlandish to others are within easy reach to you. You just need to find your mission in life and stick to it.
Compatible combinations
love—lime, gold, violet
business—lime, gold, gold

GOLD
Your deep knowledge gives you more understanding of your life's purpose. Having released your inner fears, you are now in control of all aspects of your life.
Compatible combinations
love—gold, violet, indigo
business—gold, violet, gold

Your horizons are expanding

The searchlight of your soul or sun sign color encourages you to push out the frontiers of your subconscious thought and to try out new ideas and ventures. Your destiny color of green can act as a check to such rampant, uninhibited thought and feeling, but it also gives you the insight and composure to grasp the deepest motivations of others.

IF YOUR PERSONAL EXPRESSION COLOR IS:

RED
An intense combination of colors. You struggle to reconcile your soaring, spiritual nature with your instinctive need for physical safety and material security. Bring some gold and green into your life to keep mind, body, and spirit in harmony.
Compatible combinations
love—gold, red, green
business—red, red, green

ORANGE
Your kind and generous nature draws others to you when they are in need of support. Use your powers of lateral thinking to teach them how to access their own sources of spiritual strength.
Compatible combinations
love—gold, red, blue
business—gold, red, gold

YELLOW
Physically and spiritually you are all of a piece, and you have reached a level of emotional maturity that can make you the ideal guide and teacher to others.
Compatible combinations
love—gold, red, violet
business—gold, red, gold

GREEN
You are in frequent danger of driving yourself into a rut and need to introduce some uninhibited red into your life to prevent this from happening too often.
Compatible combinations
love—gold, red, red
business—gold, red, gold

BLUE
You are a natural communicator. Your remarkable insight into the ways of the human heart and your gentle, soothing manner mean that you are never at a loss to say the right thing at the right time.
Compatible combinations
love—gold, red, orange
business—gold, red, orange

INDIGO
Your powerful subconscious notwithstanding, you are also highly methodical, sometimes to the point of obsessiveness. You need to loosen up sometimes or you could find yourself quite isolated.
Compatible combinations
love—gold, red, gold
business—orange, red, gold

VIOLET
You have a deep respect for law and order. But you sometimes feel handcuffed to traditional thoughts and beliefs, and need to find ways of breaking free from rigid patterns of thought.
Compatible combinations
love—gold, red, yellow
business—gold, red, gold

MAGENTA
You are perceptive and adaptable, and with magenta as your personal expression color you are in the enviable position of being able to give life and force to your dreams and ideas.
Compatible combinations
love—lime, gold, red
business—lime, gold, red

GOLD
You are being guided in your efforts to teach others long-forgotten spiritual traditions and truths. Use this information wisely for the good of all, and not just for the few.
Compatible combinations
love—gold, red, indigo
business—gold, red, gold

You have a strong sense of duty

Duty, discipline, and service to others are very important to you, and you often expect to receive the same measure of seriousness of purpose in return. This can lead to disappointment when others fail to live up to the same high standards of behavior that you set yourself. It can also cause bad feeling if used only for purposes of control.

IF YOUR PERSONAL EXPRESSION COLOR IS:

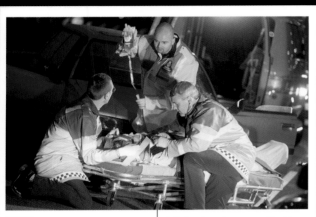

RED
You respond quickly to emergency situations out of feelings of duty and obligation. Learn to say no and let go of your feelings of guilt.
Compatible combinations
love—gold, orange, green
business—gold, orange, gold

ORANGE
You are sensible but also very sensual. The fact that you have a pronounced sense of duty doesn't mean that you have to be a doormat. You need to seek out new ways of overcoming your restrictions.
Compatible combinations
love—gold, orange, blue
business—gold, orange, blue

YELLOW
Your inclination to self-control lives in constant tension with your expansive intellect and generosity. If you don't find ways of reconciling these qualities, you could end up with some form of nervous exhaustion.
Compatible combinations
love—gold, orange, violet
business—gold, orange, violet

GREEN
You serve others out of love and not out of a sense of duty. This creates a happier lifestyle for everyone you touch, and maintains your sense of independence.
Compatible combinations
love—gold, orange, red
business—gold, orange, gold

BLUE
You choose to serve others not simply out of a sense of duty or obligation, but because of your instinctive compassion and love for others. This makes life more enjoyable for you than it otherwise would be, but you should still find time to indulge your creative and artistic pursuits.
Compatible combinations
love—gold, gold, orange
business—red, gold, green

INDIGO
You love exotic places and secretly dream of escaping to a desert island. But your sense of obligation to others keeps you bound to a life of routine. Bring some orange into your life to awaken the adventurer in you.
Compatible combinations
love—gold, orange, gold
business—gold, orange, gold

VIOLET
An overwhelming need to control stifles your capacity for greater spiritual awareness and healing. If you have any duty at all, it is to love yourself unconditionally.
Compatible combinations
love—gold, orange, yellow
business—gold, orange, gold

MAGENTA
With magenta signposting the way to your present and future potential, you are given ample opportunity to show everyone how adventurous you are, instead of screening yourself from life's biggest rewards all in the name of duty.
Compatible combinations
love—lime, gold, orange
business—lime, gold, gold

GOLD
You are an enlightened and engaging spiritual teacher. Your unique combination of sense and sensibility make you a valuable and indispensable friend and companion.
Compatible combinations
love—gold, orange, indigo,
business—gold, orange, gold

You take life very seriously

There is not enough fun and laughter in your life because you are very serious. This is not an altogether bad thing as you are also extremely fair in all your dealings, and often behave with a nobility and magnanimity that puts other more flamboyant characters in the shade. You are naturally drawn to subjects such as the law, mathematics, and philosophy.

IF YOUR PERSONAL EXPRESSION COLOR IS:

YELLOW

You are driven and ambitious, and can show ferocious energy when the need arises. But make sure you don't achieve your goals by riding roughshod over the needs and desires of others.

Compatible combinations
love—gold, gold, violet
business—gold, gold, violet

GREEN

Your serious turn of mind often leads you to ask questions about conservation issues and natural habitats. You could do a great deal to instruct others and make them more aware of the natural world and their place in it.

Compatible combinations
love—gold, yellow, red
business—gold, orange, red

BLUE

Your mind is so totally absorbed in other things that you are like the proverbial absent-minded professor. You are oblivious of anything or anyone except your own interests. This could make you uncaring about the needs of others.

Compatible combinations
love—gold, gold, orange
business—indigo, blue, orange

INDIGO

You are obsessively neat and tidy. This is the hallmark of a repressed personality. You need to find outlets for your mental and physical needs or you could end up with some form of dysfunction in mind or body.

Compatible combinations
love—gold, green, orange
business—gold, green, orange

VIOLET

Your psychic abilities are highly developed, but at the expense of your physical needs. Use gold and yellow to bring some balance and optimism into your life.

Compatible combinations
love—gold, gold, yellow
business—red, blue, yellow

MAGENTA

Through self-love you learn to face and overcome your inner fears. This takes courage and is not a sign of weakness. Doing this will simply make you stronger.

Compatible combinations
love—lime, gold, gold
business—lime, gold, gold

RED

You like to think that you can come up with a rationale for every decision you make, but you are frequently surprised by how often you resort to your remarkable powers of intuition.

Compatible combinations
love—gold, gold, green
business—gold, gold, green

ORANGE

Beneath your cool, intellectual exterior lies a sensual creature desperate to get out. If you don't try to go out and enjoy yourself, you could suffer severe imbalances of body and spirit.

Compatible combinations
love—gold, yellow, blue
business—gold, gold, violet

GOLD

Beneath your stern exterior lies a very kind and loving heart. But you need to let go of your fear of being hurt and to let people see this side to your character, or you could end up feeling very lonely.

Compatible combinations
love—gold, gold, indigo
business—gold, gold, indigo

YOUR THREE ESSENTIAL COLORS

You are a researcher

Sun sign color INDIGO
Destiny color VIOLET

Light shows up, by its very nature, things we might prefer to keep hidden. With your strong intuitive powers and even stronger spiritual instincts, you were born to understand profound mysteries. You live most of your life in your head, often looking to your imagination when the harsh realities of the manifest world get to be too much for you.

IF YOUR PERSONAL EXPRESSION COLOR IS:

RED
You are fascinated by the interplay between orthodox medicine, and alternative and natural remedies and cures. Your inquiring mind and spiritual nature will provide you with all the answers you need.
Compatible combinations
love—gold, yellow, green
business—gold, yellow, green

ORANGE
You are prone to moods and occasional spells of doubt and gloom. But it doesn't take much to cheer you up, and you know that your wonderful sense of humor is your main guard against emotional dysfunction.
Compatible combinations
love—gold, yellow, blue
business—gold, gold, blue

YELLOW
You are like a breath of fresh spring air, bringing joy and happiness to all those with whom you come into contact. You are also fiercely protective of those whom you regard as your friends.
Compatible combinations
love—gold, yellow, gold
business—gold, yellow, gold

GREEN
You are idealistic and often feel disappointed when the world doesn't conform to the grand plans you have in mind for it. Bring some gold and red into your life to give you the optimism to stay on an even keel.
Compatible combinations
love—gold, yellow, green
business—red, yellow, gold

BLUE
You are never happier than when making someone else happy and would make an excellent care-giver. Make sure that you leave some time to look after yourself or you could end up becoming tired and drained.
Compatible combinations
love—gold, yellow, yellow
business—orange, red, blue

INDIGO
Should you decide to go into the field of medicine, whether orthodox or complementary, your investigative skills and powers of intuition will be in great demand.
Compatible combinations
love—gold, yellow, yellow
business—gold, yellow, gold

VIOLET
Your insistence on finding a scientific rationale for every problem, large or small, could make you very unhappy. This will become especially apparent when you are suddenly faced with a deep crisis or personal trauma.
Compatible combinations
love—gold, yellow, yellow
business—gold, yellow, gold

MAGENTA
You love and are loved by others and everything that you do is a reflection of the connection you feel to the creatures and wonders of the universe.
Compatible combinations
love—lime, gold, magenta
business—lime, red, yellow

GOLD
You are sometimes knocked sideways by displays of cruelty in others. But you are blessed with the power of positive thinking because just when it appears that you are on the brink of collapse, you always manage to spring back into action.
Compatible combinations
love—orange, yellow, indigo
business—orange, gold, indigo

You are selfless

You are martyr-like in your devotion to the general well-being of others. But like the saints of old, you are a quiet radical, seeking to upturn old modes of thought all the time, and to come face to face with beliefs that you have developed over the course of a lifetime. With magenta representing higher spiritual energy, your experiences will enrich your soul.

IF YOUR PERSONAL EXPRESSION COLOR IS:

RED
Your physical desires are in conflict with the idea of unconditional love. If you have ever been in love, you will understand what this means.
Compatible combinations
love—lime, gold, green
business—lime, gold, gold

ORANGE
The values you have been conditioned to accept are slowly being released. Negative feelings of low self-esteem are being replaced with feelings of confidence and a growing belief in your own abilities.
Compatible combinations
love—lime, gold, blue
business—lime, gold, gold

YELLOW
You have a very happy and sunny disposition. This is at least the impression you give others. Only you know if it is the true representation of your inner self.
Compatible combinations
love—lime, gold, violet
business—lime, gold, violet

GREEN
Like your childhood beliefs in Santa Claus and the tooth fairy, the values that you have

cherished for many years may not necessarily have much validity anymore. You need to take a fresh view of your beliefs, do away with the ones that no longer have any real meaning, and replace them with ones that are relevant to you.
Compatible combinations
love—lime, gold, red
business—lime, gold, red

BLUE
It is great that you have such a caring nature and go out of your way to help others. Does this apply to everyone or only those who fit certain criteria? Unconditional love means loving others, warts and all.
Compatible combinations
love—lime, gold, orange
business—lime, gold, orange

INDIGO
You sometimes feel low for no apparent reason at all. This is natural and will pass. If it doesn't, find out what is causing these feelings and release them with the power of love.
Compatible combinations
love—lime, gold, gold
business—lime, orange, gold

VIOLET
Your personal needs and wants are continually sacrificed for others. You consequently feel rejected and undeserving of love. Learn to release these feeling and to recognize what a beautiful, unique person you are.
Compatible combinations
love—lime, gold, yellow
business—lime, gold, yellow

MAGENTA
You have had your fair share of relationships in your life, but you are still searching for your soulmate. Maybe if you stopped seeking perfection that special person may suddenly appear.

Compatible combinations
love—yellow, green, gold
business—yellow, green, gold

GOLD
With loving wisdom you are transmuting your physical needs and desires into feelings of love, compassion, peace, and tranquillity.
Compatible combinations
love—lime, gold, indigo
business—lime, gold, violet

You are exceptionally gifted

Working toward your higher spiritual goal of letting go of your need for material success, you focus on sharing wisdom with others, and on transmuting your physical desires into feelings of love for the greater good. This is a tremendous goal, requiring courage and strength of will, but with gold as your destiny color, you stand only to succeed.

IF YOUR PERSONAL EXPRESSION COLOR IS:

RED
Like everyone else you have physical needs and desires that need to be met if you are to have a happy, healthy, and fulfilling lifestyle. Learn to overcome feelings of guilt where your body is concerned, and to enjoy your sexual life.

Compatible combinations
love—gold, indigo, green
business—gold, indigo, green

ORANGE
You are exceptionally gifted. Everyone who ever comes to you for advice, benefits not only from your knowledge of the facts, but also from your unshakeable belief in the goodness of the human spirit.

Compatible combinations
love—gold, indigo, blue
business—gold, indigo, gold

YELLOW
Whatever you do brings success, but this can create feelings of envy in others. But inside you know that the real success you crave is the fulfillment of your desire for complete spiritual awareness.
Compatible combinations
love—gold, indigo, violet
business—gold, indigo, violet

GREEN
You are being restrained from following your heart's desire. Nothing happens without a reason or purpose, so learn to accept this state of affairs and in time all will be revealed.
Compatible combinations
love—gold, indigo, red
business—gold, indigo, gold

BLUE
You get very impatient when things do not work out exactly as you had planned them. You will not get so frustrated if you learn to trust in creation's mysteries and that what you are seeking will be revealed when the time is right.
Compatible combinations
love—gold, indigo, orange
business—gold, indigo, gold

INDIGO
You rarely conceal your true intentions and generously use your knowledge and talent for the benefit of all. By opening your mind to different ways of seeing the world, you stand to learn even more.
Compatible combinations
love—gold, indigo, yellow
business—gold, indigo, red

VIOLET
This is a powerful color, which intensifies the way you are able to control situations in a dignified manner. As you come to terms with your emotional insecurity, these are transformed into feelings of peace and love.
Compatible combinations
love—gold, indigo, yellow
business—gold, indigo, gold

MAGENTA
Your deep love and compassion is expressed in your life of selfless devotion to the spiritual needs of others.
Compatible combinations
love—lime, gold, indigo
business—lime, gold, indigo

GOLD
You are a true leader. Having no need for the outward shows of success, you share your knowledge generously with others, with no thought for praise or reward.
Compatible combinations
love—gold, indigo, indigo
business—gold, indigo, gold

The color violet

Violet is a powerful color, the result of mixing red with blue, so all these colors should be considered in a reading. Violet can induce feelings of deep relaxation, imparting us with feelings of power and dignity. Even more than indigo, which speaks to knowledge and the imagination, violet is the color of spirituality and helps us align ourselves with the mystical unity of the universe. A good balance of violet in a reading makes an individual feel in control, and accords a quiet dignity and determination.

The complementary color to violet is yellow (see page 58) so if you find your chart exhibiting too much relaxing violet energy you may want to consider introducing more yellow into your life. On the following pages you will find a personalized reading for each three-part combination with violet as the sun sign.

Physical health

Violet influences the nervous system, the brain, and any area of the head. Complaints that have been successfully treated with violet are amnesia, general skin problems, mental disorders, and infections. It has the power to control pain, but needs to be used with caution, because pain can indicate an underlying physical cause. It links to the crown chakra, which is called *sahasrara*, the Sanskrit for "thousandfold," and it is known as the thousand-petaled lotus. The crown chakra's associated gland is the pineal gland. This gland regulates the body's rhythms and one's emotional health and its function is related to the condition known as Seasonal Affective Disorder (SAD).

Emotional health

Violet influences the nervous system, the emotions, and one's mental state. Its sedative powers relax the nervous system and violet is a very good remedy for stress. The very gentle healing properties of violet are good for sudden emotional shock and trauma, and are even more effective when administered in the form of an amethyst crystal or essence. An individual with a well-balanced influence of violet in their color chart will feel powerful and in control. But if violet is overactive, negative qualities of irritability, impatience, and arrogance will come to the fore. A shortage of violet can lead to feelings of low self-esteem, negative thinking, and apathy.

Spiritual health

The crown chakra is a very powerful spiritual energy center, located at the top of the head. Esoterically it is linked to issues of faith, one's spiritual sense, and the search for personal meaning. A good balance of violet in an individual's life makes them fully aware of their divine essence and connection to the divine source. Too much or too little violet in one's chart leads to an imbalance in the crown chakra, leaving the individual disconnected from their spiritual source. The spiritual goal of the violet person should be to connect to and recognize the divine essence in others and to help them become aware of the centrality of their soul.

Relationships

VIOLET WITH RED This is a very intense relationship and you will have to work hard not to become overpowered by your partner.

VIOLET WITH SCARLET This will work if your partner's powerful sexual energies are controlled.

VIOLET WITH ORANGE This relationship will work. Your partner will keep your feet on the ground and release your imaginary fears.

VIOLET WITH GOLD Both of you have sound spiritual strengths and connect well together.

VIOLET WITH YELLOW You will complement each other in everything you do and your life will be very successful.

VIOLET WITH LIME Your partner will clear your mind of any negative influences, keeping you on the right path and bringing balance and harmony into your life.

VIOLET WITH GREEN You will have to work hard at this relationship, because your lack of focus may irritate your partner.

VIOLET WITH TURQUOISE As long as you don't let your partner's psychic abilities interfere, this relationship will work well.

VIOLET WITH BLUE If you are both looking for a peaceful, relaxing existence, this will be a harmonious relationship.

VIOLET WITH INDIGO For this partnership to work you will have to accept one another's strong beliefs.

VIOLET WITH VIOLET You will be on the same wavelength and always know what the other is thinking. This is both positive and negative.

VIOLET WITH MAGENTA This is a potentially wonderful partnership as your partner will help make your dreams a reality.

You have an inner intensity

Sun sign color VIOLET
Destiny color RED

The combination of these two colors creates purple, which indicates that you seek answers to the meaning of life and the existence of your soul. But with red as your destiny color, matters of survival and your physical and emotional security also figure largely in your make-up. This awareness of your mortality bolsters your need for spiritual self-awareness.

IF YOUR PERSONAL EXPRESSION COLOR IS:

RED
With this amount of red combined with violet, your masculine energies are out of balance, which may cause sexual difficulties. Release the negative feelings associated with this.
Compatible combinations
love—yellow, green, green
business—gold, green, green

ORANGE
Your creativity expresses itself through your throat chakra, the chakra associated with communication and self-expression, in the form of beautiful works of art and music.
Compatible combinations
love—yellow, green, blue
business—gold, green, blue

YELLOW
You are so busy trying to make a success of your life that you have little time to sit down and examine where you are headed and why it is you do the things that you do.
Compatible combinations
love—yellow, green, violet
business—gold, green, violet

GREEN
You desperately try to find the meaning of life and seek this in the natural world. If you accept that the divine essence is in and around you, you will find yourself ever nearer to the answer.
Compatible combinations
love—yellow, green, red
business—gold, green, red

BLUE
Your kind actions and loving qualities connect you to your divine essence and soul consciousness. You know what life is all about and help others overcome their emotional fears.
Compatible combinations
love—yellow green, orange
business—gold, green, orange

INDIGO
You are intent on exploring the meaning of life by looking at theories of reincarnation and past lives. This will show you the evidence for and against such phenomena. Only experiential knowledge will give you the real truth.
Compatible combinations
love—yellow, green, gold
business—yellow, green, orange

VIOLET
You feel completely isolated and unable to find the source of your existence. Even living a life of religious seclusion won't necessarily give you the answers you need. Being less focused on yourself and more on others' needs may.
Compatible combinations
love—yellow, green, yellow
business—yellow, green, gold

MAGENTA
There is an intense longing inside you to believe in the existence of your soul. All your acts of kindness are gradually lifting the veils of doubt and fear for you to make contact with your true being.
Compatible combinations
love—yellow, green, green
business—yellow, green, gold

GOLD
You have great faith and believe strongly in the existence of your soul and are in full control of all aspects of your life.
Compatible combinations
love—yellow, green, indigo
business—gold, green, green

You are artistic

Your spiritual and intuitive faculties are highly developed and you seek all the time to understand the true meaning and purpose of life, and your own role in the grand scheme of things. With orange as your destiny color, you are also wonderfully zany and creative and have an insatiable eye for beauty. Your spiritual nature feeds your unquestionable artistic talents.

IF YOUR PERSONAL EXPRESSION COLOR IS:

RED
As you gradually become more and more aware of your spirituality, your sexual desires decrease and are transformed into creative and artistic expression.
Compatible combinations
love—yellow, blue, green
business—gold, blue, green

ORANGE
You have great artistic expression. Your creations are right for the times you are living in, because they are out of this world. Without losing this wonderful talent, try to be a little more practical and grounded.
Compatible combinations
love—yellow, blue, blue
business—gold, blue, blue

YELLOW
You are very flamboyant, and can be impetuous and thoughtless at times. Your kind, loving nature overcomes any feelings of negativity that this may generate.
Compatible combinations
love—yellow, blue, violet
business—gold, blue, violet

GREEN
You understand the positive and negative effects of your actions on others. Use this awareness to control your actions, and you will be amazed at the results you can achieve.
Compatible combinations
love—yellow, blue, red
business—gold, blue, red

BLUE
You are a very kind and caring person, sometimes to your own detriment. But all of these qualities are taking you closer to the divine source and feeding your soul's nourishment.
Compatible combinations
love—yellow, blue, orange
business—gold, blue, orange

INDIGO
You are fascinated by philosophy, not in the dry, abstract sense, but in how it can teach you to live. So you derive your knowledge from direct experience as well as from books. Learn to find ways of expressing this through your yet untapped creative talents.
Compatible combinations
love—yellow, blue, gold
business—gold, blue, gold

VIOLET
Others come to you for advice because of your spiritual gifts. Learn to use these wisely and compassionately and to guide others to their spiritual rather than their psychic faculties.
Compatible combinations
love—yellow, blue, yellow
business—gold, blue, yellow

MAGENTA
You are very forgiving and understanding of others' needs. This is transforming your traumatic experiences into the soul qualities of unconditional love.
Compatible combinations
love—yellow, green, blue
business—yellow, green, blue

GOLD
You know when to go out and enjoy yourself and when to withdraw into your inner sanctuary of peace and quiet. As long as there is a balance between the two, you have nothing to fear.
Compatible combinations
love—yellow, blue, indigo
business—gold, blue, indigo

You have a logical mind

Sun sign color **VIOLET**
Destiny color **YELLOW**

Deep down you have a powerful need for a rich spiritual life, but you sometimes have difficulty reconciling this with your sharp logic and rationalistic mindset. Your ways of thinking compel you to continually revise your spiritual beliefs and to explore many different faiths and spiritual traditions. You are able to live with your doubts and these enhance rather than take away from your spiritual growth.

IF YOUR PERSONAL EXPRESSION COLOR IS:

RED
You are very practical and financially shrewd. This has awarded you with much success. Don't let success deny the existence of the divine essence that guides your life and creates this achievement.
Compatible combinations
love—yellow, violet, green
business—gold, violet, green

ORANGE
You are a beautiful soul. You are caring, compassionate, and generous. You are also very wise and others turn to you for spiritual guidance.
Compatible combinations
love—yellow, violet, blue
business—gold, violet, blue

YELLOW
Whatever you do, you are always successful. You are in total accord with the

divine essence that guides your life. Others seek to undermine your success out of envy, but you are wise enough to know how to overcome this.
Compatible combinations
love—yellow, violet, violet
business—gold, violet, violet

GREEN
You are very organized and dislike clutter of any kind. But you are also very open to new ideas and experiences. All of this builds your inner resources, and makes you readily adaptable to change.
Compatible combinations
love—yellow, violet, red
business—gold, violet, red

BLUE
There have been many changes in your life. These have left you feeling unsettled and unsure of where your roots really lie. It doesn't matter where they do lie, for you can connect to your soul wherever you happen to be.
Compatible combinations
love—yellow, violet, orange
business—gold, violet, orange

INDIGO
All the knowledge in the world is no good without the wisdom to interpret it. You have the life-experience and personal qualities to develop this wisdom and to use it.
Compatible combinations
love—yellow, violet, gold
business—gold, violet, gold

VIOLET
You are very talented at pulling out a key concept from a mass of seemingly unfathomable detail. This is partly due to your logical mind, but you must not underestimate the powerful role played by your intuition.
Compatible combinations
love—yellow, violet, yellow
business—gold, violet, yellow

MAGENTA
You feel an intimate connection to the natural world, and love nothing more than to escape into the wild yonder, away from the cares and worries of the material world.
Compatible combinations
love—yellow, green, violet
business—yellow, green, violet

GOLD
You need to release your negative emotional feelings. But to do this you may have to examine the psychological causes behind them. Instead of giving all your love and compassion to others, save some for yourself.
Compatible combinations
love—yellow, violet, indigo
business—gold, red, indigo

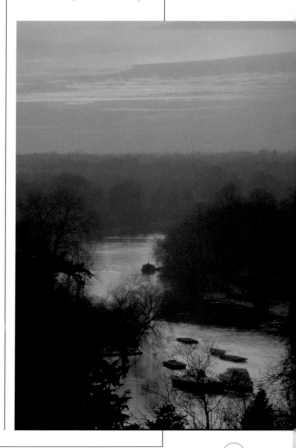

You need variety

Many people regard spiritual faith as the end of the road when it is in fact the beginning of a long and arduous journey. For your soul to develop it must undergo many trials of endurance, but with green as your destiny color, you instinctively prefer a quiet life to one of variety. You therefore need to accept change for the many opportunities it can give you.

IF YOUR PERSONAL EXPRESSION COLOR IS:

RED
This is an intense combination, and you are desperately searching for the meaning of life. This leads you to look at issues of survival, generating great emotional changes and inner fears, which you are learning to overcome.
Compatible combinations
love—yellow, red, green
business—gold, red, green

ORANGE
You love to travel and many people come and go in your life. This lifestyle makes it difficult for you to form permanent relationships. Whenever someone new comes into your life, try to learn from them. Every experience is valuable.
Compatible combinations
love—yellow, red, blue
business—
gold, red, blue

YELLOW
You are very sensitive and become upset when love relationships are ended by others. Draw on your inner courage to release the emotional trauma that is restricting your personal development.

Compatible combinations
love—yellow, red, violet
business—gold, red, gold

GREEN
Some people create change to stir things up and improve a particular situation. You are not one of them, and any more changes in your life will lead to emotional instability and ill health.
Compatible combinations
love—yellow, red, red
business—gold, red, red

BLUE
Your changing beliefs create spiritual instability and a lot of confusion. Don't deny the existence of psychic awareness, for by knowing about it you can protect yourself from negative influences.
Compatible combinations
love—yellow, red, orange
business—gold, red, orange

INDIGO
You are irritated by, and resist, the changes in your life. You need to learn to take the plunge into the unknown every now and again if you are to enjoy the exciting opportunities that life has to offer.
Compatible combinations
love—yellow, red, gold
business—orange, red, gold

VIOLET
You have overcome your fear of change and welcome the opportunity it gives for the development of your soul.
Compatible combinations
love—yellow, red, yellow
business—gold, red, yellow

MAGENTA
Your life is focused on developing the qualities your soul needs for its continued existence and journey into the higher realms of consciousness.
Compatible combinations
love—yellow, green, red
business—yellow, blue, red

GOLD
You create opportunities for your soul's development. This raises your consciousness to higher levels of divine inspiration.
Compatible combinations
love—yellow, red, indigo
business—yellow, orange, indigo

You are inspired

Sun sign color **VIOLET**

Destiny color **BLUE**

With blue as your destiny color, you have the will and power of communication to take your spiritual strengths to new heights of inspiration. You are restless in mind and in soul, and would benefit from meditation and deep relaxation if you are to find ways of nourishing your spiritual and creative needs to the utmost.

IF YOUR PERSONAL EXPRESSION COLOR IS:

RED

You desperately seek the existence of your soul. The temptations of the material world make this difficult. Gradually, you transform your physical desires into qualities of unconditional love, which will take you nearer to your goal.
Compatible combinations
love—yellow, orange, green
business—gold, orange, green

ORANGE

You are a modern-day mystic. You live a simple life and, having transformed your psychic abilities, are a pure channel for the light of divine knowledge.
Compatible combinations
love—yellow, orange, blue
business—gold, orange, blue

YELLOW

Wherever you go, whether at work or at home, you generate divine light and love from your heart to all you meet. Your strengths come from your deep belief in a divine plan that is working for the good of all humanity.
Compatible combinations
love—yellow, orange, violet
business—gold, orange, violet

GREEN

You love nature and live a very simple life. You believe strongly that a healthy body means a healthy mind and live by this principle, avoiding anything that may harm you.
Compatible combinations
love—yellow, orange, red
business—gold, orange, gold

BLUE

You are a fantastic communicator, and although kind and compassionate, you are also tough and resilient. Your main skills lie in soul communication.
Compatible combinations
love—yellow, orange, orange
business—gold, orange, orange

INDIGO

Others are amazed by your uncanny knack of knowing when to do the right thing. This doesn't just come from the knowledge you have acquired: it also comes from your spiritual connection to the divine source.
Compatible combinations
love—yellow, orange, gold
business—gold, orange, gold

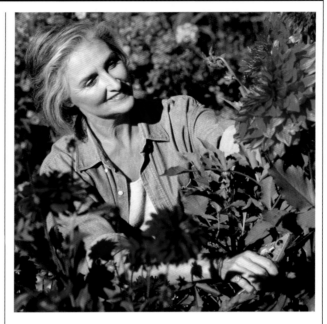

VIOLET

All your physical and emotional needs are being controlled. If they have been transformed in order to feed your soul, then that is wonderful. If they are being suppressed, then release them, or your health will suffer.
Compatible combinations
love—yellow, orange, yellow
business—yellow, orange, gold

MAGENTA

You are made aware of different dimensions of existence. These are given to you as visions, in meditation and through sensory perception. Although the realist in you has difficulty with this, the changes in your life cannot be denied.
Compatible combinations
love—yellow, green, orange
business—yellow, green, gold

GOLD

You are a true spiritual leader and teacher, living and functioning in both the physical and spiritual worlds and able to be realistic about both.
Compatible combinations
love—yellow, orange, indigo,
business—gold, orange, yellow

You have your head in the clouds

You are a dreamer, living the greater part of your life in your head. This is probably a defense mechanism as you crave purpose and simply cannot conceive of a universe empty of meaning. Your soul yearns to be set free but you are holding back out of fear. Learn how to get in touch with your divine essence and your life will take on a whole new meaning.

IF YOUR PERSONAL EXPRESSION COLOR IS:

RED
You desperately need to know the meaning of life, what you are doing here, and where you are going. As your search becomes more intense, feelings of despair may begin to surface. The only way to deal with this is to acknowledge the existence of your soul.
Compatible combinations
love—yellow, green, green
business—yellow, gold, green

ORANGE
You use your creativity to tap the parts of yourself that you had previously been unaware of. This gives you a greater insight into your purpose in life and you are less anxious as a result.
Compatible combinations
love—yellow, gold, blue
business—orange, gold, blue

YELLOW
You are full of fun and love to socialize. Overcoming your emotional fears has made you aware of their negative effect on your life and on your personal development.
Compatible combinations
love—yellow, gold, violet
business—yellow, yellow, violet

GREEN
You have to fight to get any of your new ideas accepted, but once your mind is set you persist until you get your own way. You should accept that compromise is possible, and this is often beneficial for all concerned.
Compatible combinations
love—yellow, gold, red
business—orange, gold, red

BLUE
You always try hard to do the right thing but are not very successful. If you paid more attention to your intuition, you would achieve more, and it would save you a lot of heartache.
Compatible combinations
love—yellow, gold, orange
business—yellow, gold, red

INDIGO
You are kind and caring, but there is too much blue in this combination and if you don't change what you are doing you could find yourself becoming quite depressed.
Compatible combinations
love—yellow, gold, gold,

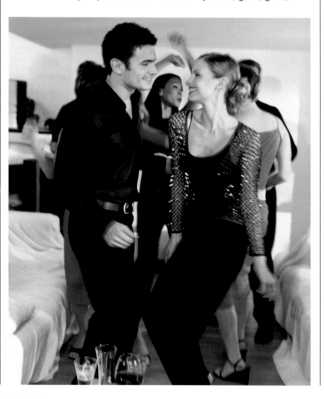

business—yellow, gold, gold

VIOLET
You do everything from the perspective of your spiritual beliefs. You must achieve a balance of all the energies in your life, instead of allowing one to dominate the others.
Compatible combinations
love—yellow, gold, yellow
business—yellow, gold, orange

MAGENTA
For spiritual progress you need to face the harsh realities of life head-on and to overcome them. With pure, unconditional love you have the power to do anything.
Compatible combinations
love—yellow, green, gold
business—yellow, violet, green

GOLD
You believe deeply in the power of the mind to overcome hardship and to change all conditions. You can use this power and belief to help others to heal themselves.
Compatible combinations
love—yellow, gold, indigo
business—yellow, green, yellow

You are restless

With this double dose of violet in your reading, you are aware of the temporal fragility of all things and know that you will be restless until you find peace in another reality, out of time and out of change. Depending on the things that happen to you in your life, you will either be open to new ideas or be closed and disbelieving.

IF YOUR PERSONAL EXPRESSION COLOR IS:

RED
You have very little time to think about your spiritual needs, and when you do, you suppress such thoughts. Your soul is crying out to be recognized. Don't let this situation continue because when you find that you really need spiritual help, you will be unable to access it.
Compatible combinations
love—yellow, yellow, green
business—gold, yellow, green

ORANGE
You are very good at visualizing ideas and your creations come from the images you receive in meditation. All of this gives you a deep belief in the spiritual world and the essence of your soul.
Compatible combinations
love—yellow, yellow, blue
business—yellow, yellow, blue

YELLOW
You have very deep spiritual beliefs but this doesn't prevent you from being a very lively and exciting person to be with. Your own needs are forgotten in your desire to serve others.
Compatible combinations
love—yellow, yellow, violet
business—gold, yellow, violet

GREEN
It is wonderful that you are so passionate about your beliefs. However, not everyone shares the same enthusiasm and you are in danger of trying to instill unwanted emotions in others.
Compatible combinations
love—yellow, yellow, red
business—gold, yellow, red

BLUE
The whole of your life is devoted to being of service to humanity. Through this service you develop the divine light in your heart, which grows stronger every time you help someone or send forth positive thoughts of love.
Compatible combinations
love—yellow, yellow, orange
business—gold, yellow, orange

INDIGO
Your deep curiosity has led you into exploring things beyond your and others' scientific minds. This has brought you closer to understanding yourself as a spiritual being.
Compatible combinations
love—yellow, yellow, gold
business—gold, yellow, gold

VIOLET
There is too much violet in this combination and you are in danger of becoming overbearing, irritable, and impatient. If you can overcome this attitude you will be an inspiration to all.
Compatible combinations
love—yellow, green, red
business—yellow, green, scarlet

MAGENTA
Through unconditional love, the light of your soul grows stronger and radiates through your thoughts and actions to all who are in need. You are able to draw on this light in times of great need and know it will always be there to guide you.
Compatible combinations
love—yellow, green, gold
business—yellow, green, red

GOLD
Your inner light is so strong that it gives you the strength and courage to overcome almost any difficulties. Learn to project this strength on to others.
Compatible combinations
love—yellow, yellow, indigo
business—gold, yellow, violet

You can achieve anything

Although outwardly quiet and unassuming, you readily confront challenge, and have great inner strength and self-belief. With violet as your soul color and magenta as your destiny color, you have the freedom to give hope and inspiration to all your ideals, and to explore new possibilities.

IF YOUR PERSONAL EXPRESSION COLOR IS:

RED

There is a tremendous power of love in your heart, which when controlled can change the world. You learn to transform the power of your primitive desires into the soul qualities of pure, unconditional love.
Compatible combinations
love—yellow, green, green
business—yellow, green, blue

ORANGE

You have a very happy and enjoyable life. You believe strongly in the existence of your soul and create the conditions necessary for its development.
Compatible combinations
love—yellow, green, blue
business—orange, green, blue

YELLOW

Once you have learned that real abundance doesn't necessarily rest with material success, you will have a greater understanding of how you can generate more prosperity in your life.
Compatible combinations
love—green, yellow, violet
business—green, yellow, blue

GREEN

Balance and harmony are key words for you. As with everything, too much spirituality is not good for your overall well-being. Keep it in proportion to the rest of your life.
Compatible combinations
love—yellow, green, red
business—lime, gold, red

BLUE

Truth, justice, and fairness for all are the qualities you hold to in order to nourish your soul. This includes being true to yourself as you continually examine your own values and beliefs.
Compatible combinations
love—yellow, green, orange
business—lime, gold, orange

INDIGO

All of your senses are used to contact the divine source. You develop this through meditation and times of deep reflection. You are now so aware of your inner worlds that these have become a part of your life.

Compatible combinations
love—yellow, green, gold
business—orange, green, gold

MAGENTA

The greatest gift you can give anyone is the gift of unconditional love. Only by accepting all aspects of your nature, good as well as bad, can you achieve full self-knowledge, and fill the lives of others with your love.
Compatible combinations
love—yellow, green, gold
business—yellow, green, red

VIOLET

Your links to higher worlds of consciousness sustain your inner strength and self-belief. But others may have difficulty with this, so be discreet in what you do, and who you trust.
Compatible combinations
love—yellow, green, yellow
business—yellow, green, gold

GOLD

You know that the divine essence is guiding you. This faith is expressed in your desire to help others in any way you can. There are no limitations to this, because you draw on an inner strength, which never fails you.
Compatible combinations
love—yellow, green, indigo
business—yellow, blue, violet

You have high standards

You derive your knowledge from the wisdom of the ages and your own direct experience. You radiate love and warmth and share your wisdom readily with others. Your chief concern is for the wellbeing of all humanity. You set very high standards for yourself and others and need to overcome negative feelings when these are not met.

Sun sign color **VIOLET**

Destiny color **GOLD**

IF YOUR PERSONAL EXPRESSION COLOR IS:

RED
There is an intensity in this combination that demands perfection in everything you do. This creates difficulties for you when you are looking for a partner or lover, because we are all human.
Compatible combinations
love—yellow, indigo, green
business—gold, indigo, green

ORANGE
You are inspirational. You selflessly prepare the fresh ground on which others can thrive and excel, and seek no reward, only the desire to bring joy and happiness to others.
Compatible combinations
love—yellow, indigo, blue
business—gold, indigo, gold

YELLOW
The love and light in your heart are not hidden. They shine for all to see through the many acts of kindness and affection you perform for others.
Compatible combinations
love—yellow, indigo, violet
business—gold, indigo, violet

GREEN
You are mature and self-assured. With wisdom and understanding, you help and encourage others to find their own inner light and teach them how to use it to heal their minds and bodies.
Compatible combinations
love—yellow, indigo, red
business—gold, blue, red

BLUE
You are a compassionate spiritual healer. Through unconditional love, you have transformed your instincts and desires into a pure channel for the healing energy being transferred from you to others.

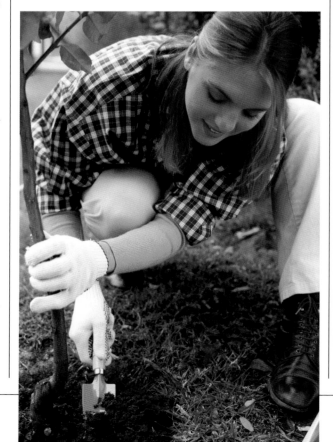

Compatible combinations
love—yellow, indigo, orange
business—gold, indigo, orange

INDIGO
Your imagination is unlimited and you use this to access altered states of consciousness. This helps you to connect to your soul, through which you receive help and guidance to give to others.
Compatible combinations
love—yellow, indigo, gold
business—yellow, indigo, orange

VIOLET
You are like the rays of the sun. Through your own example of unconditional love, you spread spiritual truth and knowledge to everyone you meet.
Compatible combinations
love—yellow, indigo, yellow
business—yellow, indigo, gold

MAGENTA
This is a beautiful combination. There is no separation between your outward personality and inner soul and you live your life as though they were one. With great love you take the dreams and visions of others and turn them into realities.
Compatible combinations
love—yellow, green, indigo
business—yellow, blue, indigo

GOLD
You are often the true power behind the throne. You seek mastery of many skills, and ways of being, but you do not seek to hurt or dominate anyone.
Compatible combinations
love—yellow, indigo, indigo
business—yellow, indigo, magenta

The color magenta

Magenta is the combination of red and violet on the color wheel, and violet the combination of red and blue, so all these colors should be considered in a reading. Magenta is the color of pragmatism and initiative. Like red, it can be overpowering, but it represents power tempered by thought and calm. A good balance of magenta makes one cooperative, and appreciatve. Too much of it and we become demanding and overbearing. Too little and we forget our spiritual needs.

The complementary color to magneta is lime (see page 68), so if you find your chart exhibiting too much overpowering magenta energy, you may want to consider introducing more lime into your life. On the following pages you will find a personalized reading for each three-part combination with magenta as the sun sign.

Physical health

Magenta energizes the adrenal glands, the heart action, and the reproductive system. It is used to treat tinnitus, breast cysts, thrombosis, enlarged spleen, lymphoma, and as a diuretic. It influences the carotid glands, whose main function is to maintain an adequate supply of oxygen to the body. Because magenta contains ultraviolet light, it may also prove effective in fighting airborne infections, and is being studied at the moment for use in hospital ventilation systems.

Emotional health

Psychologically, magenta helps an individual release old emotional patterns that prevent their personal and spiritual development. A good balance of magenta in one's reading puts an individual in control of their moods, allows them to respect themselves and others, and to be self-sufficient, tolerant, and kind. If magenta is overactive, an individual can feel overwhelmed, impatient, and intolerant. A shortage of magenta energy can make an individual lose interest in their surroundings and feel depressed and isolated.

Spiritual health

Magenta influences the whole of one's personal development and spiritual awareness. In its pale shade of pink, magenta is known as the color of unconditional love. The spiritual goal of the magenta person should be the complete integration of all facets of their personality with their soul, so that they become truly at one with themselves.

Relationships

MAGENTA WITH RED There is a lot of power in this relationship and your partner's physical desires will have to be controlled if this is going to work.

MAGENTA WITH SCARLET For this relationship to work your partner's powerful sexual energies will have to be transformed into creative expression.

MAGENTA WITH ORANGE You prefer serious discussions to socializing, so this relationship may not work.

MAGENTA WITH GOLD This partnership will work. You each have a lot of love and compassion to give to the other.

MAGENTA WITH YELLOW With your ability to produce outcomes from your partner's ideas, this will work well.

MAGENTA WITH LIME Your partner will clear away the clutter in your life and you will reach new dimensions of awareness.

MAGENTA WITH GREEN Your partner's stabilizing influence will calm you down when things don't go as planned.

MAGENTA WITH TURQUOISE You work well together. You are both open minded and have the clarity to see alternative possibilities.

MAGENTA WITH BLUE This will work. Your driving force is overwhelming but your partner will give you peace and tranquillity.

MAGENTA WITH INDIGO This is a good match as you are both serious and thoughtful.

MAGENTA WITH VIOLET You both care about the same things and aim for the same goals.

MAGENTA WITH MAGENTA This is a partnership made in heaven. You will provide one another with wonderful opportunities for growth.

You are very strong

Sun sign color **MAGENTA**
Destiny color **RED**

The predominance of red in this color combination places you at the mercy of your physical needs and desires. But you channel your drive into initiating new projects and into helping and empowering others. You are a good judge of character and can arbitrate in difficult situations. All these qualities make you strong and self-sufficient.

IF YOUR PERSONAL EXPRESSION COLOR IS:

RED
With this amount of red in your reading, your negative qualities of bullying and intolerance surface and need to be transformed into empowerment, tolerance, and patience.
Compatible combinations
love—lime, green, green
business—yellow, green, gold

ORANGE
You are a kind and helpful person but at times get a little overbearing. Don't get discouraged: everyone does this from time to time, though not everyone is willing to admit it.
Compatible combinations
love—lime, green, blue
business—red, green, blue

YELLOW
You are quick and clever, but cannot concentrate on anything for any length of time. This leaves you open to charges of fickleness, and you may need to bring some calming green into your life.
Compatible combinations
love—lime, green, violet
business—red, blue, violet

GREEN
Your sensitive antennae make you an excellent arbitrator, especially as you are capable of seeing the big picture when others are not.
Compatible combinations
love—lime, green, red
business—lime, gold, red

BLUE
You are a romantic and an idealist, but you also have the sound common sense and far-reaching vision to turn your ideas into a reality.
Compatible combinations
love—lime, green, orange
business—lime, gold, orange

INDIGO
Others see you as gentle and soulful, but this is a smokescreen for your insatiable desires and ambitions. With enough material and emotional security, you can be a true leader and initiator.

Compatible combinations
love—lime, green, gold
business—lime, green, orange

VIOLET
You are very capable and self-sufficient, but this can make you appear aloof. If you don't let your guard down, you may suffer from feelings of loneliness.
Compatible combinations
love—lime, green, yellow
business—lime, green, gold

MAGENTA
You derive great satisfaction from helping others. You also demand hard work and perfection in return for your efforts. You need to relax sometimes and let people make a few mistakes.
Compatible combinations
love—lime, yellow, green,
business—lime, yellow, red

GOLD
You are steadfast, loyal, and true. Your dedication to the task at hand drives you to achieve the unachievable. But you need to be more realistic about what you can expect from others.
Compatible combinations
love—lime, green, indigo
business—lime, green, violet

Sun sign color **MAGENTA**

Destiny color **ORANGE**

You are a team player

This is a powerful combination. You are aware of the importance of nourishing your emotional and spiritual needs. There may have been unresolved emotional traumas in your past, and through unconditional self-love you have transformed them into qualities of forgiveness and are now able to help others deal with their negative emotions. You have the courage and determination to succeed in whatever you do.

IF YOUR PERSONAL EXPRESSION COLOR IS:

RED
Your creative talents are not fulfilled in the way that they should be because you are too busy to find enough time to yourself. Learn to slow down a little bit and to transmute your creativity into the throat chakra where it will be expressed in many different ways.
Compatible combinations
love—lime, blue, green
business—turquoise, yellow, green

ORANGE
You are full of joy and vitality and have a great deal of love to give. You love going out and meeting people and are an excellent organizer of social events. Find time to replenish your energies.
Compatible combinations
love—lime, blue, blue
business—lime, violet, blue

YELLOW
You give the impression of being in control, but this conceals inner feelings of turmoil, probably related to childhood experiences. You need to release your fears and let others see you for the delightful person you are.
Compatible combinations
love—lime, blue, violet
business—red, green, violet

GREEN
You go out of your way to help others and are a model of cooperation in the workplace. But you can also be quite solitary when you want to be, and others may mistake this for aloofness.
Compatible combinations
love—lime, blue, red
business—orange, blue, red

BLUE
We all like to feel needed and wanted, but you sometimes take caring for others too far. Examine your motives for why you do this, and whether your actions help or hinder your personal and spiritual development.
Compatible combinations
love—lime, blue, orange
business—red, blue, violet

INDIGO
You appreciate the power of positive thinking, but find it difficult to turn thoughts to action. Trust in the principle that there is no such thing as failure, only feedback, and your life will just take off.
Compatible combinations
love—lime, blue, gold
business—lime, blue, red

VIOLET
Change creates opportunities for us to look at our lives in a wholly new light. Learn to welcome change and to enjoy the thrill of the ride.
Compatible combinations
love—lime, blue, yellow
business—lime, blue, yellow

MAGENTA
A good combination. You are very talented at picking the right people for the job and then motivating them to work together to produce magnificent results.
Compatible combinations
love—lime, green, blue
business—red, green, green

GOLD
Your instinctive compassion compels you to speak up for others and to improve conditions around you. Your limitless stamina mean that you throw your energies into active political participation when necessary.
Compatible combinations
love—lime, blue, indigo
business—lime, blue, violet

You are your own boss

Sun sign color **MAGENTA**
Destiny color **YELLOW**

With this color combination you are enthusiastic to a fault, but abhor the idea of anyone standing over your shoulder telling you what to do. With yellow as your destiny color you are given ample freedom to explore your practical initiatives and inner spirituality. You are skilled at setting limits for yourself and at preventing your energies from getting out of hand. With the right amount of self-control you can truly be a mogul.

IF YOUR PERSONAL EXPRESSION COLOR IS:

RED
You are energetic and full of life and vitality. Try to channel this energy into other pursuits such as sports or walking where you can get rid of excess energy.
Compatible combinations
love—green, violet, green
business—lime, violet, green

ORANGE
You have a very successful creative life. You are doing too many different things and this gives you very little time for yourself. Learn to be less active and relax more. At these times you can try to access realities beyond the reach of the physical senses.
Compatible combinations
love—lime, violet, blue
business—red, violet, blue

YELLOW
You enjoy life in any way you can. Your strength and courage to examine your values and beliefs has released emotional fears and transformed them into the qualities needed for your soul's enrichment.
Compatible combinations
love—lime, violet, violet
business—lime, red, violet

GREEN
This is a superb combination. All the colors are compatible and give you all the qualities you need for your personal and soul development. You are able to access dimensions you never thought it possible to reach.
Compatible combinations
love—lime, violet, red
business—green, violet, red

BLUE
Once you get an idea in your head no one can make you change your mind. Stubbornness and tenacity are all very well, but it is not good to have such a rigid attitude, because you can always learn from others. This applies very much to the realm of your spiritual beliefs, too.
Compatible combinations
love—lime, violet, orange
business—lime, violet, gold

INDIGO
You are very efficient and your powers of organization are a source of wonder to all. But you live in denial of your spiritual side. Try to ask yourself what it is about this aspect of your being that makes you so wary.
Compatible combinations
love—lime, magenta, gold
business—magenta, yellow, indigo

VIOLET
You are one of life's great survivors. Past personal experiences have tested your spiritual beliefs and allowed you to transform your feelings of low self-esteem and fear into qualities of self-love and confidence.
Compatible combinations
love—lime, violet, yellow
business—red, violet, orange

MAGENTA
With this amount of magenta in your reading, you risk being a little too domineering and bossy. Try to rein your energies in and to transmute them into higher powers of spiritual awareness.
Compatible combinations
love—lime, green, violet
business—yellow, green, violet

GOLD
You learn to control and release all your negative emotional feelings. This is not easy but you have all the courage and determination you need to do this.
Compatible combinations
love—lime, violet, indigo
business—green, violet, indigo

Sun sign color MAGENTA
Destiny color GREEN

You love adventure

Magenta as your sun sign color allows you to make the necessary mental shifts to alter the way you think and act. Your greatest fear—that of personal loss—is transformed, allowing you to answer the restlessness inside you and to try different ways of being. But with green as your destiny color, you stay grounded in reality.

IF YOUR PERSONAL EXPRESSION COLOR IS:

Compatible combinations
love—lime, gold, red
business—lime, red, blue

YELLOW
Your inner courage has released the emotional trauma that was restricting the development of your soul. You remain optimistic even when things are difficult.
Compatible combinations
love—lime, red, violet
business—lime, red, gold

GREEN
There is too much stability and routine in your life and you need to do something about this. Just because you have deep spiritual beliefs, this shouldn't prevent you from enjoying yourself.
Compatible combinations
love—lime, red, red
business—lime, red, orange

BLUE
You are aware of all the different levels of spiritual existence and are taking precautions to protect yourself from negative influences. Bring some orange into your life to make you enjoy life more.
Compatible combinations
love—lime, red, orange
business—lime, red, yellow

RED
With the link of magenta to your soul you have greater spiritual insight. Emotional fears of survival no longer affect you and you can help others to overcome their irrational fears.
Compatible combinations
love—lime, red, green
business—lime, red, blue

ORANGE
You have overcome the feelings of mutual dependency that has kept you tied to others in the past. This has given you a lot more freedom to do what you want to do without feeling guilty.

INDIGO
You have recognized the marvelous opportunities awarded to you by the changes in your life. Your knowledge is expanding as a result and you are altogether happier and more contented.
Compatible combinations
love—lime, red, yellow
business—lime, red, orange

VIOLET
Many changes are taking place on all levels of your body, mind, and soul. You trust deeply in the divine power that everything has a purpose and is working for the development of your soul.
Compatible combinations
love—lime, red, yellow
business—lime, red, orange

MAGENTA
Your opportunities and experiences have tested your beliefs and taught you to appreciate the wonder of life. All of these have developed the qualities your spiritual life needs for its continued sustenance.
Compatible combinations
love—lime, green, red
business—blue, green, red

GOLD
You are a wonderful spiritual teacher. You are always there to encourage and help others, never criticizing or disempowering them, and you give them all the knowledge they need for their development.
Compatible combinations
love—lime, red, indigo
business—lime, red, gold

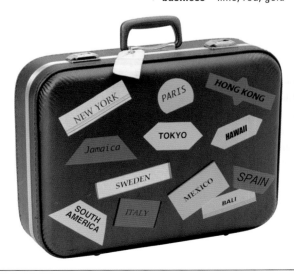

YOUR THREE ESSENTIAL COLORS

You are in touch with your soul

You know that you cannot find your way across life's landscape armed with rational faculties alone. In need of a belief system to sustain you in your darker moments, you are drawn to opportunities to plumb the depths of your soul and to give it the serenity it craves. With blue as your destiny color you should achieve such fullness of awareness.

IF YOUR PERSONAL EXPRESSION COLOR IS:

RED
You have transformed all your desires and instincts into the soul qualities of unconditional love. Instead of fighting for the needs of others in an aggressive manner, you have learned the power of diplomacy, which achieves even more.
Compatible combinations
love—lime, orange, green
business—lime, orange, indigo

ORANGE
By learning to forgive yourself and others, you have found yourself less isolated than in the past. You have the best of both worlds, because you enjoy social activities and also recognize the benefits of peace and quiet.
Compatible combinations
love—lime, orange, blue
business—lime, red, blue

YELLOW
You learn the values of respecting and trusting others and have overcome your need to buy friendship and success. This makes you less fearful of rejection and more open to new experiences.
Compatible combinations
love—lime, orange, indigo

business—lime, orange, violet

GREEN
You have a clear vision and can see both sides of any argument. You are very fair and just and work to bring balance and harmony into disruptive situations.
Compatible combinations
love—lime, orange, red
business—lime, orange, gold

INDIGO
You seek new ways to open up your mind to other worlds and your higher consciousness. You know the importance of doing this slowly and carefully to avoid any negative influences.
Compatible combinations
love—lime, orange, gold
business—lime, orange, yellow

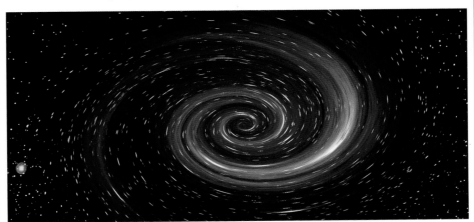

BLUE
You have a very deep connection to your soul. This gives you inner resilience and peace of mind. But you may need to bring some more orange into your life to give you more zest and energy.
Compatible combinations
love—lime, orange, orange
business—lime, orange, yellow

VIOLET
This is a wonderful combination. You are linking to the divine creative source through the qualities of unconditional love, which feeds and nourishes your soul.
Compatible combinations
love—lime, orange, yellow
business—lime, orange, gold

MAGENTA
Having learned to love yourself, you make no demands on others. Instead, you teach, guide, and encourage others through your own example and the deep love in your heart.
Compatible combinations
love—lime, green, orange
business—lime, green, gold

GOLD
You have overcome all your emotional fears, and even negative thoughts from others cannot harm you. If others are in need, you will enter appalling situations with an almost reckless neglect of your own well-being.
Compatible combinations
love—lime, orange, indigo,
business—green, orange, indigo

You have a quiet strength

Being in touch with your soul makes you aware of other possible states of experience and degrees of reality. You are nonetheless pragmatic and energetic, and fascinated by a great many things, particularly by the metaphysical sciences. You have a quiet dignity and power, which others are aware of and profoundly respect.

IF YOUR PERSONAL EXPRESSION COLOR IS:

RED
You are intelligent, witty, and strong, but you make your decisions slowly and carefully. You need meaning in your life and through your continuing experiences you will get closer to the answers you seek.
Compatible combinations
love—lime, gold, green
business—scarlet, gold, green

ORANGE
You are mentally very agile, and know how to convey your knowledge to people from a wide mix of backgrounds. You are respected for the very thorough way you research evidence, and this gives you the credibility you seek.
Compatible combinations
love—green, gold, blue
business—lime, gold, blue

YELLOW
You have learned to control your impetuous nature. You have an expansive mind, which gives you the freedom to further your horizons and challenge the way you see the world.
Compatible combinations
love—lime, gold, violet
business—lime, magenta, violet

GREEN
You have learned to let go of the rigid thoughts and ideas that had previously restricted your soul's nourishment. This release has expanded your horizons and made your life so much more interesting.
Compatible combinations
love—lime, gold, orange
business—lime, gold, red

BLUE
The principles of duty and respect that you have held dear since childhood are being continually challenged. You are aware of how these may have been used to control others, and are changing your values accordingly.
Compatible combinations
love—lime, gold, orange
business—lime, yellow, orange

INDIGO
You are a kind and lovable soul, but perhaps a bit too serious about life in general. Learn to relax and lighten up a little. Laughter and humor can make you very strong.
Compatible combinations
love—lime, gold, gold,
business—lime, gold, green

VIOLET
You are almost obsessive in your desire to uncover logical inconsistencies and errors. You may need to bring some yellow and gold into your life to help you relax and unwind.

Compatible combinations
love—lime, gold, yellow
business—green, gold, red

MAGENTA
Your life has not been easy. There have been many challenges in your life to date, and these have caused you to adapt, and

sometimes overturn, your values and beliefs, and to unlock feelings that were restricting your emotional development.
Compatible combinations
love—lime, green, gold
business—lime, green, red

GOLD
You can be a little too independent, but there is nothing wrong with that. You are learning to be less impatient of others' faults and teach them ways of being independent themselves.
Compatible combinations
love—yellow, gold, violet
business—yellow, gold, indigo

You are a pioneer

You have a quiet dignity and determination, and complete any undertaking you agree to do. You care about the needs of others and if necessary will make sacrifices for them, but you are not interested in speculating about their inner motives. You are always the first to initiate and promote ideas, and are in every respect a ground breaker.

Sun sign color **MAGENTA**

Destiny color **VIOLET**

IF YOUR PERSONAL EXPRESSION COLOR IS:

RED
You come closer to the meaning of life and your purpose in it. All your fears of survival and your own mortality have been overcome, because you have acknowledged the existence of your soul.
Compatible combinations
love—lime, yellow, green
business—magenta, yellow, green

ORANGE
With your feet on the ground and access to your soul, you have the best of both worlds. You recognize the value of different experiences and are open to people from different backgrounds.
Compatible combinations
love—lime, yellow, blue
business—green, yellow, red

YELLOW
You have explored many different spiritual concepts and, taking the best parts from them, have learned to develop your own belief system. As you develop, it is inevitable that this system will change too.
Compatible combinations
love—lime, yellow, violet
business—green, yellow, violet

GREEN
You learn to be more diplomatic when sharing your beliefs with others. By doing this you enable them to have the choice of creating their own beliefs and values.
Compatible combinations
love—lime, yellow, red
business—lime, orange, red

BLUE
As a pure channel of light you communicate with your soul through your divine essence. You have overcome your instincts and desires and transformed them into qualities of unconditional love.
Compatible combinations
love—lime, yellow, orange
business—green, yellow, orange

INDIGO
From your dreams you have learned how to access altered states of consciousness and the essence of your soul. This opens your mind to dimensions and possibilities beyond your present reality.
Compatible combinations
love—lime, yellow, gold
business—green, red, gold

VIOLET
Learn to transform your emotional feelings of irritability and impatience into soul qualities of tolerance, patience, and peace. This will make you less demanding and more understanding of the needs of others.
Compatible combinations
love—lime, green, magenta
business—scarlet, green, magenta

MAGENTA
All of your experiences have tested your desire to make contact with the existence of your soul. Through unconditional love you have passed the test and your life is guided by this divine essence.
Compatible combinations
love—lime, green, gold
business—blue, green, gold

GOLD
You have overcome your need for perfection and know your limitations. You now set yourself realistic goals and standards.
Compatible combinations
love—lime, yellow, indigo
business—lime, orange, indigo

Sun sign color **MAGENTA**

Destiny color **MAGENTA**

You are irrepressible

All the qualities of magenta are intensified in this reading. You have tremendous power to overcome the negative influences in your life and to surmount obstacles. You bowl others over with your powers of reasoning but are at the same time highly creative. This makes you unstoppable in meeting life's challenges.

IF YOUR PERSONAL EXPRESSION COLOR IS:

RED
You are passionate and loyal, but sometimes make decisions without a moment's thought and live to regret the consequences. Use your powers of discernment and learn to look before you leap.
Compatible combinations
love—lime, yellow, green,
business—lime, yellow, blue

YELLOW
You are ambitious and determined, but your love of money and material success is tempered by your strong need for an enriching spiritual life.
Compatible combinations
love—lime, green, yellow
business—lime, blue, yellow

BLUE
You have a fantastic understanding of human psychology and because of this you can help and empower others to resolve their emotional issues.
Compatible combinations
love—lime, yellow, green
business—lime, gold, orange

INDIGO
Your uncanny sixth sense acts as an aid to your natural power and pragmatism. You often seem to know what is going to happen before it happens, and you treat this as a fact of life rather than an inexplicable mystery.
Compatible combinations
love—lime, yellow, green,
business—lime, yellow, blue

VIOLET
You are very energetic, but at the same time crave the silence, serenity, and peace that will allow you to explore your spiritual side to the utmost.

Compatible combinations
love—lime, yellow, green,
business—lime, yellow, green

MAGENTA
You no longer have any physical wants and desires. You are like a saint who has given up everything for the sake of their spiritual beliefs. This is not realistic for the purposes of the material world, and you may need to change your lifestyle.
Compatible combinations
love—lime, yellow, green,
business—green, orange, lime

GOLD
With this amount of divine guidance you will be very successful and there are no limitations on what you can achieve.
Compatible combinations
love—lime, yellow, blue
business—magenta, yellow green

ORANGE
You have great artistic expression and, with your boundless enthusiasm, you are capable of achieving wild and wonderful things.
Compatible combinations
love—lime, orange, green
business—lime, yellow, blue

GREEN
Your life could easily get out of balance if the restraining element of green in your reading was absent. Learn to accept the judicious voice of your soul; it knows what is best for you.
Compatible combinations
love—lime, yellow, green,
business—lime, gold, red

You are a law unto yourself

Sun sign color **MAGENTA**
Destiny color **GOLD**

The age-old concept of "turning base metal into gold," espoused by the alchemists, applies very much to the way you lead your life. You radiate love and warmth to others and share your wisdom with them to help the development of their souls. You dislike being hemmed in by rules and regulations, and answer only to your own values.

IF YOUR PERSONAL EXPRESSION COLOR IS:

RED
All your physical desires have been overcome and transformed into soul qualities of unconditional love. Like St Christopher carrying his load, your life is now devoted to serving others.
Compatible combinations
love—lime, indigo, green
business—magenta, indigo, green

ORANGE
With gold being a higher vibration of orange, all your creative abilities are being used for reaching the divine source. You are fascinated by nature's workings, and by mankind's relationship with the universe.
Compatible combinations
love—lime, indigo, blue
business—lime, indigo, gold

YELLOW
In spite of your instinctive skepticism you accept that not everything can be proven scientifically. You no longer doubt the existence of your soul and of other dimensions beyond those of space and time.
Compatible combinations
love—lime, indigo, violet
business—lime, indigo, violet

GREEN
With great love and wisdom you are teaching children and young people to appreciate that there are some things that cannot logically be explained.
Compatible combinations
love—lime, violet, red
business—lime, blue, red

BLUE
You hide your thoughts behind a million different masks. Others know they can look to you in times of crisis, but they still find it difficult to know exactly what you are thinking.
Compatible combinations
love—lime, indigo, orange
business—lime, indigo, yellow

INDIGO
Knowledge is of no use without wisdom and love, qualities which you have in abundance. You set a marvelous example for others to follow and rarely let anyone down.
Compatible combinations
love—lime, indigo, gold
business - lime, blue, gold

VIOLET
You are a spiritual counselor and guide, receiving your wisdom and guidance from the deepest part of your soul.
Compatible combinations
love—lime, indigo, yellow
business—lime, indigo, gold

MAGENTA
You are a wise soul who has lived through many lifetimes and had many different experiences to achieve your current peace of mind.
Compatible combinations
love—lime, green, indigo
business—lime, green, blue

GOLD
You are a true spiritual master in direct contact with the divine truth and wisdom.
Compatible combinations
love—lime, indigo, indigo
business—lime, indigo, gold

Introducing
COLOR INTO YOUR LIFE

Now that you have been attuned to the colors resonating in your life and have a greater understanding of their meanings, you can use this knowledge to improve your life and the lives of those around you. Although it must be emphasized that color applications either on the body or through the eyes should only be administered by a qualified light and color practitioner, there are other ways that you can introduce color yourself, and the following guidelines show you how to do this.

MEDITATION

For the best result record this on tape first and then play it back.

First, re-acquaint youself with the chakra system (see pages 10–11). Make sure you will not be disturbed for about 30 minutes and make yourself comfortable either sitting or lying down. Focus on your breathing and allow your breath to come in and go out, just as the tide gently flows in and out. Be aware that just as the tide has its own rhythm so you too have your own unique rhythm which connects you to the universal rhythm of life. As your breathing slows down, imagine that there is a ball of light above your head of all the colors of the rainbow.

CHAKRA CONTEMPLATION

This slowly begins to enter your crown chakra. As it does, it changes to violet and fills the chakra with that color giving you divine inspiration. This then flows outward into the rest of your physical body, filling every cell of your being with violet. Gradually

it flows down and becomes the indigo of the brow chakra giving you divine knowledge and understanding. It fills this chakra and flows out to the rest of your physical body, filling every part of you with indigo. As your awareness moves to the throat chakra it becomes blue, the color of divine peace. It fills this chakra and flows to the rest of your body, filling every cell of your being. It then flows to the heart chakra where it becomes the gentle, healing green of nature. Moving your awareness to the solar plexus, the color turns to yellow, the color of divine courage. Again it fills this chakra and flows to the rest of your body and cells. Flowing down from the solar plexus, it meets the orange of the sacral chakra where it gives you divine inspiration and fills this chakra. It then flows out into the whole of your being, filling every cell with wonderful orange. It finally flows down to the base chakra where it changes to the powerful color of red and again flows out into the whole of your being filling you with power and energy. From there it flows down below the soles of your feet into the earth.

SEALING THE MEDITATION

To finish the meditation, imagine a spiral of pure white light rising up through all the chakras through the crown like a burst of energy which falls down each side of your body into the earth and meets below you, forming a protective cloak of light and power. Be aware of any impressions you receive as you focus on each chakra and any colors which predominate. Thank the divine source of creation for all that you have received and seal each chakra by imagining a cross of light encircled by light on each chakra, or by seeing each chakra as a flower which closes its petals as you focus on it.

COLOR BREATHING AND AFFIRMATIONS

As you breathe in imagine that you are breathing a color into your body and as you do so say an affirmation. You do this six times and can make up an appropriate affirmation to do this. The following are some suggestions for you to use:

The red ray fills me with energy and power.
I have all the strength I need

The scarlet ray brings love and joy into my life.
I am full of creativity

The orange ray fills me with joy.
I soar like a bird

The golden ray gives me wisdom and knowledge.
I use this for the benefit of all

The yellow ray releases any fear.
I am a free spirit

The lime ray cleanses my whole being.
I enjoy new experiences

The green ray restores order to my life.
I welcome any changes

The turquoise ray clarifies my thoughts.
I can see clearly the path ahead

The blue ray expresses my understanding.
I am calm and at peace with the world

The indigo ray raises my awareness.
I have great knowledge and understanding

The violet ray inspires me.
My mind is open to all possibilities

The magenta ray fills me with divine love.
I can heal myself and others

SOLARIZATION

We can introduce specific colors into our life through the intake or use of water, placebos, and oils that have been solarized using sunlight and color filters. With water, solarization can be carried out by filling a colored glass container with pure water and placing a same color filter over the top. Alternatively, an ordinary glass can be filled with pure water, colored fabric wrapped around it, and the glass covered with the same color filter or glass. The relevant vessel must be left on a sunny windowsill for approximately one hour. The water must then very slowly be sipped. Placebos and oils are solarized when placed in a small glass container. The container is placed in a box to hide the sun's rays from all but the container's top, and a piece of colored glass laid over the top. The container is then placed in the sun as described above and the relevant material administred accordingly.

FOODS, CRYSTALS, OILS, AND ESSENCES

We take in white light and cosmic energy through the crown chakra which is stepped down through the various energy layers of each of the other chakras. The color of each vegetable food refers to its outer color and links to the dominant chakra of that same color. For those colors of the pigment color wheel not related explicitly to the seven main chakras, they are nevertheless linked in the following way: scarlet links to red, gold to orange and violet, lime to green, turquoise to blue, and magenta to violet.

Different colored foods should be eaten at the times given. Although crystal healing should be carried out by an experienced practitioner, just having crystals around one's person can alleviate pain, elevate vibrational energies, promote clarity, and release emotional blocks. Oils can be administered by an aromatherapist or added to a bath. Flower essences can be purchased, and usually come with clear instructions. The colors and their correspondences to the chakras, foods, crystals, oils, and certain flower remedies are shown opposite.

SILKS AND NATURAL FABRICS

When using fabrics to receive color, it is always best to use natural fibers such as silk, cotton, or pure wool. An individual can then wear clothes or use interior decoration of the relevant colors. Both natural and silk flowers impart us with their color energy and they will very quickly change the vibrations in a room. The general rule with all color is to stimulate energies using the colors of red, orange, and yellow, and to slow energies down with more relaxing blues and violets.

CHAKRAS & COLORS	FOODS	CRYSTALS	OILS	FLOWER ESSENCES
Crown—Violet	Eggplants and gold skinned fruits and vegetables such as mangoes and pumpkin. Eat in evening.	Amethyst Fluorite	Sandalwood Frankincense Jasmine Lavender	Cedar, Chamomile, Jasmine, Forget-me-Not, Live Forever, Grapefruit, Mugwort, Pimpernel, Harvest Brodiaea, Lotus (all aspects of the body)
Brow—Indigo	All purple and dark blue skinned fruits and vegetables Eat in evening.	Sodalite Lapis lazuli	Rosemary Thyme	Amaranthus, Blackberry, Comfrey (endocrine system) Hops, French Marigold, Star Tulip, Spice Bush
Throat—Blue	Blue plums, blueberries, bilberry, cabernet grape. Eat in evening.	Turquoise Aquamarine Blue lace agate	Blue Chamomile (dark blue German) English Chamomile	Almond, Celandine, Daisy, Four Leaf Clover, Self Heal
Heart—Green	Green salads, all green skinned fruits and vegetables. Eat at midday.	Adventurine Rose quartz Tourmaline	Rose Inula Black pepper	Centaury Agave, Bleeding Heart, Cosmos, Borage, Manzanita, Spruce
Solar plexus—Yellow	Bananas, golden grains, nuts, and seeds. Eat in morning.	Citrine Yellow Calcite	Juniper Vetivert	Avocado, Lemon, Saguaro, Banana, Buttercup, Sunflower
Sacral—Orange	Oranges. Eat in morning.	Citrine Red jasper Carnelian	Sandalwood Rose Jasmine	Squash, Apricot, Banana, Madia, Chaparral, Bottlebrush, Gingseng, Blue Flag
Base—Red	Red skinned apples. Eat in morning.	Hematite Red garnet Tigereye	Patchouli Myrrh Rosewood	Bloodroot, Red Clover, Camphor, Dandelion, Cedar, Redwood

Index

Credits

Quarto would like to acknowledge and thank the following for supplying pictures reproduced in this book.

(key: l left, r right, c center, t top, b bottom)

p8t Ann Ronan Picture Library
p29t Digital Vision
p32l Digital Vision
p40 Digital Vision
p50 Digital Vision
p54r Digital Vision
p84 Pictor
p104l Digital Vision
p105b Digital Vision
p110t Ann Ronan Picture Library
p113l Digital Vision
p120b Digital Vision
p124 Digital Vision

All other photographs and illustrations are the copyright of Quarto. While every effort has been made to credit contributors, Quarto would like to apologize should there have been any omissions or errors.

For a fuller intuitive interpretation of your color chart, you can contact DOROTHYE PARKER on www.colour-resonance.com

Further Reading

All Publishers are in the USA unless otherwise stated.

Ursula Anderson M.D., *Immunology of the Soul: The Paradigm for the Future,* InSync Communication LLC, 2001

Richard Gerber M.D., *Vibrational Medicine for the 21st Century,* Eagle Brook, 2000

Pauline Wills, *Colour Healing Manual,* Piatkus, UK, 2000

Roger Coghill, *The Healing Energies of Light,* Charles E Tuttle Co, 2000

Primrose Cooper, *The Healing Power of Light,* Samuel Weiser, 2001

Dr. Brian Weiss, *Messages from the Masters: Tapping into the Power of Love,* Warner Books, 2000

Brian Breiling, *Light Years Ahead: The Illustrated Guide to Full Spectrum and Colored Light in Mindbody Healing,* Celestial Arts, 1996

C.G. Harvey and A.Cochrane, *The Encyclopaedia of Flower Remedies: The healing power of flower essences from around the world,* Thorsons, UK, 1995, an Imprint of HarperCollins Publishers USA

C.W. Leadbeater, *Ancient Mystic Rites,* Theosophical Publishing House, 1995

Naomi Ozaniec, *The Elements of the Chakras,* Element Books Ltd, UK, 1990

Marie Louise Lacy, *Know Yourself Through Colour,* Acquarian Press, UK, 1989

Gabriel Cousens M.D., *Spiritual Nutrition and The Rainbow Diet,* Cassandra Press, UK, 1986

Edwin D.Babbitt, Edited and Annotated by Faber Birren, *The Principles of Light and Colour,* Citadel Press, UK, 1967

Roland Hunt, *The Seven Keys to Colour Healing,* C.W. Daniel, UK, 1958

Faber Birren, *Colour Psychology and Colour Therapy,* Citadel Press, UK, 1950

Carl G. Jung, *Modern Man in Search of a Soul,* Harvest Books, 1995